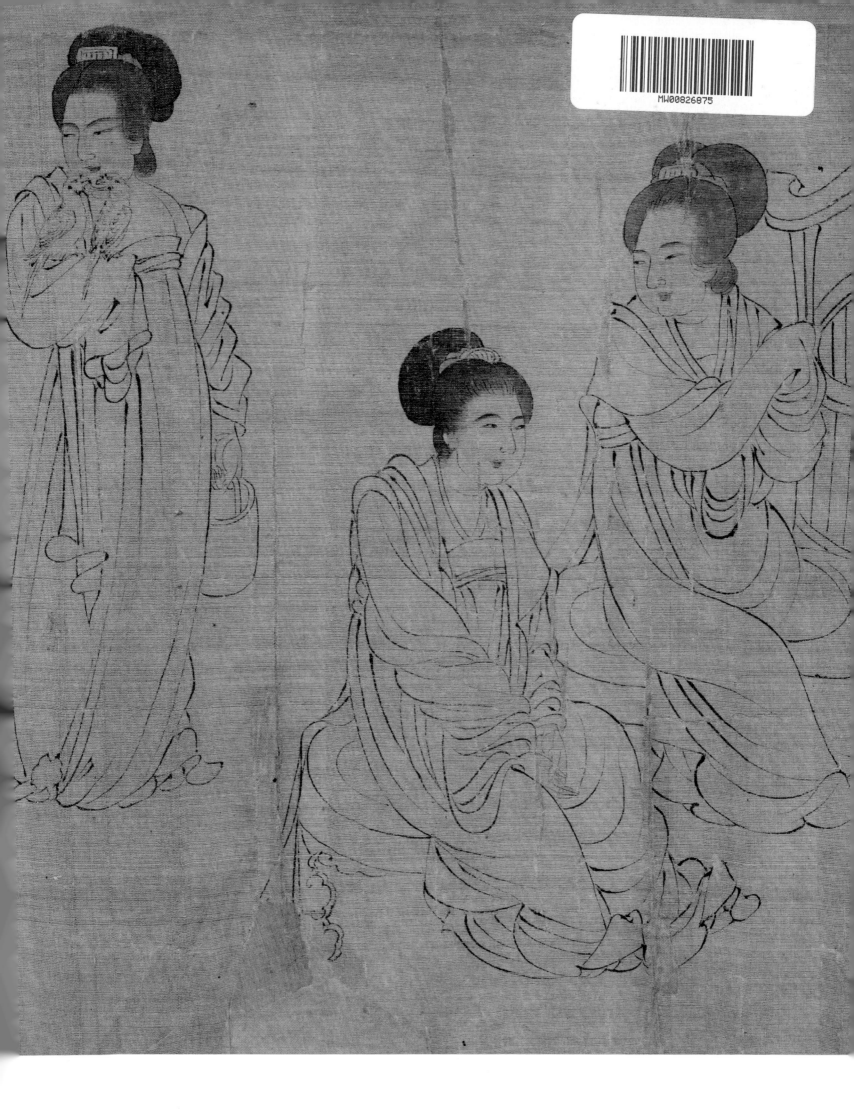

Princeton University Art Museum

Distributed by Yale University Press
New Haven and London

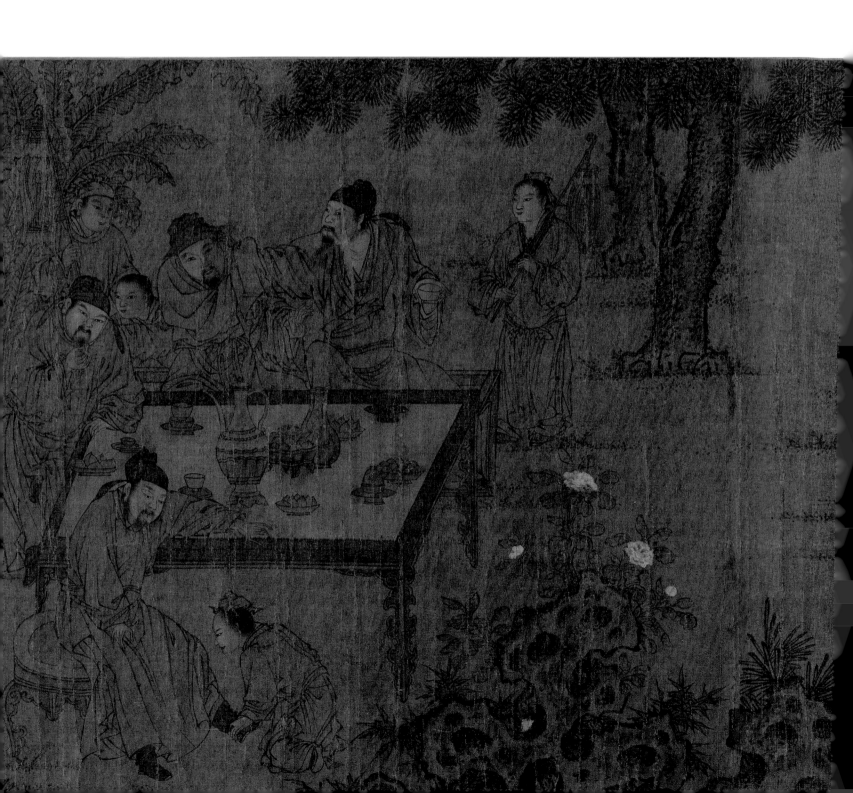

The Eternal Feast

Banqueting in Chinese Art from the 10th to the 14th Century

ZOE S. KWOK

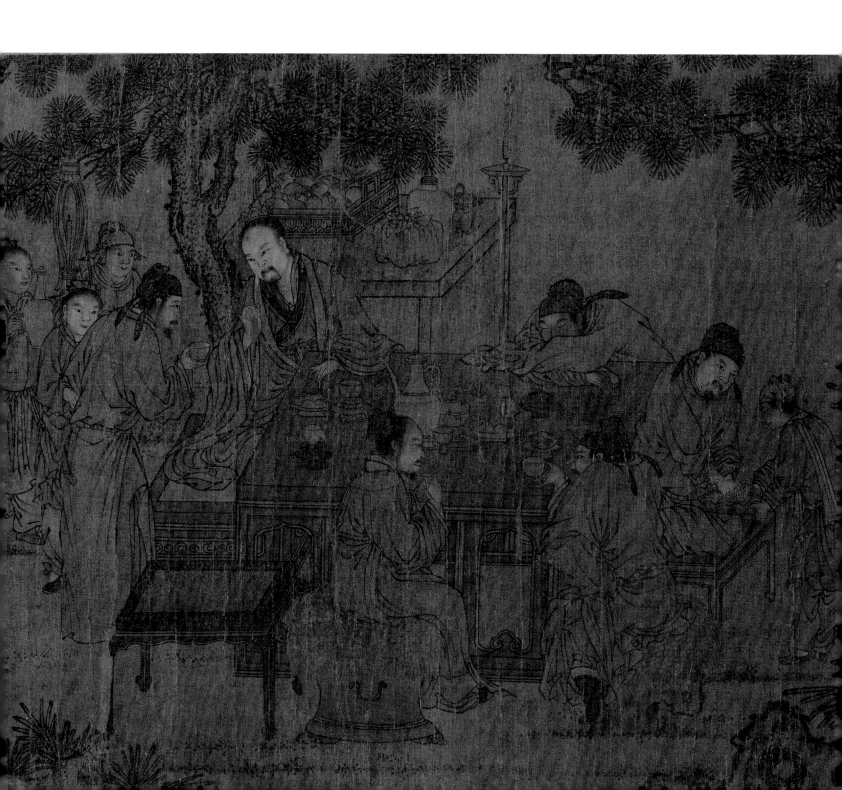

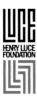

This book is published on the occasion of the exhibition *The Eternal Feast: Banqueting in Chinese Art from the 10th to the 14th Century*

Princeton University Art Museum
Princeton, New Jersey
October 19, 2019–February 16, 2020

The Eternal Feast: Banqueting in Chinese Art from the 10th to the 14th Century is made possible by lead support from the E. Rhodes and Leona B. Carpenter Foundation; the John B. Elliott, Class of 1951, Asian Art Fund; the Allen R. Adler, Class of 1967, Exhibitions Fund; Henry Luce Foundation; and the Cotsen Chinese Study Fund. Generous support is also provided by the Blakemore Foundation; Christopher E. Olofson, Class of 1992; David Loevner, Class of 1976, and Catherine Loevner; Robert L. Poster, Class of 1962, and Amy Poster; and the New Jersey State Council on the Arts, a partner agency of the National Endowment for the Arts. Additional supporters include Princeton University's Center for the Study of Religion, P. Y. and Kinmay W. Tang Center for East Asian Art, Program in East Asian Studies, and Center for Collaborative History; the Princeton Institute for International and Regional Studies; Shao F. and Cheryl Wang; the Chopra Family Youth and Community Program Fund; and the Partners and Friends of the Princeton University Art Museum.

The accompanying publication is made possible with support from the Barr Ferree Foundation Fund for Publications, Department of Art and Archaeology, Princeton University; the Andrew W. Mellon Foundation Fund; and the Shau-wai and Marie Lam Family Foundation.

Produced by the Princeton University Art Museum
Princeton, New Jersey 08544-1018
artmuseum.princeton.edu

Project editor: Janet S. Rauscher

Designed by Margaret Bauer, Washington, DC

Copyedited, proofread, and indexed by Jane Friedman

Maps by Anandaroop Roy

Color separations and printing by Meridian Printing, East Greenwich, Rhode Island

Typeset in Minion Pro and Adobe Kaiti, and printed on Sterling Premium Matte Text

Distributed by Yale University Press
PO Box 209040
302 Temple Street
New Haven, Connecticut 06520-9040
yalebooks.com/art

Printed and bound in the United States of America

ISBN (Princeton University Art Museum)
978-0-943-01225-4

ISBN (Yale University Press)
978-0-300-24690-2

Library of Congress Control Number: 2019948422

front cover, pp. 80–81: detail of *Coffin Box Panel: Arranging an Outdoor Banquet* (cat. 4); front endsheets: detail of *In the Palace* (cat. 23); facing p. 1: detail of *Coffin Box Panel: Attendants Bearing Offerings* (cat. 2); pp. 2–3, 152–53: detail of *Evening Literary Gathering* (cat. 33); pp. 6–7: detail of *Coffin Box Panel: Horse and Grooms* (cat. 6); p. 10: detail of *Odes of the State of Bin* (cat. 34); pp. 14–15: detail of *Eighteen Songs of a Nomad Flute: The Story of Lady Wenji* (cat. 7); p. 18: detail of *Standing Court Lady* (cat. 28); p. 34: detail of *Coffin Box Panel: Preparing for an Outdoor Banquet* (cat. 3); pp. 120–21, back cover: detail of *Palace Banquet* (cat. 21); p. 197: detail of *Coffin Box Panel: Gentlemen Attendants* (cat. 1); back endsheets: detail of *Palace Ladies Bathing Children* (cat. 22)

Contents

8 Foreword
JAMES CHRISTEN STEWARD

11 Preface and Acknowledgments
ZOE S. KWOK

16 Chronology and Maps

19 Introduction: The Feast in the
Artistic Traditions of Early China
ZOE S. KWOK

35 The Feast Across Three Gatherings:
Images of Banqueting
from the 10th to the 14th Century
ZOE S. KWOK

Catalogue

80 Dining in the Afterlife
cats. 1–20

120 Ladies Banqueting in Seclusion
cats. 21–32

152 Gentlemen Feasting
as Scholarly Business
cats. 33–46

186 Bibliography

191 Index

196 Photography Credits

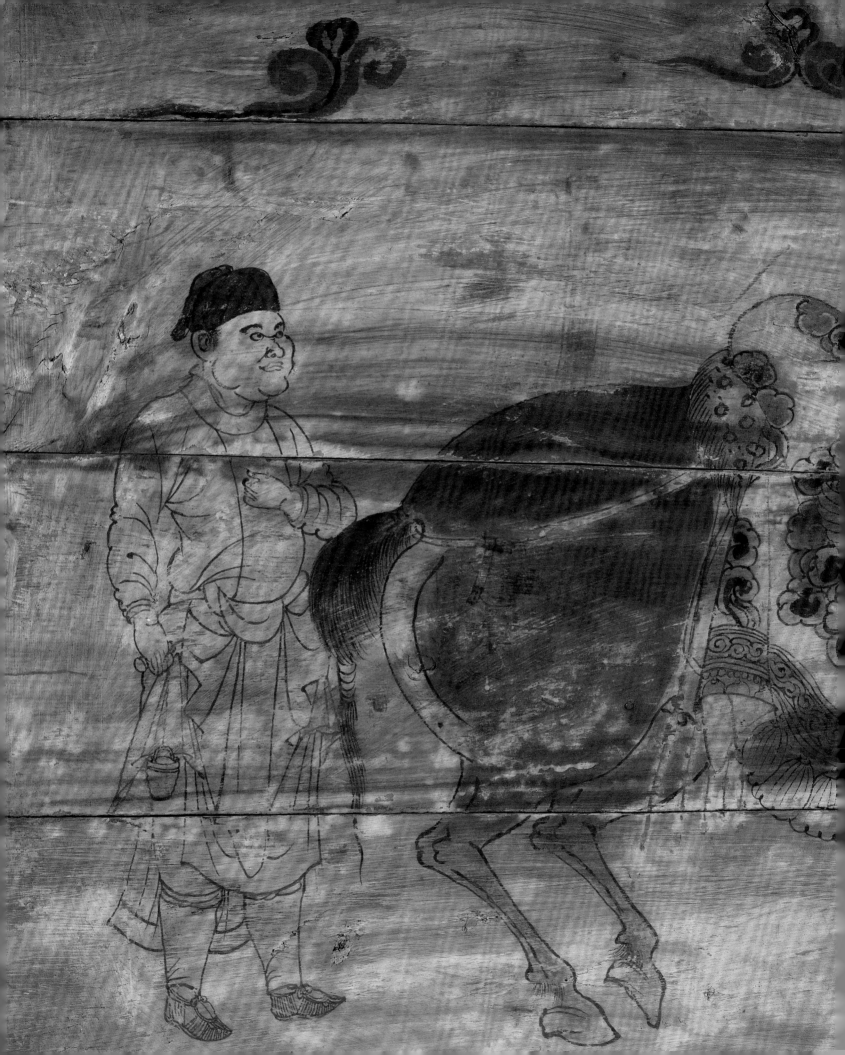

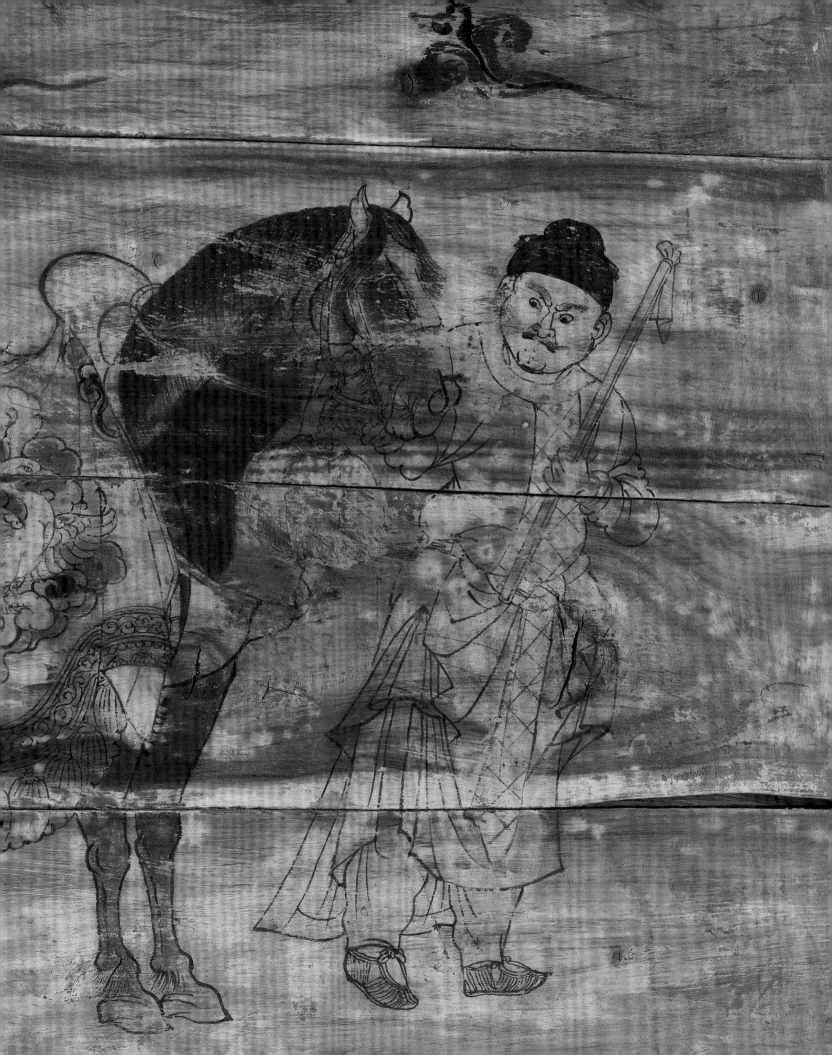

Foreword

The Eternal Feast: Banqueting in Chinese Art from the 10th to the 14th Century continues the proud tradition of scholarly investigation of Chinese art at the Princeton University Art Museum — a tradition that traces its roots to the joint establishment of the present-day Museum and what is now the Department of Art and Archaeology in 1882. Among the objects from a significant collection given to the Museum at the time of its formation as the Museum of Historic Art is a group of Chinese and Japanese ceramics, an early signal that the study of Asian art would be valued at Princeton. This proved to be the case when, in 1927, George Rowley, Graduate School Class of 1926, was appointed the Museum's first curator of far eastern art — a remarkable fact given that many larger institutions did not take up the formal study of Asian art until decades later. Rowley had begun teaching at Princeton two years earlier, in 1925, and was the first professor in this country to offer courses in the field of Asian art history. He was succeeded in 1958 by his student, the inimitable Wen Fong, Class of 1951 and Graduate School Class of 1958, one of the most influential specialists in Chinese art of his generation. The following year, Fong cofounded, with Professor Frederick Mote of the East Asian Studies Department, the first doctoral program in Chinese art and archaeology in the United States. The Museum's present curators of Asian art — Cary Liu, Class of 1978 and Graduate School Class of 1997 (and a student of Wen Fong's), and Zoe Kwok, Graduate School Class of 2013 and curator of the present exhibition — are both graduates of this program. Their work at the Museum continues Princeton's history of scholarly leadership in the study of the visual arts of China.

The Eternal Feast considers the role and impact of feasts and banqueting on the visual and material culture of China from the tenth to the fourteenth century — a historically transformative period that coincides with one of the longest-lived Chinese dynasties, the Song, as well as with the rule of several foreign dynasties, including the Liao and Yuan. Throughout this period, dramatic changes in the structures of artistic patronage transformed the way in which many things were depicted, including feasts and the objects made for such occasions. In the Museum's galleries, and on the pages that follow, the paintings and objects in *The Eternal Feast* present a rich picture of elite China that allows us to explore the ways in which these occasions, and the art connected with them, were shaped by ideas about the afterlife, gender relations, and contemporary political discourse. *The Eternal Feast* thus acts as an entry point to considering much more about dynastic China than the act of banqueting itself.

The range of inquiry in *The Eternal Feast* is matched by the breadth of objects presented in the exhibition, nearly half of which come from Princeton's own collections. For lending works from their collections to the exhibition, we are grateful to the anonymous lenders of *Evening Literary Gathering*; the Cotsen collection; the Metropolitan Museum of Art; the Asia Society Museum;

the Cleveland Museum of Art; the Harvard University Art Museums; the George Washington University Museum and the Textile Museum; the Detroit Institute of Arts; the Herbert F. Johnson Museum of Art at Cornell University; the Minneapolis Institute of Art; and an additional private collector.

Inevitably, multiyear research projects of this kind owe their existence to the generosity of many. *The Eternal Feast: Banqueting in Chinese Art from the 10th to the 14th Century* is made possible by lead support from the E. Rhodes and Leona B. Carpenter Foundation; the John B. Elliott, Class of 1951, Asian Art Fund; the Allen R. Adler, Class of 1967, Exhibitions Fund; Henry Luce Foundation; and the Cotsen Chinese Study Fund. Generous support is also provided by the Blakemore Foundation; Christopher E. Olofson, Class of 1992; David Loevner, Class of 1976, and Catherine Loevner; Robert L. Poster, Class of 1962, and Amy Poster; and the New Jersey State Council on the Arts, a partner agency of the National Endowment for the Arts. Additional supporters include Princeton University's Center for the Study of Religion, P. Y. and Kinmay W. Tang Center for East Asian Art, Program in East Asian Studies, and Center for Collaborative History; the Princeton Institute for International and Regional Studies; Shao F. and Cheryl Wang; the Chopra Family Youth and Community Program Fund; and the Partners and Friends of the Princeton University Art Museum.

The accompanying publication is made possible with support from the Barr Ferree Foundation Fund for Publications, Department of Art and Archaeology, Princeton University; the Andrew W. Mellon Foundation Fund; and the Shau-wai and Marie Lam Family Foundation.

Our greatest thanks, however, are reserved for Zoe Kwok, who as a young scholar is poised to carry Princeton into the future with intellectual suppleness, easygoing breadth, and collegial camaraderie, and for those early benefactors who launched us onto the path of Chinese art history nearly 140 years ago, and began a tradition that Zoe now brightly carries forward.

JAMES CHRISTEN STEWARD

Nancy A. Nasher–David J. Haemisegger, Class of 1976, Director
Princeton University Art Museum

Preface and Acknowledgments

The idea for *The Eternal Feast* arose during the course of my research on *Palace Banquet*, the subject of my PhD dissertation in Princeton's Department of Art and Archaeology. As I delved into different aspects of this fascinating painting, it quickly became apparent that the theme of feasting in the visual culture of China would be not only a rich topic for further study but also a worthy subject for an exhibition. Throughout Chinese history, the culture of feasting has played an outsized role in shaping artistic traditions. Presenting a selection of paintings of feasts and banquets from the tenth through fourteenth centuries alongside an array of feast-related objects, *The Eternal Feast* tells part of this unique story.

From the beginning, this project has benefited from the guidance and unwavering support of several colleagues at the Princeton University Art Museum. I would like to thank Cary Y. Liu, the Nancy and Peter Lee Curator of Asian Art, for his constant encouragement and expert advice throughout the project. I am also grateful to T. Barton Thurber, former Associate Director of Collections and Exhibitions, for helping me to the finish line. Finally, my gratitude goes to James Christen Steward, the Nancy A. Nasher–David J. Haemisegger, Class of 1976, Director. Without his steadfast support, this exhibition would have remained only an idea.

I was fortunate at several points in the development of this project to receive valuable feedback from fellow art historians. I am indebted to Jonathan Hay for inviting me to present this exhibition at the NYU–China Project Workshop in December 2016. I thank the participants at that workshop for their astute comments, and especially Stephanie Tung for her faithful notations of the proceedings. A panel on Banqueting in Chinese Art, Literature, and Religion that I organized for the 2017 Association of Asian Studies conference also led to many fruitful discussions. I extend my gratitude to those who participated with me, including Alfreda Murck, Linda Feng, and Michele Matteini. At Princeton, a small workshop on the exhibition in the summer of 2017, attended by Andy Watsky, Dora Ching, Wenjie Su, and Cary Liu, also proved extremely productive; I owe my thanks to all the participants.

Several scholars generously read all or parts of this manuscript. In particular, I owe a great debt to the two reviewers of the manuscript, Jeehee Hong and François Louis, whose detailed comments and criticisms proved invaluable. I would also like to thank my Princeton colleague Cheng-hua Wang for her timely advice on several art-historical matters. Cary Liu went above and beyond the call of duty in patiently providing his perceptive comments over the course of several drafts. During the writing of this book, many other colleagues also graciously shared their knowledge with me, including Virginia Bower, Jerome Silbergeld, Jim Lally, I-Hsuan Chen, Hsueh-man Shen, Laurie Barnes, and Heping Liu.

Special thanks must go to Robert Bagley for contributing his expertise on Bronze Age China and inspiring the archaeological examples of feasting discussed in the introductory essay; Phil Chan, curator at the Chinese University of Hong Kong and a J. S. Lee Memorial Fellow at the Princeton University Art Museum in 2019, for providing updated research on paintings and calligraphy in the Princeton collection that are included in *The Eternal Feast*; and Robert Mowry for his detailed correspondence about Song and Liao ceramics. I am grateful for the valiant efforts made by all these friends and colleagues to improve this catalogue. Any shortcomings or mistakes that remain are mine alone.

Over half of the objects in *The Eternal Feast* come from other institutions or private collections. I must offer my heartfelt gratitude to the people who made these loans possible, many of whom generously responded to calls for various kinds of support as this exhibition and book came together: Joseph Scheier-Dolberg, Maxwell K. Hearn, and Zhixin Jason Sun at the Metropolitan Museum of Art; Melissa Moy and Amy Brauer at the Harvard Art Museums; Clarissa von Spee and Sinéad Vilbar at the Cleveland Museum of Art; Margit Cotsen and Lyssa Stapleton at the Cotsen Collection; Adriana Proser at the Asia Society Museum; Yang Liu at the Minneapolis Institute of Art; Katherine Kasdorf at the Detroit Institute of Arts; Tessa Lummins and Lee Talbot at the George Washington University Museum and the Textile Museum; Ellen Avril at the Herbert F. Johnson Museum of Art, Cornell University; and the wonderfully agreeable owners of *Evening Literary Gathering*. I am also grateful to Jim Lally for the gift of the elegant Liao dynasty wooden ladle.

The Eternal Feast has benefited enormously from the work of a pair of talented designers. This beautiful publication is the result of the keen eye and hard work of Margaret Bauer. Her expert handling of the trickiest of layout problems and equanimity in the face of my many requests were a model of professionalism under pressure. The equally beautiful exhibition installation is the result of John Monaco's superb vision.

At Princeton, this publication and exhibition were realized by the gifted and energetic group of colleagues with whom I have the privilege of working. I owe the deepest gratitude and appreciation to Janet Rauscher, editor par excellence, who shepherded this project with conviction, compassion, and great wisdom. I am extremely thankful to Courtney Lacy for her tremendous grant-writing skills; Carol Rossi, the project's astute registrar; Michael Jacobs, for his deft handling of exhibition services; and Marin Lewis, our supremely capable image manager. I also want to express my great appreciation to Caroline Harris, Diane W. and James E. Burke Associate Director for Education; Julie Dweck, Andrew W. Mellon Curator of Academic Engagement; Veronica White, Curator of Academic Programs; Cara Bramson, Student Outreach and Programming Coordinator; Cathryn Goodwin, Manager of Collections Information; Jeff Evans, Manager of Visual

Resources; Dan Brennan, Museum Application Developer; Stephen Kim, Associate Director of Communication; Irma Ramirez, Graphic Designer; Bryan Just, Acting Associate Director for Collections and Exhibitions; and Elizabeth Aldred, former Associate Registrar, as well as the host of other colleagues who worked on various aspects of this project.

I would also like to express thanks to Yimin Wang, curator at the Palace Museum, and Dong Huang-Cherney for their help in obtaining images and permissions for this publication; Kent Cao, Luce Foundation Postdoctoral Fellow at the New College of Florida, for his careful eye in editing the Chinese-language terms in the manuscript; Jane Friedman for copyediting, proofreading, and indexing the book; and Danny Frank at Meridian Printing for overseeing the printing of this publication.

This project would not have materialized without the incredible generosity of its funders. They are thanked and credited elsewhere in this publication, but I would like to add an additional note of appreciation to Shau-wai and Marie Lam for their contribution to this publication, as well as to David and Cathy Loevner and Amy and Bob Poster for their support of the exhibition.

Finally, my deepest gratitude goes to my husband, Kyle Steinke, for being my partner, collaborator, and greatest supporter in every aspect of this project. Our daughter Evelyn was born as work on *The Eternal Feast* was just getting underway. Her presence brought immeasurable joy to the process. I also must thank my parents and parents-in-law for their constant support. My beloved mother and most ardent champion, Annette Kwok, passed away as this manuscript was going to press. I dedicate this book to her.

ZOE SONG-YI KWOK

Assistant Curator of Asian Art
Princeton University Art Museum

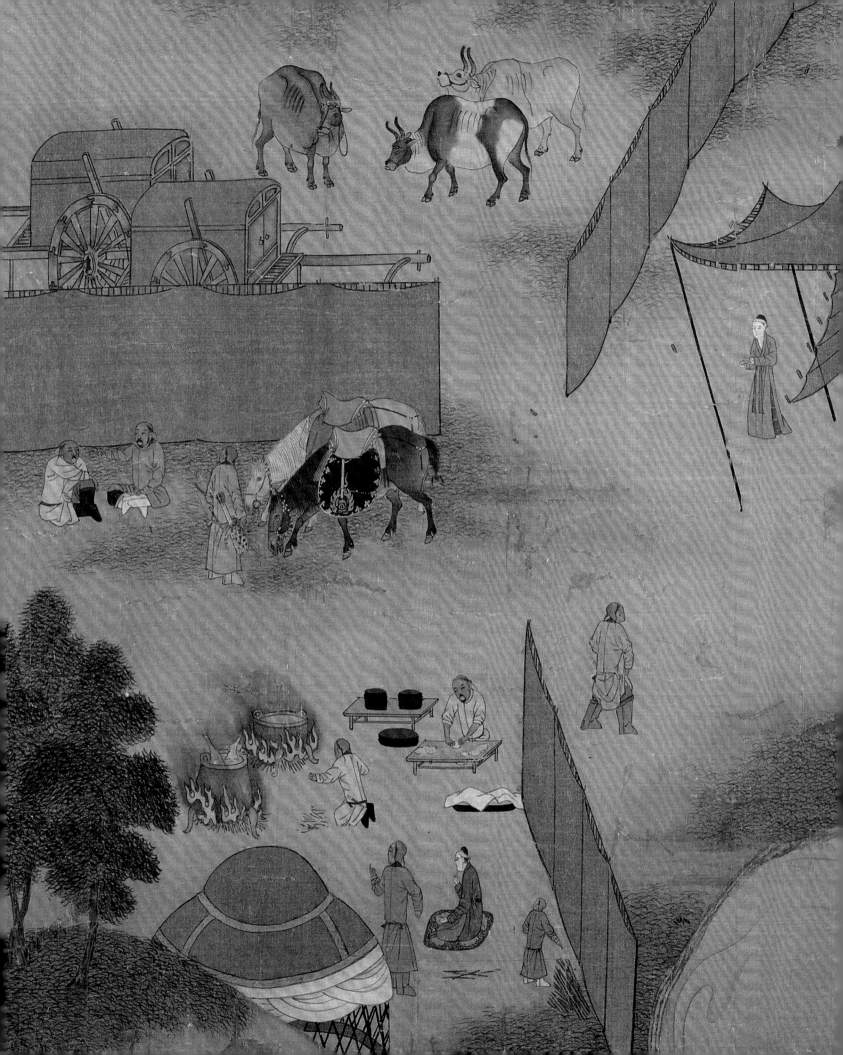

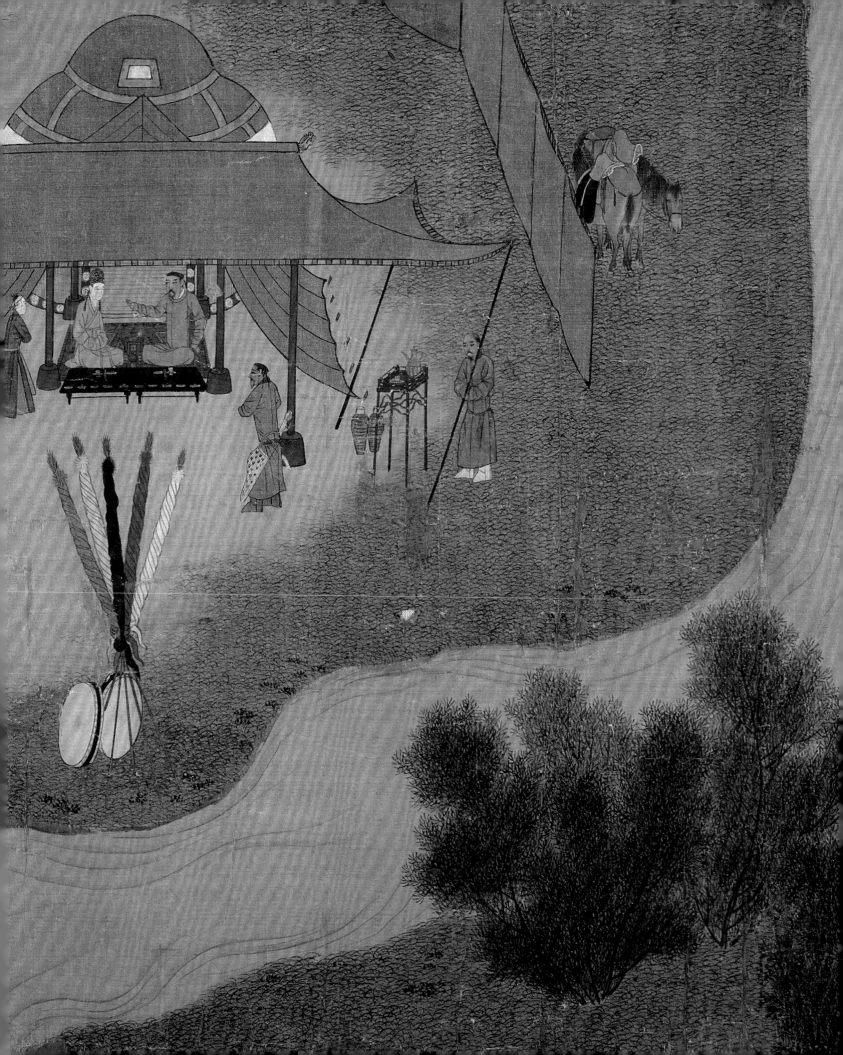

Chronology and Maps

Erligang civilization (ca. 1500–ca. 1300 BC)

Late Shang (Anyang period) (ca. 1250–ca. 1050 BC)

Western Zhou (ca. 1050–771 BC)

Eastern Zhou (770–256 BC)
Spring and Autumn (770–481 BC)
Warring States (481–221 BC)

Qin (221–206 BC)

Han (206 BC–AD 220)
Western Han (206 BC–AD 9)
Eastern Han (AD 25–220)

Six Dynasties (220–589)

Sui (589–618)

Tang (618–907)

Five Dynasties and Ten Kingdoms (907–979)

Liao (907–1125)

Song (960–1279)
Northern Song (960–1127)
Southern Song (1127–1279)

Xi Xia (1032–1227)

Jin (1115–1234)

Yuan (1260–1368)

Ming (1368–1644)

Qing (1644–1912)

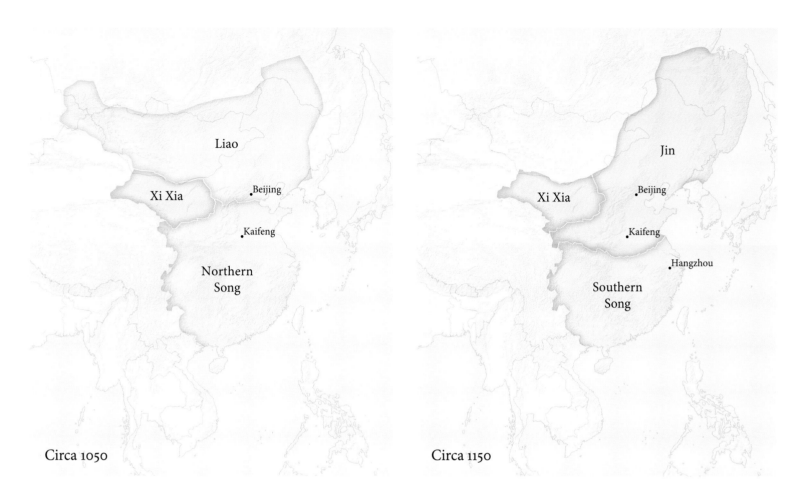

Liao

Xi Xia

•Beijing

•Kaifeng

Northern
Song

Circa 1050

Jin

Xi Xia

•Beijing

•Kaifeng

•Hangzhou

Southern
Song

Circa 1150

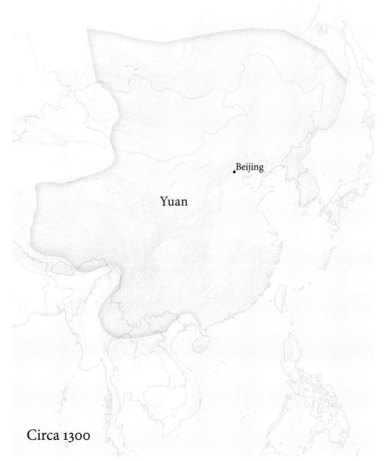

•Beijing

Yuan

Circa 1300

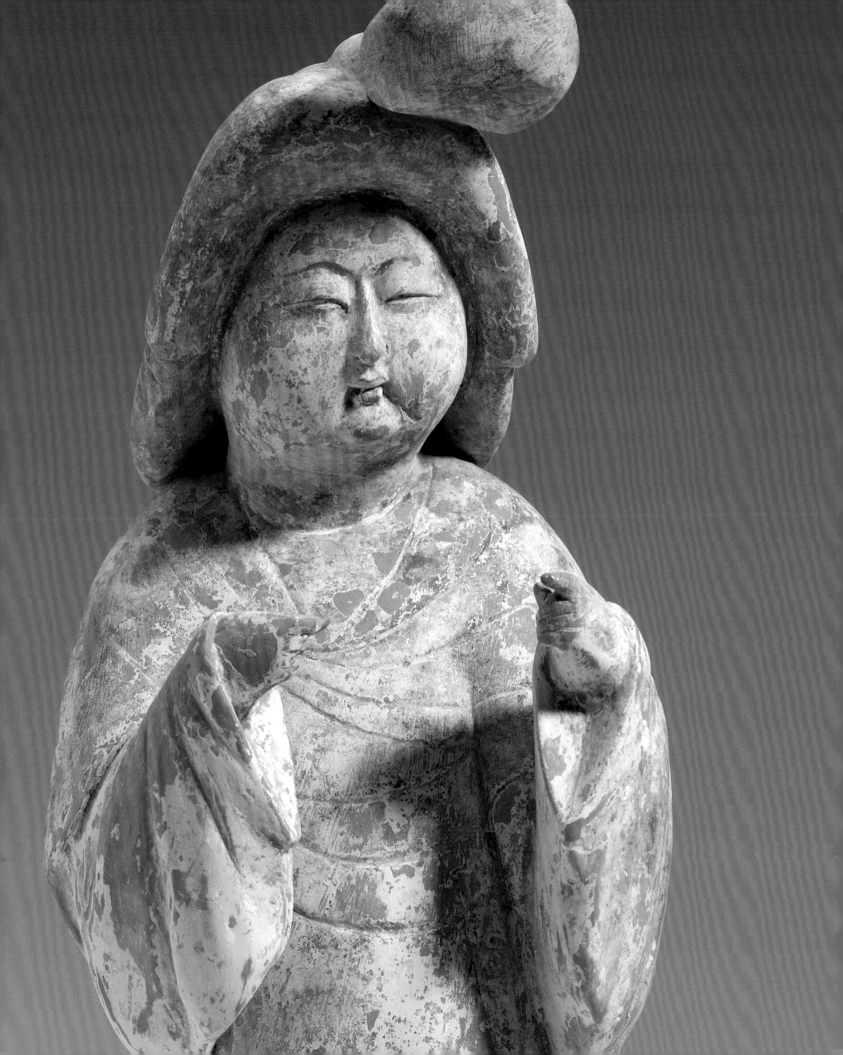

Introduction:
The Feast
in the Artistic
Traditions
of Early China

ZOE S. KWOK

Depictions of feasts are among the most immediately accessible images of human activity. No matter how remote in time period, geographic location, or cultural context, we can all identify in some way with scenes of people coming together for the special occasion of a meal. However, if we look closely at an image of a feast, we see that an entire apparatus of culture and tradition comes into play, involving not only the culinary and material culture of the society in which the feast was held but also the historical, political, religious, and social context and function of the event. Perhaps nowhere else do the various aspects of the feast come together with greater resonance and force than in China, where a long tradition of feasting and banqueting shaped the culture in important ways.

The Eternal Feast examines the impact of this culture of feasting on the artistic traditions of China through the lens of rare surviving paintings of feasts, and objects related to those depictions, from the tenth through fourteenth centuries. This time frame spans the rise and fall of the Liao (907–1125), Song (960–1279), Xi Xia (1032–1227), Jin (1115–1234), and Yuan dynasties (1260–1368) — an epoch that witnessed not only prolonged periods of rapid economic growth supporting the widespread flourishing of the arts but also intense political turmoil that led to the subjugation of Chinese territory by foreign powers. *The Eternal Feast* focuses on works from this period because they manifest a shift in the role of painting in society: the decline of the elite tomb as a major site of painting and the rise of a new class of social elites whose hunger for the visual prized paintings meant for the living.

DEFINING THE FEAST

Before delving into the exhibition, it is first worth pondering the meaning of the word "feast" and its pivotal role in earlier periods of Chinese history, the Bronze Age and the Han dynasty in particular. "Feast" is used here to describe a gathering over food and drink marked by several basic elements.[1] First, there is the food itself. The meal is a crucial component of any feast, revealing the culinary tastes and sophistication of the event.[2] Beyond the meal are the preparation and serving of food and drink, which require the marshaling of both material resources and personnel. Then there is the communal nature of the feast — the act of sharing food and drink — which demands some understanding of the appropriate social and culinary etiquette on the part of the participants.

Thus, "feast" is used here as an overarching term to encompass a range of gatherings where food and drink are served, from the informal to the formal, and for a group of participants that may include just a few guests or number in the thousands. The most formal feasts may be classified as "banquets," a word that bespeaks events involving a higher order of ritual or ceremony.[3] At the other end

of the spectrum are simple parties accompanied by food and drink. These more casual and socially relaxed occasions might not require participants to adhere to any rigid protocols, but as with all social gatherings certain conventions of behavior would always pertain.

In China, the convening of a feast represented a break from everyday routine, yet the functions of feasts varied widely. Feasts and banquets could serve to forge, strengthen, and commemorate relationships and alliances, institutional or personal, and engage a range of different communities of varying levels of exclusivity. Alternately, or in conjunction, they could mark a host of specific, significant milestones: political, religious, calendrical, and social. Whatever the goals of a particular feast, however, the outcome depended on the actions of both parties to the event — host and guest — whose interests could align or conflict.[4]

THE FEAST IN THE BRONZE AGE

Although China's culture of feasting involved all levels of society, it had already begun to play an outsized role in the lives of the elite during the Bronze Age. With enormous wealth concentrated at the highest levels of already highly stratified societies, the impact on material culture was profound. Elite banqueting prompted massive investments in the creation of luxury objects in a variety of materials, including ceramic, lacquer, bronze, jade, and silk, giving rise to new artistic achievements as well as technological innovations. The importance of these developments for later civilization is difficult to overstate. To take just one example: the early development of the sophisticated high-fired ceramics that eventually led to porcelain depended on the appetite of Bronze Age elites for expensive vessels for dining.[5] The subsequent industrial-scale production of porcelain in imperial China and its export around the world, in turn, transformed the global economy and became an important catalyst for scientific developments in Europe.[6] In short, technological advancements in ceramics, as well as lacquer and metallurgy, owe a significant debt to the early Bronze Age desire for luxury display centered on feasts and banquets.

China's early banqueting culture also had significant repercussions for the development of calligraphy and painting, alongside music, dance, and theater. For example, the creation of beautiful inscriptions on Shang and Zhou ritual bronzes led to calligraphic innovations that transformed the Chinese script.[7] Painters working on lacquerware were responsible for important developments in pictorial art.[8] After the Han dynasty, calligraphy and painting on silk and paper gradually became the prestige art forms of China, practiced by members of the social elite — not only by professional artists and scribes. By the tenth century, calligraphy and painting came to function in a manner akin to performance art,

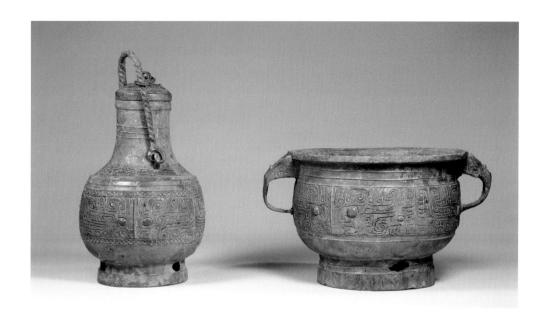

with the creation of works by host and guests alike a potential element of a feast's program of activities (see cats. 32 and 46).

Music's fundamental role in the political and cosmological rituals of Bronze Age China evolved in part from its prominence as a form of entertainment for state banquets.[9] As the culture of feasting expanded, these formal occasions afforded musicians with venues at which to demonstrate their skills; they also made up the patronage structure for the creation of sophisticated musical instruments and the extensive training needed to master them. Although the earliest evidence is less plentiful, dancing was also an integral component of the entertainment for feasts and banquets, occasions that likewise provided an important impetus for patrons to support the professionalization of the art form.

Perhaps the most important feature of the Bronze Age culture of feasting was its long-lasting association with ancestor worship and funerary rituals, which were at the core of early Chinese religious thought. This association is reflected in the very characters for "feast," *yan* 宴 and *xiang* 饗, which also describe ritual offerings of food and drink for the deceased in early China. To understand the close connection between feasts and ancestor worship, let us turn briefly to the archaeological record of Bronze Age tombs in China.

Beginning in the second millennium BC, we find elite tombs filled with enormous quantities of bronze ritual vessels for preparing and serving food and beverages (fig. 1).[10] Buried with the deceased in order to serve the ritual needs of the afterlife as well as the devotional obligations of the bereaved, these objects were undoubtedly modeled on or developed from contemporary feasting practices for the living. The reason Bronze Age elites committed significant economic and

fig. 1 / Erligang culture, wine container (*you*) and grain serving vessel (*gui*) from Lijiazui Tomb 1, Panlongcheng site, Hubei province, 14th century BC. Bronze, H. 31 cm (*you*); H. 17.4 cm, diam. at mouth 22 cm (*gui*). Hubei Provincial Museum

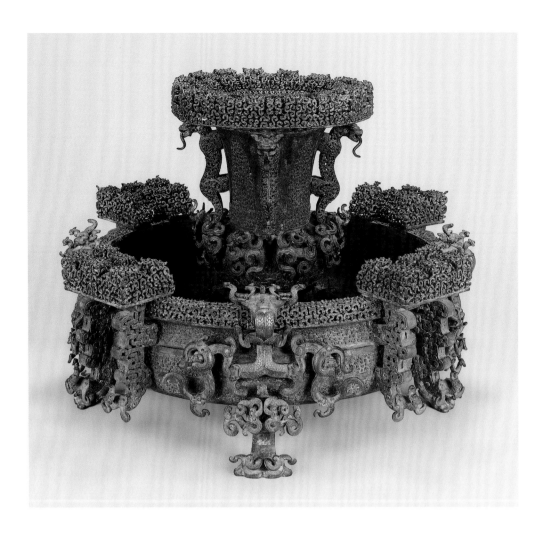

labor resources to sustain a highly sophisticated, large-scale bronze industry devoted in no small part to the production of ornate vessels lay in the critical role these objects and the rituals of feasting played in Bronze Age society.[11]

Elite funerary rituals during the Shang (late 2nd millennium BC) and Western Zhou (ca. 1050–771 BC) periods required bronze vessels filled with meat, grain, and alcohol to be presented as offerings for ancestors, whose transformed spirits could intercede with the gods in matters concerning their descendants.[12] Central to the lives of the ruling elite in early China, this "cuisine of sacrifice" drew together multiple generations of a lineage — the deceased ancestors, the living, and the unborn descendants — in a community based on the eternal presentation of food and drink.[13]

The archaeological record of the subsequent Eastern Zhou period (770–256 BC) suggests that feasts, and the elaborate material culture that supported them, only continued to grow in importance. To cite one spectacular example:

fig. 2 / Eastern Zhou, vase (*zun*) and tray (*pan*) set from the tomb of Marquis Yi of Zeng, 5th century BC. Bronze, H. 30.1 cm, diam. at mouth 25 cm (*zun*); H. 23.5 cm, diam. at mouth 58 cm (*pan*). Hubei Provincial Museum

the fifth-century tomb of Marquis Yi of Zeng (d. 433), ruler of a small state located in present-day Hubei province, contained not only a vast number of ritual bronze vessels cast specifically for the tomb but also an array of objects that almost certainly figured in the state banquets of Marquis Yi during his lifetime.[14] This banqueting apparatus comprised not only impressive vessels for food and drink, including a particularly sensational bronze wine vase and tray (fig. 2), but also twenty instruments of a large musical ensemble.[15] The most remarkable of these instruments is a tuned set of sixty-five bronze bells, many featuring gold inlaid inscriptions, that survived in playable condition, mounted on a three-tiered wooden stand with bronze fixtures (figs. 3–4).[16]

　　　Marquis Yi's tomb attests to the overwhelming influence of state-level banquet rituals on elite funerary practices. The *Zhouli* 周禮 (Rites of Zhou), a work that likely dates to the late Warring States period (481–221 BC), gives some sense as to the perceived scale of the highest strata of state-level dining. It lists the Zhou king's palace staff at nearly 4,000 servants, a staggering 2,271 of which are said to be involved in the preparation of food and drink. This group included 256 chefs evenly divided between the internal needs of the palace, preparing meals for the king and his family, and the external obligations of serving state guests. An additional 62 cooks were available for assistance. The kitchen staff also included "335 specialists in grain, vegetables, and fruits; 62 specialists of game; 342 fish specialists; 24 turtle and shellfish specialists; 28 meat dryers; 110 wine officers;

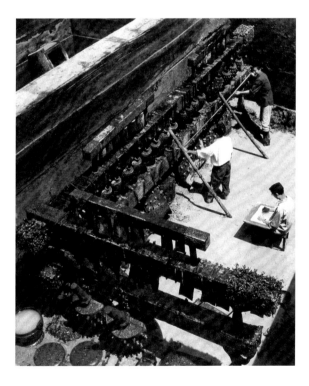 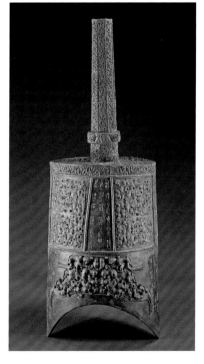

fig. 3 / Archaeologists excavating the main compartment of the tomb of Marquis Yi of Zeng, Suixian, Hubei province. The two poles resting against the bell stand were used for striking the largest bells.

fig. 4 / Eastern Zhou, *yongzhong*-type bell, from the middle tier of the set found in the tomb of Marquis Yi of Zeng, 5th century BC. Bronze with gold inlaid inscription, H. 65.6 cm. Hubei Provincial Museum

340 wine servers; 170 specialists in the 'six drinks'; 94 ice men; 31 bamboo-tray servers; 61 meat-platter servers; 62 pickle and sauce specialists; and 62 salt men."[17] These numbers suggest what a third-century author might have believed was probable for the greatest of royal households.

In the centuries following the Zhou period, waves of political unrest resulted in fundamental changes to Chinese thought and society. Nonetheless, feasts retained their status as major events in the social and political lives of the elite and continued their vital role in funerary rituals. Turning to later periods, we begin to see in the literary record more detailed accounts of feasts and the activities that accompanied them, while in the archaeological record new forms of material evidence, including pictorial art and sculpture, shed further light on developments in cuisine and dining culture.[18]

THE FEAST IN THE HAN DYNASTY

A famous account of a historical banquet suggests how feasts came to be embedded in both literary and popular culture in the Han dynasty (206 BC–AD 220) and later periods. The feast in question was the Banquet at Hongmen (*Hongmen yan* 鴻門宴), which took place in 206 BC near the Qin dynasty (221–206 BC) capital of Xianyang, on the outskirts of present-day Xi'an. The Banquet at Hongmen is regarded as a turning point in the struggle for power between Liu Bang (256–195 BC) and Xiang Yu (232–202 BC), two warlords vying for supremacy amid the chaos following the fall of the Qin. The suspenseful political standoff is recounted by the Han historian Sima Qian (ca. 145–86 BC) in his magnum opus, *Shiji* 史記 (Records of the Grand Scribe).[19] Hosted by Xiang Yu, the feast constituted political theater of the highest order: a seating-arrangement power play; an assassination plot fashioned and then foiled; and an etiquette-breaking early departure by Liu Bang, who went on to found the Han dynasty.[20] The fame of the Banquet at Hongmen is such that it is still used as a catchphrase for a trap or otherwise perilous situation.

Sima Qian's account reveals much about banquet protocols in the years preceding the establishment of the Han dynasty and their importance for the assumption and display of political power. A host of actors is involved in the machinations surrounding the event, each with his own agenda, including one Xiang Yu advisor who plots Liu Bang's murder and another who works to achieve reconciliation between the two warlords. In such a highly charged atmosphere every aspect of the occasion, from the hierarchy of the seating arrangement to the entertainment — in this case an impromptu sword dance turned dangerous — becomes a source of intrigue. The banquet's food even features in Sima Qian's wonderfully concise narration: Liu Bang's bodyguard

makes a bravura appearance carving up pork shoulder with his sword on an overturned shield en route to rescuing his master.

It is in the Han dynasty that we begin to learn more about the sophisticated cuisine that took center stage at most feasts. Of the recent finds from Han archaeology, perhaps none paints a more complete picture of food at the dawn of the imperial age than the trio of tombs discovered in 1972 at Mawangdui, near present-day Changsha, Hunan province. Tomb 1 (fig. 5) belonged to a woman

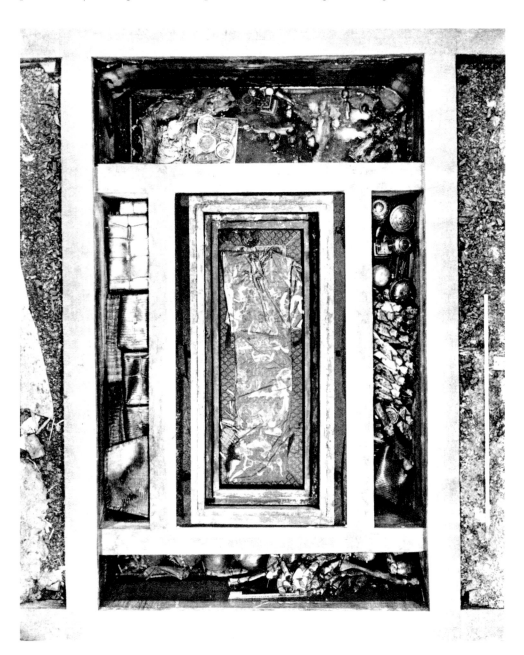

fig. 5 / Overhead view of the tomb of the Lady Marquis
of Dai, Mawangdui, Changsha, Hunan province

identified as Xin Zhui 辛追.[21] About fifty years of age, Xin Zhui is believed to have been the wife of the occupant of the second tomb. The remains of Tomb 2 are thought to be those of Li Cang 利蒼, the Marquis of Dai (r. 193–186 BC), prime minister (相 *xiang*) to the king of Changsha, a province within the Han empire. Tomb 3 housed the remains of a younger man, likely the couple's son, who died sometime before the Lady Marquis of Dai, around 168 BC.

The tomb of the Lady Marquis of Dai was found in remarkable condition. As was the case with the tomb of Marquis Yi, the stable, waterlogged conditions

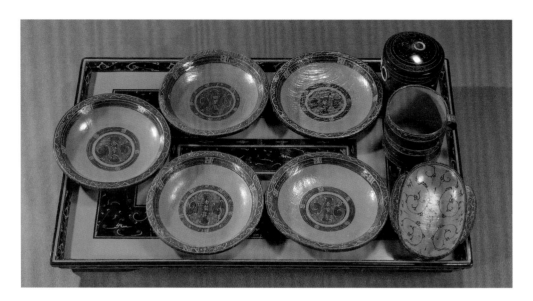

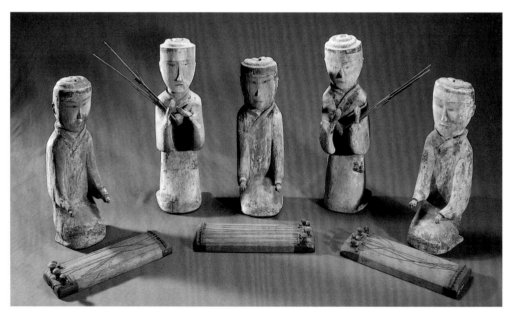

fig. 6 / Western Han, tray with five plates, ear cup, and two wine jars from the tomb of the Lady Marquis of Dai, Mawangdui, Changsha, Hunan province. Lacquer, L. 60.2 cm, W. 40 cm, H. 5 cm (tray). Hunan Provincial Museum. Inscriptions on the plates and cup bear a toast for the user to enjoy their contents.

fig. 7 / Western Han, manikin ensemble of five musicians with zithers (*se*) and mouth organs (*sheng*) from the tomb of the Lady Marquis of Dai, Mawangdui, Changsha, Hunan province. Painted wood and thread, H. 32.5–38 cm (figures). Hunan Provincial Museum

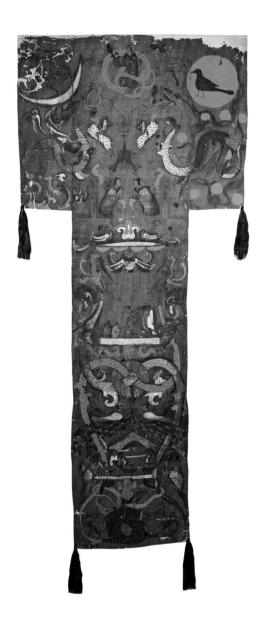

of the sealed tomb preserved a range of highly perishable items that typically do not survive in the archaeological record.[22] The tomb also contained a wealth of representational art — a new development of the Warring States and Han periods. The tomb comprised five compartments (see fig. 5), the central of which held the well-preserved corpse of the lady inside a quartet of nested coffins. The other four compartments housed the lady's supplies for the afterlife. The top compartment was arranged and apportioned as a dining room for the Lady Marquis of Dai, including cushions for her to sit on and a lacquer tray with dining ware filled with an already prepared meal (fig. 6).[23] Small wooden manikins of dancers and musicians found in the compartment would have provided the entertainment for the lady's meal (fig. 7).[24]

Inscribed bamboo slips from another of the tomb's compartments included lists of food, providing a wealth of information regarding preferences for seasoning and methods of cooking and preserving food. A wide array of grains, seeds, fruits, roots, meats, poultry, and fish survived intact in different compartments of the tomb. An autopsy of the lady herself even revealed the contents of her last meal — muskmelon. No other excavated tomb provides anything close to this wealth of material pertaining to Han dynasty cuisine and personal-dining habits.[25]

The side and bottom compartments of the tomb included domestic provisions of all kinds: replica coins and musical instruments; wooden manikin servants; and baskets, lacquerware, and pottery vessels stocked with food, medicines, toilet articles, and the lady's wardrobe.[26] The full contents of the tomb are too rich to enumerate here, but one other object should be noted: an immense, T-shaped painted silk banner found atop the lady's innermost coffin (see fig. 5).[27] Well over six feet long and three feet wide, the banner is filled with a baroque composition of fanciful creatures and figural scenes framed by designs of interconnected jade ornaments and dragons (fig. 8). The obscure iconography of the painting and its implications for Han ideas of the afterlife have been much debated.[28] Several of the banner's figural scenes have special relevance for our purposes. One pictures the Lady Marquis of Dai herself supported by a walking stick — among the earliest extant portraits of a tomb occupant.[29] Another scene seems to depict a funeral, with her cloth-wrapped corpse surrounded by attendants and ritual vessels (figs. 9–10).[30] These images mark a watershed in the history of Chinese art, featuring innovations in pictorial representation that herald later developments in feast imagery in Han funerary art.

As pictorial art flourished during the Han dynasty, images drawn from daily life began to appear in the visual art preserved in funerary contexts. Paintings and reliefs from Han tombs include some of the earliest depictions of kitchens and feasts.[31] This development in pictorial art also coincided with the rise of other representational art forms, including architectural and figural sculpture.

fig. 8 / Western Han, funeral banner from the tomb of the Lady Marquis of Dai, Mawangdui, Changsha, Hunan Province. Painted silk, L. 205 cm., w. at the top 92 cm, w. at the bottom 47.7 cm. Hunan Provincial Museum

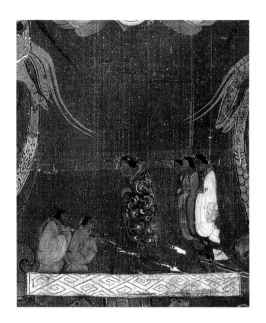
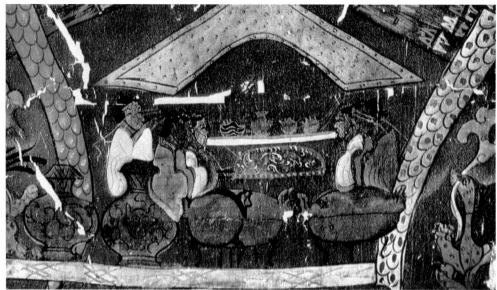

By the Eastern Han (AD 25–220), elite tombs had evolved into large-scale underground domiciles of brick or stone, often adorned with murals and reliefs. Scenes of the deceased participating in a feast of the afterlife comprised a common element of the visual program of Eastern Han tombs. These images seem to owe a debt to early funeral scenes, such as that depicted on the banner of the Lady Marquis of Dai (see fig. 10). If we compare the lady's funeral scene with a mural painting from a late-second-century AD tomb from Zhucun, Luoyang (fig. 11), we can get a sense of their shared pictorial conventions.[32] Both include a canopy with groups of flanking figures accompanied by vessels.[33] However, in the Eastern Han scene the funeral becomes a lively banquet. The cloth-wrapped corpse of the deceased at the center of the action has been replaced by the seated figures of the tomb occupant and his spouse, who enjoy a feast laid out before them.

THE FEAST AFTER THE HAN

In later periods we continue to encounter scenes of banquets and small-scale sculptures of figures that would have entertained at or participated in feasts. A full accounting of the art of the feast leading up to the tenth century is beyond the scope of this introduction. Suffice it to note some of the important connections between the cosmopolitan art of the Tang dynasty and the tenth- to fourteenth-century works included in *The Eternal Feast*.

The changes in Chinese art, culture, and society that occurred between the fall of the Han empire and the founding of the Tang were immense. During

fig. 9 / Detail of the Lady Marquis of Dai's funeral banner. The lady is depicted with her walking stick, escorted by three female attendants. Two male attendants kneel before her with trays of offerings.

fig. 10 / Detail of the Lady Marquis of Dai's funeral banner. The scene appears to depict a funeral, with two groups of attendants flanking the cloth-wrapped body of the deceased.

the years following the collapse of the Han in AD 220, religious traditions changed as new theological ideas, both foreign and domestic, were embraced. Among these, Daoism and Buddhism had perhaps the greatest impact, transforming concepts of life and death and introducing novel forms of material culture. When we arrive in the seventh century, we are faced with a very different civilization. The Tang emperors ruled over a society with greater global connections. The wealth and prosperity created during the Tang, and its thriving trade connections with the rest of the Asian continent, led to other transfers of ideas, technology, and materials that had a lasting impact on Chinese culture, particularly in the areas of cuisine and dining. Changes in artistic traditions also affected both the apparatus and the depiction of the feast.

Literary sources from the period, especially poetry, refer to a plethora of foods, reflecting the exceptional diversity of Tang cuisine.[34] At the same time, an almost entirely new array of vessels and other accoutrements arrived on the dining scene, laying the foundation for the ceramic, lacquerware, and metalware designs we find in the Song dynasty.[35] Many of the shapes and decorations of these vessels derived from objects that originated beyond the Tang empire's borders, most importantly in Central Asia. Other features were the sole result of local artistic and technical innovations pioneered by Tang artists. Visual motifs also traveled to and from China, woven and embroidered into textiles (see cat. 31). This transfer of artistic ideas and the techniques to realize them transformed art across the Asian continent.

fig. 11 / Eastern Han feast scene with tomb occupant and spouse seated on a canopied divan flanked by pairs of male and female attendants. Before the couple a low table is set with bowls of food filled with the contents of a pot in the foreground. Mural from Tomb 2, Zhucun, Henan province, late 2nd century AD.

In the field of figural painting, Tang artists reached new heights of fame, strongly influencing later depictions of feasting. The circulation of Tang paintings in subsequent eras, and the familiarity of later artists with those compositions, is attested by the innumerable copies that survive from the tenth and eleventh centuries (see cats. 22–24). The connection between Tang art and that of later periods briefly sketched here is discussed in greater detail in "The Feast Across Three Gatherings" and in the catalogue section of *The Eternal Feast*.

FEASTING IN THREE COURSES

Armed with this summary outline of the culture of feasting and its role in the artistic traditions of China, we will now turn to the contents of this exhibition. *The Eternal Feast* is divided into three sections reflecting the different social, political, and religious roles played by feasts from the tenth to the fourteenth century: Dining in the Afterlife, Ladies Banqueting in Seclusion, and Gentlemen Feasting as Scholarly Business. Each section is organized around a painting or group of paintings illustrating its theme. The feasts portrayed in the paintings differ in the occasions for which they were held and the participants involved. The paintings depict scenes of the afterlife, the past, and the present, demonstrating the range of conceptual issues addressed by feast images. Every image served a particular function that depended on the needs of the artist and patron as well as the work's intended audience.

The first section, Dining in the Afterlife, centers on some of the earliest works in the exhibition, a set of six paintings on wood made for a Liao tomb (cats. 1–6). Four of the images depict preparations for a feast. The wood panels were produced during the tenth or early eleventh century in the territory of the Liao empire, which encompassed parts of Manchuria, North China, and Mongolia.[36] The dynasty was founded in 907 by Abaoji (872–926), who became khagan of the nomadic Khitan (*Qidan* 契丹) tribes. Enthroned as emperor of the Liao in 916, he modeled his regime in part on the newly fallen Tang dynasty. The Liao government bureaucracy and its funerary rituals likewise drew heavily on Tang antecedents. As a result, Liao tombs and tomb art represent a late stage in a long period of development reaching back to the Han dynasty. In contrast to the more austere burial traditions of contemporary Song tombs influenced by the dominant literati class, Liao tombs retained a number of the more elaborate features of Tang examples, such as expansive pictorial programs that included scenes of feasting.[37]

Ladies Banqueting in Seclusion, the second section of the exhibition, turns our attention to the ladies' banquet, a rarely studied topic. This section highlights a large Southern Song dynasty (1127–1279) hanging scroll entitled *Palace*

Banquet (cat. 21). Connected to the genre of court-lady paintings along with other types of Song picture making, *Palace Banquet* offers a bird's-eye view of a magnificent compound full of women preparing for an evening banquet. The painting is essentially nostalgic, presenting the women as Tang dynasty court ladies.

Palace Banquet is an example of a work that changed hands more or less continuously aboveground over the tumultuous course of the last millennium. Prior to the Song, the material record is dominated by finds from tomb plundering and archaeological excavation, as well as other types of recent finds, such as the twentieth-century discovery of Tang dynasty manuscripts and paintings at Dunhuang. The Song dynasty marks a period from which large numbers of the objects transmitted from generation to generation in institutional or private hands have survived to the present day. These works include an astonishing corpus of paintings, books, and decorative art. From this material we have a privileged view of the innovative directions in which Song art developed, directions that were to have a lasting impact on later Chinese art, especially painting.

The centerpiece of the final section, Gentlemen Feasting as Scholarly Business, is *Evening Literary Gathering* (cat. 33), a handscroll that dates from the Yuan dynasty. The Mongol-ruled Yuan empire was another foreign regime, like the Liao, but the first to essentially conquer the entirety of the Chinese-speaking world. Paintings produced during the Yuan continued to develop and innovate based on Song precedents.[38] *Evening Literary Gathering* depicts a thirteenth- or fourteenth-century scene of gentlemen enjoying a casual feast that is rich in both historical allusion and contemporary social and political commentary.

Although paintings of feasts continued to be produced in later periods, by focusing on the five centuries of the Liao, Song, and Yuan dynasties, *The Eternal Feast* charts one of the most significant shifts in the function of the feast in the visual arts — the evolution from images meant for the afterlife to those designed for the here and now. The apparatus of art objects created for use in the feast is also vividly explored in each of the exhibition's sections. As discussed above, prior to the modern era, elite feasts constituted an important impetus for the production of fine decorative art, in textiles, ceramics, lacquer, and metalware. As the arts of the brush took on a central role in the formation of aristocratic and elite identity in the late tenth century, the performance of poetic compositions and displays of calligraphic mastery became an inseparable facet of banqueting, along with the creation and exchange of paintings. Feasts were also crucial opportunities for other forms of performance art, including music, dance, and theatrical productions. *The Eternal Feast* presents objects related to these essential features of the feast along with figural sculpture depicting different kinds of feast participants and performers. Together, these works offer a window into the feast as a site for the creation and consumption of art in the ever-changing cultures of China.

NOTES

1. One of the earliest recorded uses of the word in the sense of "a sumptuous meal or entertainment, given to a number of guests" dates from 1200. Another usage, first recorded in 1393, does not specify the size of the gathering, referring only to "an unusually abundant and delicious meal." OED Online, s.v. "Feast (n.)," accessed May 29, 2019.

2. The topic of food in China is rich and has been explored in the fields of archaeology, anthropology, history, and literature. Throughout Chinese history, food was not only important for creating and cementing social status, critical in any political and social interaction, but also intimately linked to religion (Buddhism and Daoism especially), medical practices, and discourses on the maintenance of health. See K. C. Chang, ed., *Food in Chinese Culture: Anthropological and Historical Perspectives* (New Haven, CT: Yale University Press, 1977); David R. Knechtges, "A Literary Feast: Food in Early Chinese Literature," *Journal of the American Oriental Society* 106, no. 1, Sinological Studies Dedicated to Edward H. Schafer (January–March 1986): 49–63; E. N. Anderson, *The Food of China* (New Haven, CT: Yale University Press, 1988); Roel Sterckx, ed., *Of Tripod and Palate: Food, Politics, and Religion in Traditional China* (New York: Palgrave Macmillan, 2005); Isaac Yue and Siufu Tang, eds., *Scribes of Gastronomy: Representations of Food and Drink in Imperial Chinese Literature* (Hong Kong: Hong Kong University Press, 2013).

3. A banquet is "a feast, a sumptuous entertainment of food and drink; now usually a ceremonial or state feast, followed by speeches." OED Online, s.v. "Banquet (n. 1)," accessed May 29, 2019.

4. See Monica L. Smith, "Feasts and Their Failures," *Journal of Archaeological Method and Theory* 22 (2015): 1215–37.

5. The development of high-firing-temperature ceramics involved a complex host of technologies, including the selection of materials and kiln design. For a discussion of the importance of the proto-porcelains pioneered in Jiangxi and neighboring provinces during the Bronze Age, and the sophisticated societies that produced them, see Kyle Steinke, "Erligang and the Southern Bronze Industries," in *The Art and Archaeology of the Erligang Civilization*, ed. Kyle Steinke with Dora C. Y. Ching (Princeton, NJ: P. Y. and Kinmay W. Tang Center for East Asian Art, Department of Art and Archaeology, Princeton University, in association with Princeton University Press, 2014), 151–70.

6. See Cyril Stanley Smith, "Porcelain and Plutonism," in *A Search for Structure: Selected Essays on Science, Art and History* (Cambridge, MA: MIT Press, 1981), 317–38.

7. See Kyle Steinke, "Script Change in Bronze Age China," in *The Shape of the Script: How Writing Systems Change and Why*, ed. Stephen D. Houston (Santa Fe, NM: School for Advanced Research Press, 2012), 135–58.

8. See Alain Thote, "Artists and Craftsmen in the Late Bronze Age of China (Eighth to Third Centuries BC): Art in Transition," *Proceedings of the British Academy* 154 (2008): 201–41. For an example of a pioneering figural scene from the late fourth century BC, see the lacquer toilet case from Tomb 2 at Baoshan, Jingmen, Hubei province. The burial, dating to 316 BC, contained the remains of Shao Tuo, a high-ranking official of the Chu state. For the Baoshan excavation report, see Hubei sheng Jingsha tielu kaogudui, ed., *Baoshan Chu mu* (Beijing: Wenwu chubanshe, 1991).

9. Erica Fox Brindley, *Music, Cosmology, and the Politics of Harmony in Early China* (Albany: SUNY Press, 2012), 1–21.

10. For an overview of the rise of large-scale bronze industries in China during the mid-second millennium BC and early bronze ritual vessel assemblages, see the essays in Steinke with Ching, *Art and Archaeology of the Erligang Civilization*.

11. Bronze vessels for preparing and serving food and wine, such as the examples from Panlongcheng shown in figure 1, were fundamental to the elite feasting rituals of the Erligang state (ca. 1500–ca. 1300 BC). In the fourteenth century BC, when the Erligang state briefly expanded from its base in the Central Plains into an empire reaching as far as the banks of the Yangzi River, Erligang colonists brought their bronze industry with them. The initial transfer of bronze metallurgy to societies in southern China likely occurred through contact with Erligang outposts such as Panlongcheng. See Steinke, "Erligang and the Southern Bronze Industries."

12. Dates for the full extent of the Shang dynasty are difficult to determine. Archaeological excavations and contemporary oracle-bone inscriptions tell us that the Shang kings ruled at their capital of Anyang over the last two centuries of the second millennium BC. Earlier Bronze Age–type sites sometimes associated with the Shang at Erlitou (ca. 1800–1500 BC) and Erligang (ca. 1500–ca. 1300 BC) lack contemporary inscriptions, making the political affiliations of these material cultures as yet impossible to ascertain.

13. See Constance A. Cook, "Moonshine and Millet: Feasting and Purification Rituals in Ancient China," in Sterckx, *Of Tripod and Palate*, 9.

14. The tomb comprised three compartments. The main compartment, the largest of the three, held the banqueting apparatus suitable for an audience hall. The north compartment included large bronze wine containers, thousands of weapons, and horse-and-chariot gear. A record of the funeral procession written on bamboo slips found in the compartment is the earliest surviving example of Chinese writing on that everyday medium. The east compartment seems to have represented the private chamber of Marquis Yi. It contained his coffin and those of his concubines along with a range of other personal possessions, including silks, jade ornaments, lacquers, and gold vessels. See Hubei sheng bowuguan, ed., *Suixian Zeng Hou Yi mu* (Beijing: Wenwu chubanshe, 1980).

15. These vessels were actually made for an earlier marquis of Zeng. Marquis Yi had the name of the former ruler scratched out of the inscription on the *pan* and replaced with his own. An inscription on the *zun* claiming ownership of the vessel for Marquis Yi is likewise a later alteration. The intricate decoration along the lips of the vessels was cast by the lost-wax method and soldered on. The vessels represent the only lost-wax castings among the ten metric tons of bronze in the tomb.

16. The tomb of Marquis Yi is easily the richest archaeological find for the study of music in Bronze Age China. The ensembles of musical instruments in the main chamber featured drums, winds, strings, bells, and chimestones. A second, smaller ensemble in the east chamber that held the marquis's coffin included only drums, winds, and strings. The tomb also included companion burials of twenty-one young women, some of whom appear to have been musicians. The bells, which feature an unusual almond-shaped cross section, produce two different notes, either a major or minor third apart, depending on where they are struck. The lower two tiers of bells are tuned to cover five octaves, three of which include all the notes of the chromatic scale. Inscriptions on the bells and chimestones discuss complicated musical ideas concerning pitches and the interrelation of musical scales of neighboring states. For a discussion of the inscriptions, the instruments on which they appear, and the implications of the discovery of Marquis Yi's tomb for the history of music, see Robert Bagley, "The Prehistory of Chinese Music Theory," *Proceedings of the British Academy* 131 (2005): 41–90.

17. K.C. Chang, introduction to Chang, *Food in Chinese Culture*, 11.

18. See Yü Ying-shih, "Han," in Chang, *Food in Chinese Culture*, 55–83.

19. For a translation of the account, see Burton Watson, *Records of the Historian: Chapters from the "Shih-chi" of Ssu-ma Ch'ien* (New York: Columbia University Press, 1969), 82–86.

20. Yü Ying-shih, *Chinese History and Culture*, vol. 1, *Sixth Century BCE to Seventeenth Century* (New York: Columbia University Press, 2016), 122–33.

21. Her name appears on a seal found inside one of her toilet sets. See Hunan sheng bowuguan and Zhongguo kexueyuan kaogu yanjiusuo, eds., *Changsha Mawangdui yi hao Han mu* (Beijing: Wenwu chubanshe, 1973).

22. The tombs of both Marquis Yi and the Lady Marquis of Dai seem to have filled with water shortly after burial and remained filled until archaeologists drained them some two thousand years later. Once the extremely well-sealed tombs filled with water, the anaerobic environment inside stifled the microbial activity responsible for decomposition.

23. The walls of the compartment were hung with silk curtains; a bamboo mat covered the floor. Silk slippers, a walking stick, and two toilet boxes containing cosmetics and a wig were also found in the compartment. A painted screen was set behind the lady's seat. In life the Lady Marquis of Dai would have eaten her meals in a similar arrangement as that found in the compartment: seated on cushions placed directly on the floor with a dining tray set on her lap. Chairs did not appear in China until after the Han dynasty. See John Kieschnick, *The Impact of Buddhism on Chinese Material Culture* (Princeton, NJ: Princeton University Press, 2003), 223–36.

24. In the photograph only the zither in the center is arranged correctly, with the tuning knobs on the player's left.

25. For a more detailed discussion of the food from the tomb, see Yü, "Han."

26. Stamped inscriptions on the wood cores of some lacquer vessels from the tomb identify their place of manufacture: Han government factories in Sichuan province. Lacquers from Sichuan have been found as far away as Korea and Mongolia. Quality-control inscriptions on some later lacquers identify both the workers and the specific tasks for which they were responsible, suggesting that Han industrial lacquer production involved sophisticated divisions of labor. See Wang Zhongshu, *Han Civilization*, trans. K.C. Chang et al. (New Haven, CT: Yale University Press, 1982), 86.

27. The coffin of Mawangdui Tomb 3, presumed to house the remains of the lady's son, included a similar T-shaped banner. The tomb was also provided with other works on silk, including texts, illustrations, diagrams, and a map.

28. The exact purpose of the banner, referred to as a "flying mantle" (*feiyi* 飛衣) in the tomb inventory, is unclear. Perhaps the banner was used in funerary processions for the deceased; its fantastic imagery includes pictures of the tomb occupant in scenes of this world and the next.

29. A walking stick was found among the contents of the top compartment of the tomb. Other vignettes in the painting also appear to portray the Lady Marquis of Dai.

30. The identification of the occasion depicted has been the subject of much debate, although a precise interpretation of the scene matters less for our purposes than its pictorial structure — the arrangement of the figures and the types of objects depicted. Ritual vessels in the foreground (two *hu* and three *ding*) match the color and shapes of pottery vessels found in the tomb. Objects on a dais in the background appear to be a mix of pottery and lacquer.

31. Yü, "Han," 59–70.

32. Luoyang shi di er wenwu gongzuo dui, "Luoyang shi Zhucun Dong Han bihua mu fajue jianbao," *Wenwu* 12 (1992): 15–20. The Zhucun tomb consisted of a vaulted brick room with an antechamber. The tomb's entrance passageway is located to the right of the mural.

33. In the Mawangdui funeral scene, a jade pendant hanging from the tassel of a jade disk with dragons winding through it serves as the canopy. The pair of dragons run the length of the lower two thirds of the banner, framing the figural scenes in this section.

34. See Edward H. Schafer, "T'ang," in Chang, *Food in Chinese Culture*, 85–140.

35. See cats. 8, 9, 10, 11, 17, 25, 26, 35, 36, 37, 38, 39, 40, 41, and 42 in this volume.

36. For an introduction to the Liao empire, see Denis Twitchett and Klaus-Peter Tietze, "The Liao," in *The Cambridge History of China,* vol. 6, *Alien Regimes and Border States, 907–1368* (Cambridge: Cambridge University Press, 1994), 43–153.

37. See Jeehee Hong, "Changing Roles of the Tomb Portrait: Burial Practices and Ancestral Worship of the Non-Literati Elite in North China (1000–1400)," *Journal of Song-Yuan Studies* 44 (2014): 203–64. See also Dieter Kuhn, ed., *Burial in Song China* (Heidelberg: Editio Forum, 1994).

38. See Max Loehr, *Chinese Painting after Sung* (New Haven, CT: Yale University Press, 1967).

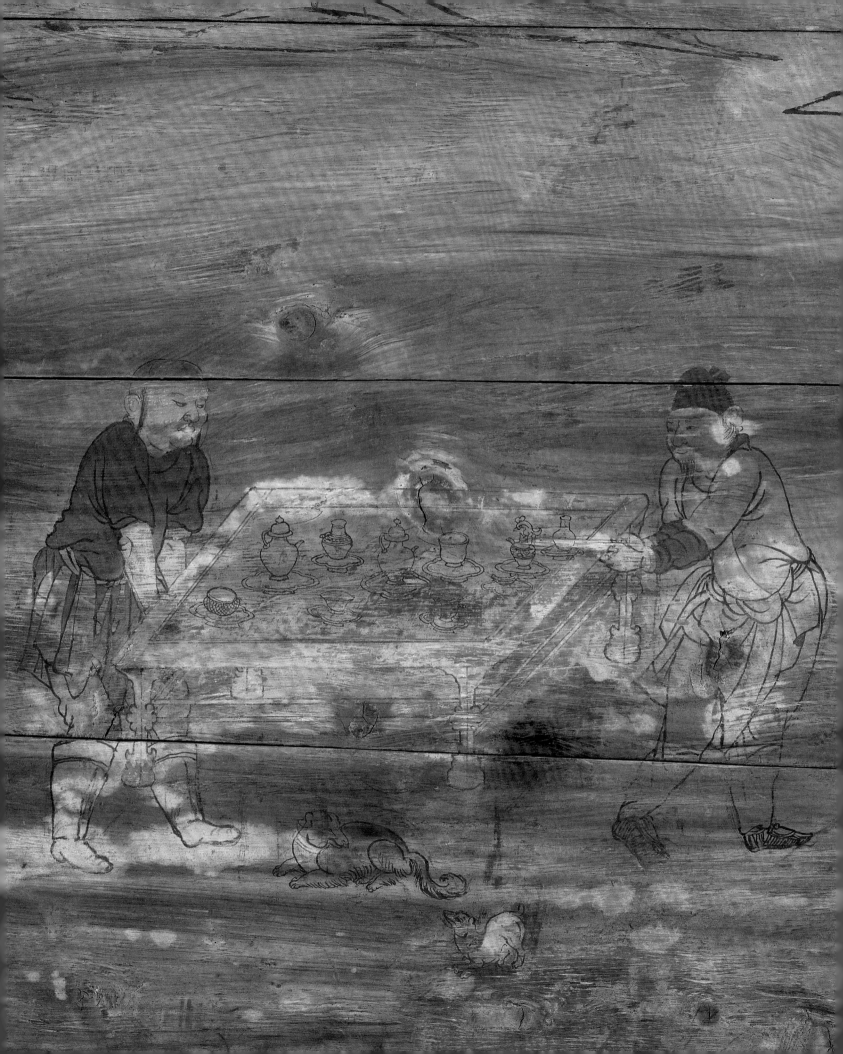

The Feast Across Three Gatherings: Images of Banqueting from the 10th to the 14th Century

ZOE S. KWOK

Prior to the tenth century, most images of feasts in China come to us from paintings and reliefs found in tombs. This situation changes after the tenth century, as the importance of the elite tomb as a major site of pictorial art gradually declines and paintings made for the enjoyment of the living begin to survive in greater numbers. This essay examines images of feasting from the tenth through fourteenth centuries drawn from both of these sources: a set of Liao dynasty (907–1125) tomb paintings on wood panels (cats. 1–6), a Song dynasty (960–1279) hanging scroll known as *Palace Banquet* (cat. 21), and a Yuan dynasty (1260–1368) handscroll entitled *Evening Literary Gathering* (cat. 33). Together, these works manifest important shifts in the production, role, and themes of feast scenes over a period of several hundred years.

Before we turn our attention to the paintings, however, a few points should be made about their art-historical background. The tenth to fourteenth centuries mark a dynamic period in Chinese history that witnessed the spectacular economic growth of the Song dynasty as well as the rise of multiple foreign dynasties, including the Liao, Xi Xia (1032–1227), Jin (1115–1234), and Yuan. This period holds particular interest for the history of Chinese painting because it coincides with important changes in the way the art form was practiced and sponsored.

Following the collapse of the Tang dynasty (618–907), China fell into a period of political disunity, during which a series of short-lived dynasties controlled most of northern China, while rule over southern China was divided between many small states. This period, known as the Five Dynasties and Ten Kingdoms (907–979), marks the beginning of the rise of the great military powers of the seminomadic tribes of the steppe that would dominate the political geography of China for much of the next millennium. The first of these states was the Liao empire of the Khitans, which took control of parts of northern China, including the area of present-day Beijing, in the first half of the tenth century.

The founding of the Song dynasty in 960 began a two-decade process of unification that eventually resulted in the annihilation of the remaining states of the Five Dynasties and Ten Kingdoms period. With the establishment of the Song court at Kaifeng a new period of imperial artistic patronage began, attracting professional painters from all over China who had served in the courts of former states destroyed by the Song. Throughout the Northern Song (960–1127), court painting flourished, culminating in the reign of Emperor Huizong (r. 1100–1126), an avid painter and calligrapher whose patronage of the arts was a centerpiece of his rule.[1]

In 1125 the Liao were conquered by another empire born of a confederacy of seminomadic tribes, the Jurchen-led Jin dynasty. After the fall of the Liao, the Jurchen army laid a series of sieges to the Song capital, eventually sacking it in 1127 and taking Huizong and much of the Song imperial family hostage. Huizong's ninth son, Emperor Gaozong (r. 1127–1162), managed to escape the destruction of Kaifeng, fleeing south, where he established a new Song court at Hangzhou in 1132.

The loss of the north had a devastating impact on the Song. Nonetheless, the Southern Song (1127–1279) remained a large and prosperous state. Commerce and trade prospered, accompanied by rapid urbanization. By the middle of the thirteenth century, the Southern Song capital was "the richest and most populous city in the world."[2] From Hangzhou, Gaozong launched another era of ambitious artistic patronage (see cats. 7 and 34). Over the course of his reign and the century that followed, Southern Song court painting thrived, forging a visual language distinct from the tradition of the Northern Song.[3]

The collective work of Northern and Southern Song court artists represents one of the finest achievements of imperially sponsored painting in Chinese history. The fall of Hangzhou to the Mongols in 1276, however, effectively dismantled the Song tradition of court painting.[4] With the rise of the Yuan dynasty, prestige shifted away from court painters and toward a new class of artists working outside the institutions of imperial patronage.

Throughout the Song, journeymen painters, working in thriving cities like Hangzhou, supplied a burgeoning public art market with images intended for private enjoyment. Stimulated by the demand from their rapidly growing customer base, these artists introduced new genres into Chinese painting. As the Song appetite for pictures grew, another movement, centered on paintings by self-styled amateur artists, began to flourish. This movement was led by members of the literati class, the educated participants of the Song civil examination system that was used to select officials for government service. Already required to be skilled calligraphers by the educational system in which they trained, artistically inclined literati adapted their mastery of careful brushwork to the art of painting. Espousing a new aesthetic consonant with their own artistic skill set and deliberately at odds with the traditions of court painting, literati artists exploited their considerable social prestige to move the tastes of the marketplace in their favor.[5] By the Yuan, literati painters had become the most celebrated artists of their time (see cat. 46).[6]

During the tenth through fourteenth centuries, Chinese painters increasingly found themselves in the service of non-Chinese patrons. Professional painters in Liao, Jin, and Yuan territory navigated complex cultural exchanges as they sought or were forced to seek employment under these foreign regimes. In many cases, painters ended up serving elites, both non-Chinese and Chinese, whose identities straddled the divide between the two cultures. This development also deeply influenced the work of literati painters. After the Mongol-led Yuan dynasty wiped out the Song, literati, many of whom had held prominent positions within the Song government, were left with the choice of remaining loyal to the fallen dynasty or serving the new regime that brought about its downfall — a dilemma that would come to haunt Yuan literati painting.[7]

With this historical background in mind, we may now turn to the paintings that are the subject of our inquiry: the Liao tomb panels, *Palace Banquet*,

and *Evening Literary Gathering*. These works form the basis for the three case studies of the feast in Chinese painting featured in this essay. The first, Dining in the Afterlife, investigates the structure and functions of the imagery of banqueting featured in the Liao tomb panels as well as its relationship to contemporary Khitan and Chinese material culture and ideas about the afterlife. The second, Ladies Banqueting in Seclusion, focuses on the Southern Song hanging scroll *Palace Banquet*. This study examines the painting's connections to contemporary dining practices and Song dynasty innovations in figural and architectural painting. It also attempts to determine how the work's nostalgic presentation of a feast attended by Tang dynasty court ladies might have served the Song dynasty patron who commissioned it. The final study, Gentlemen Feasting as Scholarly Business, places *Evening Literary Gathering* within the context of Song and Yuan depictions of gentlemen's gatherings, exploring how the painting's scenes of inebriated feasting interacted with historical models of literati identity and contemporary politics.

DINING IN THE AFTERLIFE

The earliest paintings in *The Eternal Feast* belong to a set of six wooden panel paintings from an unidentified Liao dynasty tomb (cats. 1–6). The panels include two illustrations of the preparations for an intimate outdoor feast as well as images of attendants, a horse and grooms, and a doorway scene. Five of the panels are part of the collection of the Princeton University Art Museum. The sixth, *Gentlemen Attendants*, belongs to the collection of Lloyd Cotsen. For ease of discussion, when mentioned together the six will be referred to as the "Princeton panels."

The Liao state was ruled by the Khitans, a people whose homelands included a vast steppe region to the north of China. At the pinnacle of its territorial might, the Liao empire included much of present-day Mongolia, North China, and Manchuria.[8] The Khitans were first mentioned in Chinese texts from the fourth century AD, in which they are described as pastoral nomads, reliant on their animal herds for survival. During the Tang dynasty, Khitan tribes began to organize. They followed the example of the Uyghurs, another tribal group in the Eurasian steppe, who in the eighth century constructed a capital city and established a centralized administrative system that united once loosely connected tribes into a confederacy. The development of the Khitan confederacy culminated in the rule of Yelü clan chieftain Abaoji (872–926), who declared himself Great Khan in 907 and in 916 emperor of the Khitan.

Upon his death, Abaoji was succeeded by his second son, Yelü Deguang, known as Emperor Taizong (r. 927–947), who changed the name of the empire to Liao. In 937, Yelü Deguang annexed the Sixteen Prefectures from the Later Jin

(936–947), one of the Five Dynasties that briefly ruled over northern China after the fall of the Tang. The strategically critical Sixteen Prefectures comprised parts of the provinces of Hebei and Shanxi, which contained most of China's northern defenses. The appropriation of the territory gave the Liao unfettered access to the North China Plain, eventually resulting in the conquest of the Later Jin, which had been a protectorate of the Liao, and the brief occupation of its capital, Kaifeng, in 947.

By the middle of the tenth century, the Khitans had formed a dual government that provided for the needs of both its tribal and its sedentary populations. The government included numerous features of the Tang state, including a capital city modeled on Chang'an (the Tang capital), complex administrative structures, a writing system, and the use of Chinese names for emperors and dynasty. The Khitans maintained this system, and enjoyed trade and diplomatic relations with their southern neighbors, for over two centuries. Relations with the Song, however, were not without complication. After the founding of the Song dynasty in 960, the Liao and Song courts adopted the imperial rhetoric of equals in their diplomatic interactions, exchanging gifts while warily observing the other side. War eventually broke out as the Song emperors sought to recapture the Sixteen Prefectures, which had been ceded to the Liao in the first half of the tenth century. A series of armed conflicts ensued, culminating in a Liao offensive that led the Song state to sue for peace. In 1005 the two empires adopted the Shanyuan Covenant, requiring the Song court to send the Liao yearly tributes of silk and silver.[9] In the eleventh century, Song diplomatic relations with the Liao continued to be grudgingly peaceful. In a second treaty, adopted in 1042, the Song emperor formally acknowledged a kinship relation with the Liao imperial family, referring to the Liao as the "northern court" and the Song as the "southern court."[10]

Culturally, the Liao strove to preserve their Khitan identity and customs.[11] However, over the course of the dynasty Khitan practices increasingly intermingled with Chinese traditions. This evolution is especially evident in elite Khitan tombs from the dynastic period, which incorporated a range of Chinese burial customs. Prior to the formation of the Liao dynasty, the Khitan elite did not construct underground tombs for their dead but instead, according to Chinese historical texts, conducted open-air rituals.[12] Once they started participating in dynasty building, Liao elites adopted the long-held Chinese practice of constructing elaborate tombs to demonstrate status and power.[13] Liao-period Khitan tombs were modeled on a format seen in northern China during the Tang dynasty: one or more subterranean chambers with a corbelled-dome ceiling accessed by a long, sloped entry passageway (see fig. 18).[14] The rear chamber, which held the coffin, is where the six Princeton panels would likely have been found.

Each of the Princeton panels is composed of four horizontal wood boards pinned together.[15] The panels are all around 67 centimeters in height but

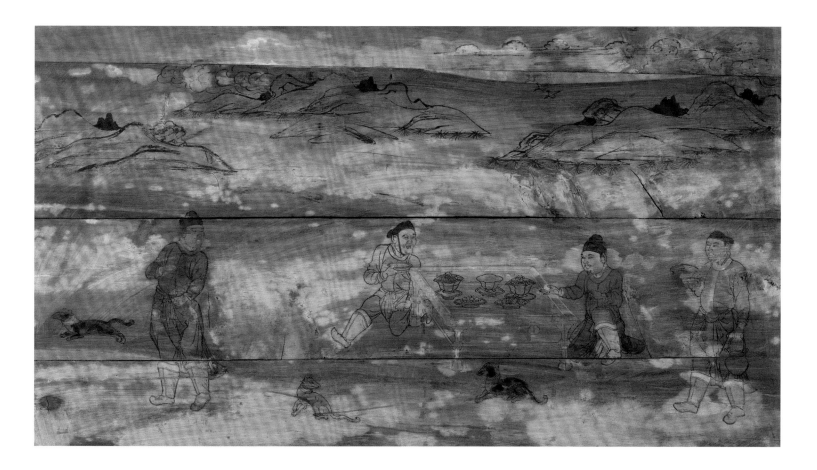

vary in length from 90 to 115 centimeters. The left and right sides of each are notched to create a long tenon, allowing them to fit into the mortises of connecting struts or columns.

Two of the panels depict scenes of attendants in the final stages of preparing for an open-air feast. The central focus of *Arranging an Outdoor Banquet* (cat. 4; fig. 12) is a low, square table upon which are set three large bowls on stands, two with ornate lids (see cat. 12), as well as two platters of food. To the right of the table, a kneeling attendant directs the vessel arrangements, gesturing with both hands to a figure across from him who holds a small platter in one hand. The figures at the table are flanked by two standing attendants. The figure furthest right brings a bowl and a pot; the figure on the left observes the preparations. Three lively dogs join the occasion in the foreground. The scene's outdoor setting is indicated by a pastoral landscape in the background. The vista consists of a trio of rolling hills under an open sky interspersed with swirls of clouds and a flock of birds ascending into the distance.

The panel *Preparing for an Outdoor Banquet* (cat. 3) presents a complementary scene of a group of attendants moving a table set with drinking vessels.

fig. 12 / Detail of *Arranging an Outdoor Banquet*
(cat. 4)

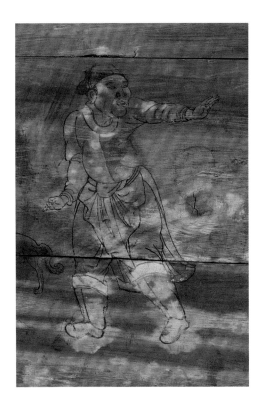

The focus of the scene is another low table, nearly identical to the one in *Arranging an Outdoor Banquet*, already set with numerous small cups, ewers, and bowls. Two servants hold the table aloft as they transport it to the banquet site (see p. 34). Another pair of men follow from the right, carrying large vessels. Yet another attendant, standing to the left, looks back as he directs the proceedings (fig. 13). Three dogs accompany the busy scene, which is again positioned before a backdrop of hills, clouds, and birds.

The number of vessels and the indications of plentiful food and drink are befitting a grand feast for the afterlife. They also serve as markers of the wealth and high social status of the tomb occupant, as do the well-groomed dogs. A closer inspection of the choice of dining vessels helps to situate with greater specificity the tomb occupant's position in Liao society. In *Preparing for an Outdoor Banquet*, the table for drinks holds two lidded ewers (see cat. 10), a phoenix-head ewer (see cat. 17), two small bottles with ovoid bodies, three cups (see cats. 8–9), and a small metal bowl with a basket-weave decoration (see cat. 11). All the vessels are placed on small, saucer-shaped stands.[16] Following the attendants carrying the table are two young men, each holding a large, long-necked jar. Among all the objects, only the lidded ewers and large jars are matching pairs; the rest are single vessels. A less diverse assortment of objects is seen on the dining table in *Arranging an Outdoor Banquet*. The lids that cover two of the large bowls feature different ornamental patterns. The aesthetic preference for a mixed range of objects is noteworthy, perhaps pointing to a tomb occupant who was a local elite rather than a grand aristocrat, as the latter would likely have had matching sets of cups, bowls, and ewers.

Two other panels in the Princeton group, *Gentlemen Attendants* (cat. 1) and *Attendants Bearing Offerings* (cat. 2), connect to the banquet theme of the panels discussed above. Each portrays a row of four standing figures of descending size facing the same direction; one panel is all men and the other all women. The men stand facing toward the left (fig. 14). The first and largest figure is also the most formally dressed, with floor-length robes and a black hat. His attire, dignified bearing, and prominence within the composition mark the figure as the most important in the panels. From this we may conclude that the gentleman is most likely the son of the tomb occupant and the benefactor of the tomb's construction.[17] This identification would also suggest that the figure is the host of the feast whose preparation is shown depicted in the other panels.

Behind this gentleman stand three other men; all sport Khitan hairstyles of closely cropped hair, with a fringe to the mid-forehead and longer locks that trail down in front of the ear. Both the lead figure and the man behind him have their hands clasped in a distinctive gesture that is presumably a sign of homage directed toward the tomb occupant, the left hand grasping the right thumb. This gesture is frequently modeled by male figures in both Liao and Song funerary art,

fig. 13 / Detail of *Preparing for an Outdoor Banquet* (cat. 3)

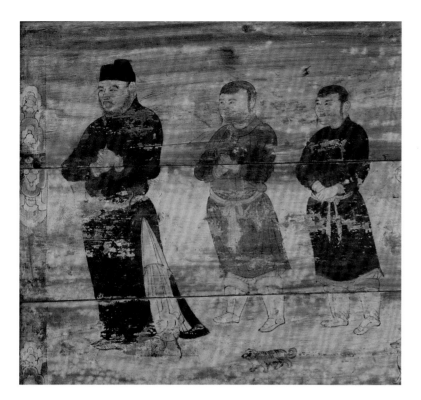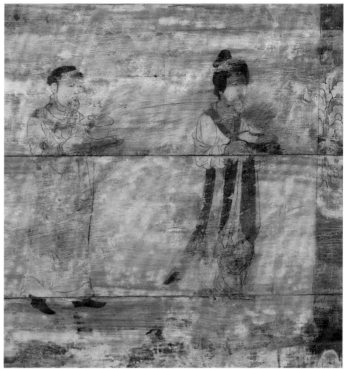

including a standing attendant in another of the Princeton panels, *Four Figures Flanking a Doorway* (see fig. 25). Again, a trio of dogs joins the male figures.

The ladies' panel mirrors the format of the panel of male figures (fig. 15). Facing toward the right, each lady holds a large serving vessel. The first and largest figure is an elegant woman, possibly the wife of the lead figure in the gentlemen's panel and the daughter-in-law of the tomb occupant. Her flowing V-neck robes and elaborate coiffure follow Tang dynasty fashion. The hairstyle and dress of the two women behind the lead figure conform to Khitan fashion. Both women wear closer-fitting dresses, and their hair is pulled back in a low chignon with a fringe framing their eyes. The face of the last and smallest figure is obscured by damage to the painting. Although depicted in knee-length robes and high boots, attire more commonly associated with males, this figure is nonetheless likely a young serving girl. Women dressing in male clothing was not uncommon in Liao culture.[18] Three more well-groomed dogs appear in front of the women. All the women carry bowls on stands, apparently offerings for the feast. A ladle (see cat. 13) is tucked into the second lady's bowl.

The remaining two panels of the set, *Four Figures Flanking a Doorway* and *Horse and Grooms*, likely formed the end panels of the coffin box (cats. 5–6). These panels feature compositions that relate to notions of traveling to the afterlife. The arrangement of the panels will be discussed below.

fig. 14 / Detail of *Gentlemen Attendants* (cat. 1)

fig. 15 / Detail of *Attendants Bearing Offerings* (cat. 2)

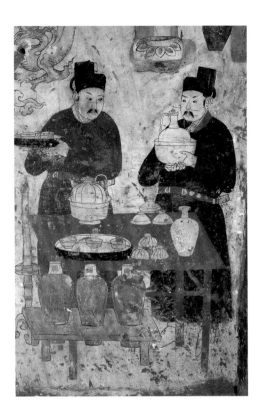

The visual program of the first four panels revolves around the theme of the afterlife banquet, a feast at which the tomb occupant will not only serve as the honored guest but also partake in for eternity. In the panel of male attendants, the lead figure, presumably the son of the deceased and the putative host of the feast, stands by with attendants in a posture of reverence and piety. In the ladies' panel, the presumed daughter-in-law and her attendants do the same as they bear offerings for the feast.

The two panels presenting banquet tables, however, only give us a view of the preparations for the feast. In this respect, the Princeton panels are typical of Liao tomb imagery in that scenes of servants preparing food and beverages were more frequently portrayed than the meal itself. This convention is also seen in Tang dynasty tomb paintings, an important influence on the visual program of Liao funerary art. Particularly vibrant scenes of servants preparing wine, tea, and food were found in a group of tombs in Liao territory (near Xuanhua in Hebei province) dating from 1093 to 1117.[19] The tombs belong mostly to members of the same Han Chinese family, surnamed Zhang. A painting from Tomb 1, belonging to the Liao official Zhang Shiqing (d. 1116), illustrates servants preparing wine for a feast, but not the meal itself (fig. 16).[20]

Liao tombs are known to include offerings of food and drink along with the vessels and furnishings necessary for the ritual nourishment of the tomb occupant. In 1093, Zhang Shiqing had tombs constructed for the reburial of several ancestors as a demonstration of filial piety. In one of those tombs, which belonged to Zhang Shiqing's uncle, Zhang Wenzao (d. 1074), a table set before the coffin in the burial chamber included vessels with offerings of fruit, nuts, and cooked dishes (figs. 17–18).[21] The inclusion of scenes related to the feast in Liao funerary art in all likelihood served the same ends as the offerings.[22] Perhaps imagery of the feast itself taking place, rather than the preparations for it, was sometimes deemed unnecessary for the visual program because the prepared meal was already present in the tomb, awaiting the deceased.

Despite the lack of imagery of the actual banquet, Princeton's panels nonetheless reveal much about the event to come, including its similarity to a famous later depiction of Khitan feasting. The Princeton panels stand out among surviving Liao feast preparation scenes for the detail of their portrayals of the low dining tables, set with an array of vessels and dishes and placed in a pastoral setting. One of the closest parallels to this dining mode is seen in fragments from a Song dynasty handscroll dating to the second quarter of the twelfth century (figs. 19–20).[23] The painting, which survives complete in a Ming dynasty (1368–1644) copy (cat. 7), tells the story of Lady Wenji, daughter of a Han dynasty official, who was abducted by Xiongnu invaders (an early northern nomadic tribe) in AD 195. Held captive for twelve years, Lady Wenji was forced to marry a Xiongnu chieftain, with whom she bore two sons.

fig. 16 / Liao dynasty, *Servants Preparing Wine for a Feast*, 1116. Mural from the tomb of the Liao official Zhang Shiqing (Tomb 1), Xuanhua, Hebei province

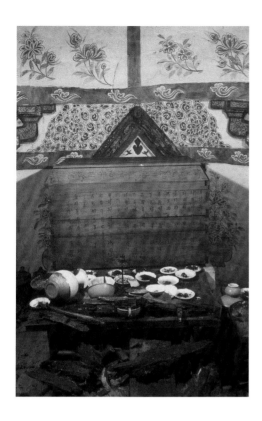

The Song dynasty artist chose to portray the nomadic invaders as Khitans, a familiar subject for the artist and his contemporary viewers due to the long-standing encounters between the Song and Liao states. Two feast scenes featuring Lady Wenji and her husband survive (figs. 19–20). In both scenes the couple is seated outdoors, under a canopy in front of a yurt. They sit side by side on carpets on the ground in front of a long, low table set with small dishes. Several men and women in Khitan garb stand ready to attend to them. The third feast scene, found in the Ming dynasty copy of the scroll, illustrates a slightly larger gathering, with Lady Wenji and her husband seated in their usual positions and joined by five other seated figures, some of whom are playing musical instruments (cat. 7).

Three aspects of the feast scenes in the Lady Wenji scroll and the Princeton panels may be isolated to form an impression of Khitan banquet practices. First, despite adopting certain forms of Chinese governance, the Khitans still retained elements of their nomadic lifestyle and a preference for living out in the open. Both groups of feast imagery take place outside, in the landscape of the steppe region, with vast plains and rolling hills dotted with short trees and shrubs. The tables in the Princeton panels have short legs, indicating that the guests will dine seated on the ground, perhaps on a carpet, as is the case in the Lady Wenji scroll. Second, these are small gatherings, perhaps unsurprising given the remote nature of the setting. In the two surviving feast scenes from the Song scroll, Lady Wenji dines accompanied only by her husband and a handful of servants. The number of guests planned for in the Princeton panel's feast is less certain, although the single table of food points to a very small gathering. Finally, there is an abundance of vessels for food and drink. In all of Lady Wenji's feasts, several small dishes are laid before the diners, with other ewers and platters held by attendants. Both *Preparing for an Outdoor Banquet* and *Arranging an Outdoor Banquet* feature a host of dining ware.

fig. 17 / Offering table and coffin in the rear chamber of the tomb of Zhang Wenzao (Tomb 7), Xuanhua, Hebei province

fig. 18 / Plan of the tomb of Zhang Wenzao (Tomb 7), Xuanhua, Hebei province

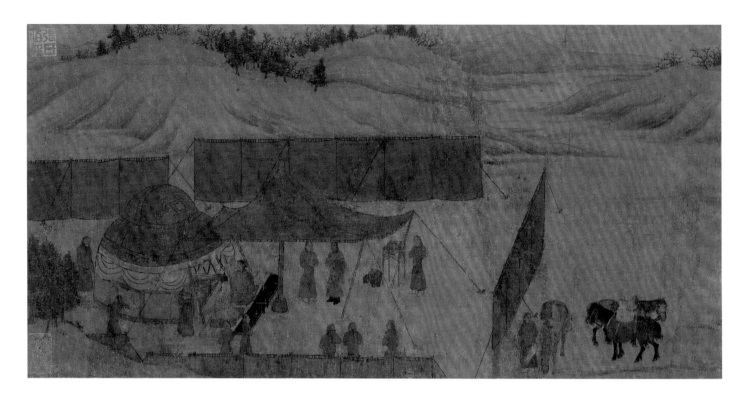

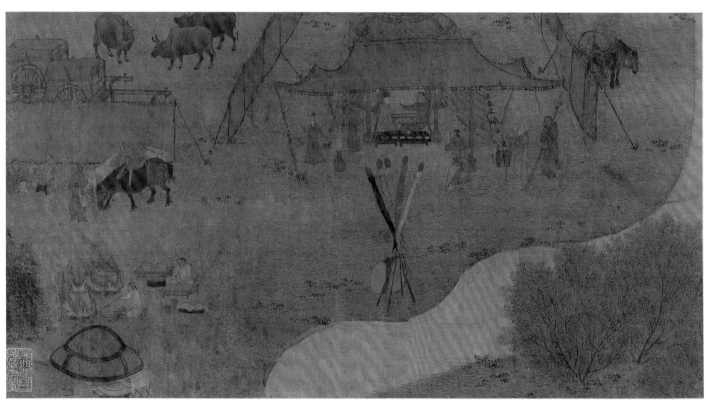

fig. 19 / Southern Song dynasty, *Lady Wenji's Return to China: Encampment in the Desert*, second quarter of the 12th century. Ink, color, and gold on silk, 24.7 × 49.8 cm. Museum of Fine Arts, Boston. Denman Waldo Ross Collection (28.62)

fig. 20 / Southern Song dynasty, *Lady Wenji's Return to China: Encampment by a Stream*, 12th century. Ink, color, and gold on silk, 25 × 46.6 cm. Museum of Fine Arts, Boston. Denman Waldo Ross Collection (28.63)

Although the Lady Wenji scroll sheds light on pictorial representations of Khitan dining practices, the comparison does not address the Princeton panels' connections to the history of feast scenes in funerary art. To better understand the special characteristics of the Princeton panels, we need to contextualize them within the larger history of the afterlife banquet in Chinese tomb painting. Elaborate scenes of formal banqueting adorning the walls of tombs survive from as early as the Han dynasty (206 BC–AD 220). One notable example dating from the late Eastern Han period (AD 25–220) comes from a pair of tombs discovered in 1959 west of Dahuting, a village in Henan province.[24] Constructed of stone and brick, the central chamber of Tomb 2 was decorated with lively murals, including a long horizontal scene of feasting along the upper section of the north wall of the central chamber (figs. 21–22).[25] The prominent position of the feast painting in the tomb, along with its large size and complex composition, speaks to the importance of banqueting scenes in tomb art of the Han period.

In contrast with the Princeton panels and other Liao tomb paintings, such as those from Xuanhua, the Dahuting scene presents another mode of depicting the deceased within a feast. At one end of the long banquet, a lady and a gentleman sit under an ornate canopy (see fig. 21). Small dishes are set on a table before them. The other figures in the scene direct their actions toward the couple, including a trio of figures offering obeisance directly in front of them. Clearly the highest-ranking participants of the feast, the couple in the scene almost certainly represent the tomb occupants.

Guests are seated on mats in front of the couple in two long, opposing rows along the top and bottom of the composition (see fig. 22). Dishes are laid out in front of each guest, and additional dishes are seen between the rows.

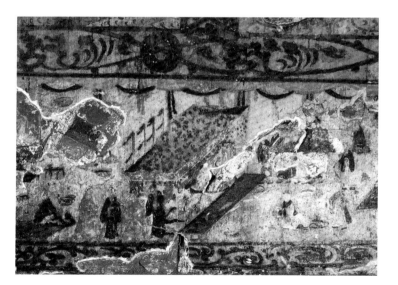

figs. 21 and 22 / Eastern Han dynasty, *Banquet Scene* (details), late 2nd century. Mural from the northern wall of the central chamber of Dahuting Tomb 2, Mixian, Henan province

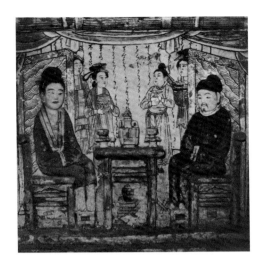

Entertainments abound; there are dancers, musicians, and jugglers. Servants are seen busily preparing and serving food.

Despite its elaborate nature, the painting does not function as a narrative scene. The artist's goal was not to tell a specific story but rather to formally display the presumed qualities of the tomb owner's lifestyle. Above all, the composition prioritizes an iconographic clarity that transcends the specifics of any particular event in favor of evoking the wealth and social status of the tomb occupant. The result is a banquet scene that sets forth an exemplary version of the activities and responsibilities of the deceased to be reenacted for eternity during the afterlife.

While the Dahuting banquet scene constitutes an early example of an elaborate feast scene designed for a tomb, the Princeton Liao dynasty panels belong to one of the late stages of this tradition. Although dining scenes continue to appear in later funerary contexts, they became rarer as burial practices underwent a major shift during the Song dynasty.[26] A Northern Song tomb dating to 1099, discovered in Baisha, Henan province, included a relief painting of the deceased couple seated before a table set with cups and a ewer (fig. 23).[27] While portraits of tomb-occupant couples seated together at a table, such as the Baisha relief painting, remained a common feature of the iconography of Song tombs, the accoutrements of feasting gradually receded from the images.

Although there are painterly links spanning the eight hundred years that separate the Dahuting feast scene from the Liao panels (for example, in both scenes figures and objects are outlined in black ink and placed on a blank, steeply angled ground plane), the compositional focus on the figures and the rendering of the landscape align the Liao panels more closely with Tang dynasty antecedents. The walls of Tang elite tombs were typically adorned with paintings of large-scale figures set against a blank background and often positioned in dynamic groupings. The Tang imperial tombs at Qianling in Shaanxi province contain a wealth of figural paintings similar to the Liao panels. A portion of the murals of the tomb of Prince Zhanghuai (Li Xian, 654–684) depict a meeting of three Tang officials and three foreign envoys (fig. 24).[28] The painting technique is comparable to that found in the Liao panels. Thick and confidently painted outlines expediently render facial features, expressions, and the solid forms of the figures concealed beneath their robes. The grouping of the figures in Prince Zhanghuai's mural conjures an array of nuanced human interactions. Bodies turn toward one another; faces engage. The figures in *Arranging an Outdoor Banquet* and *Preparing for an Outdoor Banquet* do not interact with the same physical proximity as the officials in the Prince Zhanghuai painting, but the positioning of their bodies, their gestures, and their linked gazes draw on Tang prototypes. The artist responsible for the Princeton panels clearly inherited much from Tang artistic traditions, as was the case for most Liao tomb painters.

fig. 23 / Northern Song dynasty, *Portrait of the Tomb Occupants Seated at a Banquet with Attendants*, 1099. Painted relief from the west wall of the front chamber of Baisha Tomb 1, Yuxian, Henan province

fig. 24 / Tang dynasty, *Tang Officials Receiving Foreign Envoys*, 706. Mural from the east wall of the passageway of the tomb of Prince Zhanghuai, Xi'an, Shaanxi province

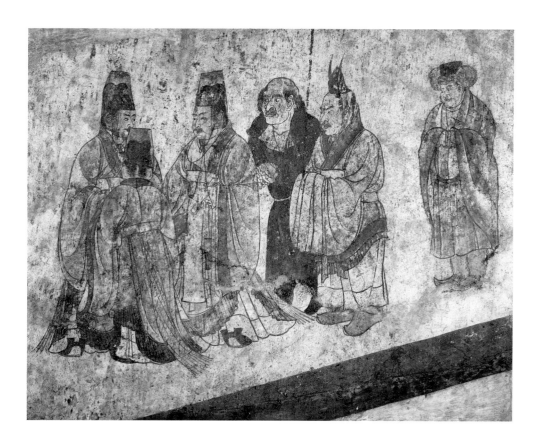

The six Princeton panels are thought to have once served as part of a coffin box. However, the panels were separated before Princeton acquired them, making it difficult to ascertain their original form. Yet based on the structure of the panels and archaeological evidence from other Liao tombs, this identification remains the most likely. The paintings came into the Princeton collection classified as tomb panels. Their size suggests they would have been used as part of an outer coffin within which an inner coffin holding the corpse would have been placed. Although the Princeton collection includes a number of struts that may have once connected the panels, the objects' deterioration impedes any attempt to reconstruct the original structure.

Two of the panels in the Princeton group may have served as the ends of an outer coffin. One depicts a horse with an ornate saddle and two grooms (cat. 6), and the other features four figures flanking a doorway (cat. 5). A riderless horse with a groom is a conventional motif symbolizing an upcoming journey, presumably the tomb occupant's passage to the afterlife. The subject frequently appears in tomb paintings in close proximity to feast scenes, not only in Liao tombs but also in tombs from the Han dynasty.[29] Doorway scenes also have a long history in Chinese tomb art. Most portray an open or half-open doorway with a female figure peering out. These doorways have been interpreted as metaphors for the transition

between life and the afterlife, representing the threshold that separates the two realms.[30] In the Princeton doorway panel two young boys, each accompanied by a dog, sit on either side of the doorway. Two men stand facing the door, one clasping his hands together in a gesture of homage (fig. 25) identical to that of the male figures in the attendant panel (see fig. 14). It is noteworthy that the door is closed. The Princeton collection also contains a similar image of a closed doorway flanked by two standing attendants that clearly formed the pedimented end panel of an inner coffin (see fig. 42).

Other possibilities for the function of the Princeton Liao panels should be mentioned. Wooden structures resembling miniature buildings, within which a coffin was placed, have been discovered in Liao tombs.[31] The Princeton panels could have formed part of the exterior or interior walls of one of these structures. Painted wood panels also were used for Liao burial platforms, suggesting another alternative.[32] However, the size of a box formed by the six panels accords with the dimensions of an outer coffin.[33] The iconographic similarity between *Four Figures Flanking a Doorway* and the pedimented end panel of the inner coffin in the Princeton collection lends further support to this interpretation.

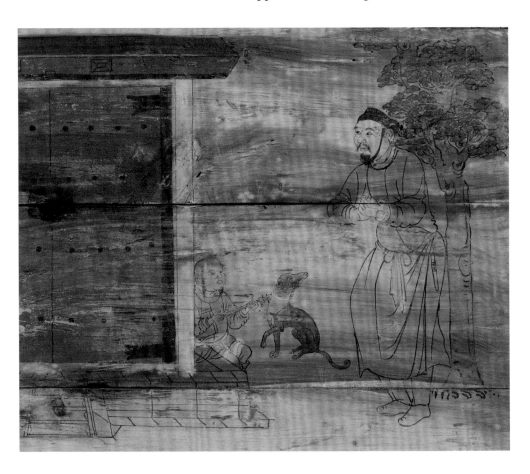

fig. 25 / Detail of *Four Figures Flanking a Doorway*
(cat. 5)

The Princeton Liao panels date from the waning years of a long and rich tradition of feast scenes in the funerary art of China. As such, they represent a direct link to earlier images of feasts as ritual events convened to worship the ancestors. Feeding the soul of the deceased is an enduring concept in Chinese culture. During the Liao dynasty it was clearly appropriated by Khitan elites, whose tomb art developed in various ways to fulfill this purpose. The Liao panels provide an important visual reflection of the Khitan adaptation of this custom, or at least the artist's perception of it.

Around the time the Liao panels were made, south of the Liao border China was still struggling with the upheavals caused by the collapse of the Tang dynasty in 907. In 960, Zhao Kuangyin (927–976), a military leader from central China, founded the Song dynasty and began the process of unifying the country. By the early decades of the Song, the highest echelons of society looked markedly different from those of the Tang dynasty. Tang elites composed a class of hereditary aristocrats that wielded much influence and power. As late as the ninth century, members of powerful clans received high governmental positions based solely on familial prestige.[34] During the Song the elite class came to be dominated by scholar-officials, a category of men who had achieved positions in government, and thereby high status for themselves and their families, through an official examination system. This coterie of elites fashioned a society and culture that was deeply rooted in intellectual and aesthetic pursuits. These societal changes influenced all aspects of elite life, including burial practices and painting. As a result, paintings of feasts from the Song and the subsequent Yuan dynasty moved beyond the realm of the tomb and assumed new identities aboveground without ever completely severing their ties to ancestor worship and the afterlife.

LADIES BANQUETING IN SECLUSION

Paintings of women's feasts are rare among extant examples of Chinese painting from the premodern period. Only two paintings from the tenth through twelfth centuries, both on silk, are known to depict a scene of women gathered together for a social occasion over food and drink. One, probably from the tenth century, is titled *Palace Concert* (fig. 26).[35] The other is *Palace Banquet* (cat. 21), which dates to the Song period, most likely the twelfth century.[36] The titles of works listed in the *Painting Catalogue of the Xuanhe Period* (*Xuanhe huapu* 宣和畫譜), the inventory of the imperial collection of Emperor Huizong, confirm the rarity of the subject matter.[37] The catalogue, whose preface dates to 1120, lists only eleven paintings with titles containing the character *yan* 宴 ("feast") or one of its variants. Of these titles, none include characters that hint at female participants.[38]

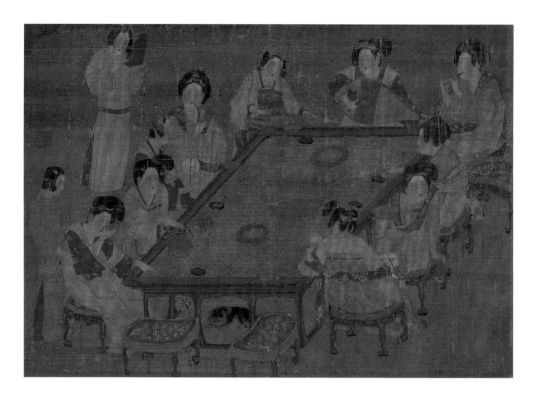

Of course, painting titles do not necessarily reveal narrative or compositional content, and surviving lists may indeed include paintings of woman feasting that simply cannot be recognized by their titles. Nevertheless, in the Song period paintings of this particular subject appear to have been rare.

Although the two paintings are both rich visual resources, *Palace Banquet* and *Palace Concert* are composed on vastly different scales. *Palace Concert* features a closely cropped scene of women around a table with no clear indication of the setting, time of day, relationship among the women, or reason for their gathering. *Palace Banquet*, on the other hand, depicts an entire architectural compound filled with interrelated scenes of court ladies engaged in the preparations for a grand feast (fig. 27). An exploration of these scenes yields insights into how artists approached the representation of the cloistered world of court ladies and the role feasts played in their lives.

In *Palace Banquet*, a sharply tilted ground plane presents an elevated view into the compound. Here, a wealth of detail unfurls before us. Trees line passageways and flank buildings; interiors are splendidly appointed with paintings and furnishings. At the center of the compound, ladies, serving women, and young girls congregate on an outdoor terrace around three large tables laid out with numerous plates and ewers. Around them a lamp is lit, musical instruments are readied, and incense burners await use. It is evening, and the women anticipate the start of a night filled with music, feasting, and revelry.

fig. 26 / Tang dynasty, *Palace Concert*, 10th century. Ink and color on silk, 48.7 × 69.5 cm. National Palace Museum, Taipei

fig. 27 / Detail of *Palace Banquet* (cat. 21)

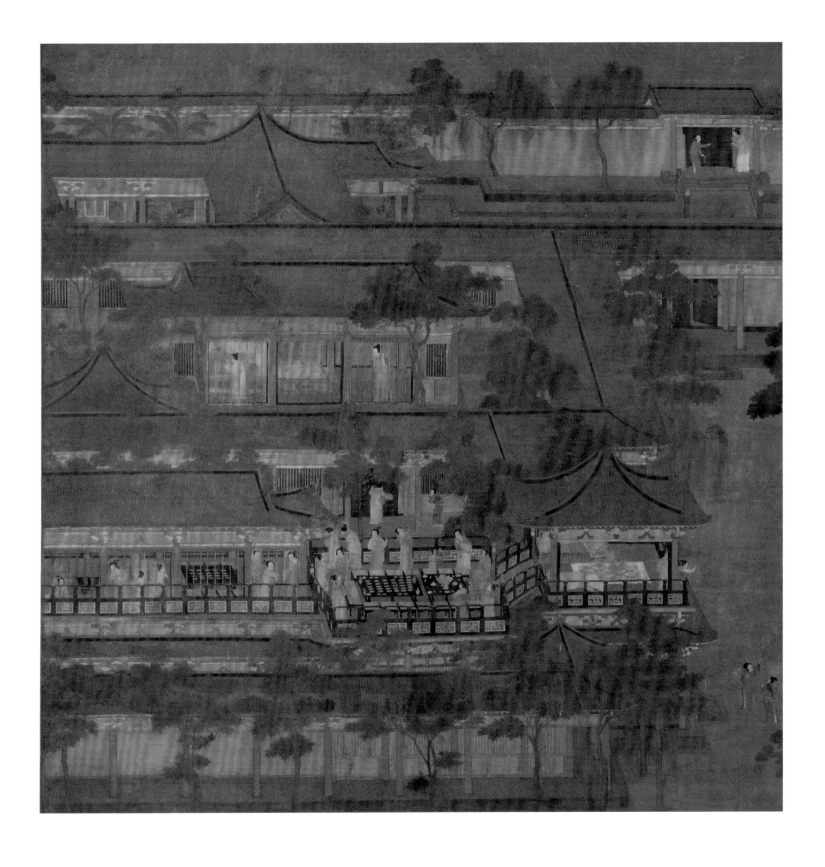

At first glance, the unusual subject matter of *Palace Banquet* is concealed by its most dominant feature, the architectural compound inhabited by the female figures. The complex is clearly quite large; only a portion of it is depicted in the painting. Although the large scale and virtuosic execution of the buildings are exceptional, the overall character of the architecture fits in well with what is known from other Song dynasty architectural paintings, a genre that flourished during this period.[39]

Before discussing the painting further, we need to step back and address the connection between the history of images of feasting known primarily from tomb art and the growth and technical development of other genres that inspired *Palace Banquet*, such as figural and architectural painting. By the Song dynasty, we begin to see evidence of artists treating the theme of feasting in images intended for display outside of a funerary context. Among the surviving paintings on silk or paper that circulated aboveground, the earliest examples that take up the theme of feasting, such as *Palace Concert*, date no earlier than the tenth century. Neither do we encounter evidence of later copies of pre-tenth-century compositions on the subject.

Given the enormous quantity of Chinese paintings lost over time, it is impossible to say whether the omission of the theme from the surviving corpus of early painting is the result of a bias in preservation or a sign that painters did not engage the subject matter beyond funerary art prior to the tenth century. None-theless, the extant scenes of feasting in portable paintings from the tenth through twelfth centuries attest to the dramatic difference in their compositions when compared to contemporary paintings of feasts known from tombs (see fig. 23).

As the complexity and scale of feast scenes seemed to grow in portable paintings from the tenth century onward, the opposite apparently occurred within the context of tomb painting. The appearance of banquet scenes outside of funerary art turns our attention not only to the shifts in burial practices during the Song dynasty but also to concurrent developments in the history of Chinese painting.

The beginning of the Song dynasty saw the cultural and philosophical revival of Confucianism. The teachings of Confucius (ca. 551–479 BC) were influ-ential from ancient times onward, but their influence waxed and waned as they competed with other political philosophies and religions. The Song revival of Confucianism emphasized self-cultivation as a means to achieve harmony and proper virtue in the self, society, and state.[40] The effects of Song dynasty Neo-Confucianism were felt in many areas, including tomb construction, tomb art, and burial rituals as a whole. Simple burials became standard among the literati.[41] This shift resulted in tombs whose painting programs were reduced in size and ambition compared to earlier periods.

Another significant factor that affected burial practices — and more generally broadened the religious landscape of China — was Buddhism. Imported

by traders from Central Asia, Buddhism first came to China around the first century AD. In the Tang dynasty, Buddhism enjoyed periods of growth that continued into the Song. With Buddhism, the possibilities for how one's afterlife might be spent greatly expanded. Although worshipping ancestors and caring for their needs was still a common cultural practice during the Tang and Song dynasties, the appeal of the Buddhist notion of a cyclical process in which death is followed by rebirth led to a syncretic religious landscape that allowed for a much wider range of conceptions of death and the afterlife. This change, in turn, drastically altered the visual program of funerary art. In a Buddhist context, the inclusion of a feast scene could no longer be taken for granted.[42]

Contemporaneous with these cultural developments, the production of paintings and fine-art objects also dramatically increased. The impression of the Song dynasty as a period of widespread artistic flowering derives in part from changes in the material record, as greater numbers of paintings on silk and paper survive from the tenth century onward. However, striking economic development during the period, which resulted in greater wealth in the hands of greater numbers of elite, along with a burgeoning art market, point to systemic changes that permanently altered the trajectory of Chinese art. During the Northern Song, state-level patronage of artistic institutions greatly expanded. Indeed, few other periods in Chinese history can rival the Northern Song for the prominent role played by imperial patrons in both promoting artistic production and raising technical standards — a role that affected developments in a range of mediums, including painting, calligraphy, ceramics, and textiles.[43] The Song dynasty also coincides with the emergence of literati painting — paintings produced by self-styled amateurs outside the institutions of state and palace patronage — which eventually transformed not only Chinese painting but also the role of the artist in Chinese society.

Although Song dynasty painting is renowned for its landscapes and flora and fauna scenes, the importance of other genres for Song audiences, especially figural and architectural painting, should not be underestimated. The same forms of ambitious patronage that fostered the growth of landscape painting also led to rapid developments in the complexity and technical facility of Song figural and architectural painting. It is this art-historical backdrop that lies behind a painting such as *Palace Banquet*.

At the same time, the relative rarity of feast scenes among the great output of Song figural and architectural painting needs to be addressed. What did it mean when a visual theme strongly associated with a burial context was translated to a setting unrelated to the afterlife? Tomb paintings were filled with imagery that presented activities engaged in by the living, but banquet scenes had particular resonance with rituals for the dead and conceptions of the afterlife. The perception that Song painters produced relatively few images of feasts during a

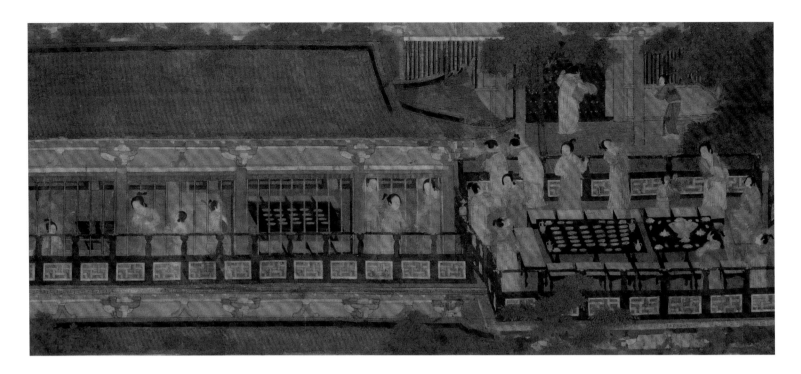

period when various genres were booming leads to the ostensible conclusion that their patrons were not especially interested in commissioning such scenes. Although feasts were an integral part of social, communal, and familial life at all levels of society, patrons during the Song period may have associated paintings of feasts with funerary art and thus shied away from commissioning or acquiring such images as a result.

In the case of both *Palace Banquet* and *Palace Concert*, the fact that the scenes are nostalgic in nature helps us understand their origins and also draws attention to their vast remove from the types of images of feasts found in tombs. Both paintings seem to be deeply influenced by figural painting traditions centered on depictions of Tang court ladies. A closer look at *Palace Banquet* vividly demonstrates this connection.

Palace Banquet's architecture — along with the objects depicted within the compound, such as the screen paintings in the chamber behind the outdoor terrace (see fig. 30) and the metal ewers on the largest banqueting table (fig. 28) — can be linked to the Song period, the early to mid-twelfth century in particular.[44] The depictions of the women, on the other hand, suggest that the image was intended to be viewed as a scene from the past.[45] With their slightly rounded figures covered with flowing dresses, the women evoke ladies from Tang dynasty painting and sculpture (see cat. 28). Plump female figures enjoyed a period of popularity in Chinese art between the eighth and late tenth centuries. In subsequent periods, the depiction of plump female figures acted as a visual shorthand

fig. 28 / Hall and outdoor terrace, detail of *Palace Banquet* (cat. 21)

to conjure associations with the zenith of the Tang dynasty, notably embodied in the rotund portrayals of Yang Guifei, the notorious consort of the Emperor Xuanzong (r. 713–756).[46] The Song dynasty audience for *Palace Banquet* would no doubt have understood the women to represent the Tang period, and the scene to be historically oriented despite the contemporary feel of the setting.

Portrayals of court women engaged in everyday activities were a popular theme in painting throughout the Tang and Song dynasties. *Palace Ladies Bathing Children* (cat. 22) and *In the Palace* (cats. 23–24) are two exemplars of the genre, which manifest this taste for behind-the-scenes glimpses of court life. The paintings include scenes of court ladies playing with children and dogs, putting on makeup, and performing music. However, these intimately scaled vignettes contrast with the palatial setting presented in *Palace Banquet*, a reminder that the later painting owes a debt as much to new developments in the genre of architectural painting as to traditions of figural painting.[47] Nonetheless, *Palace Banquet* does reveal an attention to the smaller-scale details of the lives of court women, a strategy that may have satisfied the expectations of the genre of court-lady painting while also distancing itself from the type of banquet scene typically found in tombs from earlier periods.

Turning to the composition of *Palace Banquet*, the bird's-eye view affords an extraordinary look into the layout of the inner quarters of the palace. Although paintings of women from high-status households were popular in both the Tang and Song periods, most works in this genre that take us into these private quarters do so in fanciful ways that conform to certain accepted conventions. *Palace Concert* (see fig. 26), *Palace Ladies Bathing Children* (cat. 22), and the long handscroll *In the Palace* (cats. 23–24) all portray court women as essentially stageless actors deprived of the architectural setting in which their lives would properly play out. The viewer is given almost no information regarding their private spaces and how their lives transpired within this realm. *Palace Banquet* supplies these intimate details by taking the viewer directly into the heart of the inner quarters, a segregated section of a palace inhabited only by the women of the household. In this way, the painting potentially has much to tell us about contemporary perceptions of how elite women banqueted and socialized.

The women of *Palace Banquet* are presented before the start of a feast. Many gather around an open-air terrace set with three tables. Although they are dining out of doors, the women are still located in the center or near the center of their quarters. A ring of walls, hallways, courtyards, and rooms surround their dining tables. The ladies are separated from the outside world, securely cloistered within their own realm. One scholar has proposed that the women are awaiting the arrival of a guest not seen in the painting.[48] Two women, one of them a maidservant, are seen in the upper-right corner of the painting, handling a lock on a door that leads to an outer passageway (see fig. 27). They might be preparing to

unlock it to admit a visitor. If the visitor were the person claiming ownership of the compound and its women, this person would be male and, given the scale of the compound, a gentleman of high rank: a prince if not the emperor. However, the women attending to the lock stand at the north wall of the compound, a secondary entrance. The emperor or a prince would more properly approach from the south, the location of the main entry. He would also undoubtedly enter with greater fanfare than a reception party comprising a single court lady and a serving girl. Since the artist appears to be depicting an event exclusively for women, the ladies are more likely preparing to admit additional female guests or performers.

Hints abound of the pleasures awaiting the ladies gathered in *Palace Banquet*. The numerous small dishes, ewers, and plates set on tables positioned on the central, outdoor terrace, as well as on tables glimpsed in the hall to the left of the terrace (see fig. 28), bespeak a bountiful feast. Large, ornate metal vessels are also seen in the outdoor terrace, perhaps holding some form of libation. On the outdoor terrace, a group of gilded silver censers lie on a table covered in blue cloth. Another set of censers, each in the shape of a seated lion, sit on a carpet in the pavilion to the right of the outdoor terrace. When the censers are lit, the emanating fragrances will waft over the banquet. Apart from incense and fine food and drink, the ladies will also be entertained by musicians. One lute player, perched on a couch-platform in the indoor banqueting hall, is already warming up. Several other instruments, most still wrapped in cloth — at least three more lutes and small, oblong instruments, perhaps flutes or clappers — await their players in the pavilion to the right of the banqueting terrace. A larger object, partially obscured, might be a zither. The bottom half and base of a large drum is also visible.

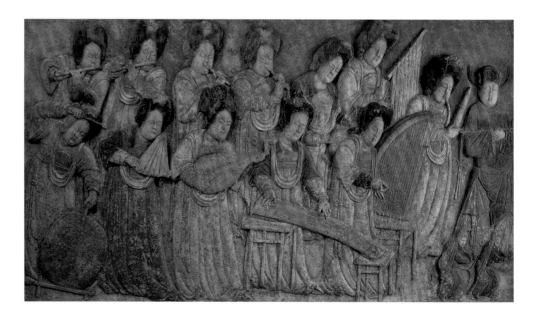

fig. 29 / Later Liang dynasty (907–923), *Ensemble of Female Musicians*. Painted reliefs from the tomb of Wang Chuzhi (863–923), Quyang, Hebei province

fig. 30 / The sleeping lady and her attendants, detail of *Palace Banquet* (cat. 21)

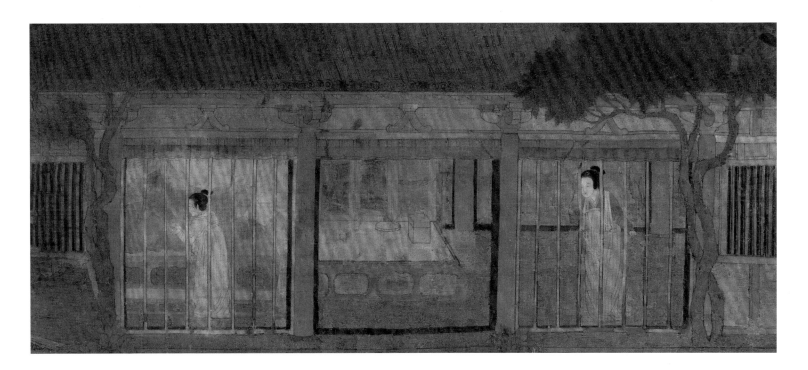

These are all the instruments one would expect in a musical ensemble, based on depictions of other banquets featuring music, notably *The Night Revels of Han Xizai* (see fig. 31), which will be discussed in the following section. Although *Night Revels* portrays a gathering arranged by a male host for male guests, the musicians performing are mostly women, save for the drum and clapper players. However, the lively all-female orchestra presented mid-performance in a painted stone relief from the tenth-century tomb of Wang Chuzhi (863–923), a military governor active during the Tang and Later Liang dynasty (907–923), demonstrates that ladies did indeed play all of these instruments (fig. 29).[49]

The purpose of the gathering portrayed in *Palace Banquet* remains unknown.[50] As tempting as it may be to try to connect the painting to a specific literary or historical source, evidence for such an interpretation remains elusive.[51] The gathering might have marked a festival, a birthday, or a multitude of other occasions that would have brought court ladies together for a banquet.

As we begin to read the painting, we might first search for the banquet's host. The main candidate for the role, a sleeping court lady, is at once seen and unseen. Nestled beneath bedclothes in a chamber to the rear of the outdoor banqueting hall (fig. 30), she is tended to by several ladies. One attendant stands before the bed, clapping her hands to wake the sleeping lady. Another stands in an adjacent chamber holding an elaborately lit candelabra. Two additional ladies are about to enter the sleeping woman's quarters, one carrying a bundle of cloth (see fig. 28).

The sleeping lady is clearly the highest-ranking woman in the compound and the possible favorite of the emperor or prince to whose household she belongs. The rumpled bedclothes and the lateness of the hour of her rising allude to a sexual encounter recently passed.[52] As the most important woman portrayed in *Palace Banquet*, she might play the default role of host while at the same time serving as guest of honor.

The guests at this gathering stand alone or in groups around the central banqueting terrace, clearly anticipating the imminent arrival of the host (see fig. 28). All of them are depicted standing in relaxed poses. They seem to possess a level of familiarity with their environment that indicates they belong to these inner quarters. The dress and hairstyles of the ladies all follow a similar fashion with the exception of the maidservants, who are attired and coiffed according to rank.

A second set of dining tables is located in a hall to the left of the terrace (see fig. 28). The arrangement of separate banqueting areas denotes two different groupings of guests. The table in the indoor area is set very simply, with even rows of small dishes. The two dining tables on the outdoor terrace are laid with small dishes as well as ewers and grander vessels. The smaller table holds the most lavish vessels. The guests dining here will be closest to the music pavilion and will thus enjoy the most privileged view of the entertainment. These hierarchical dining and seating arrangements attest that life in the female quarters was segmented to create a system in which order and rank were always preserved.

In *Palace Banquet* the figures are carefully staged in a series of tableaux throughout the grand complex they inhabit. They enact the performing of tasks and interact with each other in accordance with the models of ideal and expected behavior of court women. Relatively little is known about the personal lives of court women during the Tang and Song dynasties.[53] These were women who lived their lives within the confines of the court. At various times they were allowed greater autonomy, notably during the Tang, and at other times less. Historical and literary texts tell us something about the official, imagined, and idealized lives of these women, but their depiction in paintings must always be viewed as a visual construct dictated by the function of the work — a union, sometimes imperfect, of the patron's desires and the painter's preferences — and not necessarily based on reality. As with many early Chinese paintings, the identity of painter and patron are unknown. However, the painting itself does provide some clues to both.

The bright mineral pigments, the large size of the painting, and the complexity of the composition point to a painter employed at court. Song dynasty court paintings are known to be colorful, intricately painted images that include a wealth of descriptive detail. The formal structure of the picture, with the architecture divided into neat registers stacked one on top of the other, is also in

keeping with the work of court painters. The patron would most likely have been a high-ranking resident of the imperial palace, possibly the emperor himself.

Considering the display setting for *Palace Banquet*, the intimate nature of the work might rule out anywhere but the most private of locations. If the painting were hung as decoration for the inner quarters, the ladies inhabiting these chambers would have seen in the work depictions of their historical, idealized predecessors. The harmony and order presented in *Palace Banquet* would also have served a didactic purpose, reminding the ladies to maintain proper relations among themselves. When viewing *Palace Banquet*, the emperor would no doubt have enjoyed connecting a pleasing image of historical court women in their inner quarters with his own household. If the painting were commissioned to decorate the women's quarters, the possibility arises that a lady of the inner quarters may have been the patron.

If the patron was a lady, she must have been high-ranking, likely the empress or one of the emperor's favorites. Women of such status may have held enough power to commission works of art directly from court painters.[54] The empress/consort patron might have used *Palace Banquet* as a hanging scroll or mounted on a screen for decoration in her own rooms. She would presumably have seen herself cast in the role of the unseen sleeping lady in the three-bay hall. All the women in *Palace Banquet* show deference to her by either attending to her or awaiting her presence to signal the start of the feast. If displayed in her rooms, the painting would have visually reinforced the empress or consort's high status and importance within the inner quarters.

As much as *Palace Banquet* reveals about the banqueting practices of elite women — the event is segregated from men, held inside a cloistered architectural setting, and set in a refined atmosphere filled with incense, fine wares, and music — it undoubtedly reveals more about the conventions for depicting court women and the reinforcement of their established role in society. Although the scene is set in the past, it is not a painting attempting to document a particular historical event. The painting is a fantasy, an imagined scene created by the artist for the visual delectation of the patron and their social circle. Along with all the possible didactic functions of the painting, its power to entertain may have been its most important attribute.

The practice of portraying court women faded after the Song period, to be replaced by the more generic category of "beautiful women" paintings.[55] Feast paintings, on the other hand, became increasingly numerous. However, from the thirteenth century onward, artists focused almost exclusively on gentlemen's banquets. Although often filled with literary allusions and nods to historical men of note, these images were firmly modeled on gatherings of the present day.

Among the surviving corpus of paintings from the tenth to the fourteenth century, depictions of gentlemen feasting are not great in number but certainly more plentiful than the corresponding images of ladies. A long Yuan dynasty handscroll entitled *Evening Literary Gathering* (cat. 33) portrays the subject with a scene of eighteen gentlemen in the concluding stages of a lengthy and convivial feast. The number of gentlemen included in the composition is significant: an educated viewer would connect it to the Eighteen Scholars of the Tang dynasty, a famed group of advisors appointed by the young Emperor Taizong (r. 626–649) prior to ascending the throne. Despite the allusion to this learned group of Tang dynasty gentlemen, the scene is unabashedly dissolute, filled with images of rowdy figures drinking and conversing. Although *Evening Literary Gathering* is usually thought of as an early example of the "literary gathering" painting genre, it is unique in its celebration of the strong social ties among a group of gentlemen without visual reference to the literary engagements and erudite activities that typically defined their identity.

Similar to *Palace Banquet*, *Evening Literary Gathering* represents a new direction in the evolution of feast scenes. Earlier tomb paintings present feasts as imagined events for the participation of the deceased. They depict a familiar but idealized occasion based on the world of the living that celebrates the status of the tomb occupants while also providing nourishment for their sojourn in the afterlife. By contrast, later portable paintings of ladies and gentlemen feasting were designed for the enjoyment of the living. In the Song dynasty painting *Palace Banquet* the enjoyment is partially nostalgic, presenting a grand feast of the past filled with vignettes of exemplary Tang dynasty ladies. *Evening Literary Gathering* also presents an imagined banquet, but the relative timelessness of the gentlemen's literati attire allows for connections to both the past and the present.

Before exploring this idea further, mention should be made of two of the best-known paintings of gentlemen's feasts from the tenth to the fourteenth century: *The Night Revels of Han Xizai* (fig. 31), by Gu Hongzhong (active 10th century), and *Literary Gathering* (fig. 32), attributed to Emperor Huizong (r. 1100–1126). *The Night Revels* and *Literary Gathering* both portray famous political figures and seem to have political motives behind them. *The Night Revels*, in particular, has been the subject of much inquiry not only because it is an unusually revealing image of a gentlemen's feast but also because colophons and catalogue entries on the painting provide much information on Han Xizai, the guests depicted in the painting, the patron of the work, and the reasons why it was made. In the history of Chinese art, this is a remarkably rich amount of information for a single painting. Gu Hongzhong's original painting is no longer extant. However, the Southern Song copy that survives in the Palace Museum, Beijing, is particularly

fine, allowing us reasonable access to Gu Hongzhong's original composition.[56] Much may be said about this image, but the comments here will be limited to an analysis of the feast itself.

The Night Revels of Han Xizai was originally created for the Southern Tang dynasty (937–976) Emperor Li Yu (r. 961–976), who wanted a firsthand illustrated account of the goings-on at the infamous parties of a government official named Han Xizai. What the painter Gu Hongzhong must have presented to Li Yu was a carefully structured image that sets forth a narrative of the feast in an episodic manner.

The opening scene of the scroll draws the viewer into a feast that has already begun (see fig. 31). Bowls and platters are filled with food, and a musical performance is underway. A group of gentlemen gather among courtesans. At the center of the scene, Han Xizai is seated with another guest on a couch-bed in front of a rectangular table filled with platters of food and vessels for wine. A millinery aficionado, Han is easily identified by his extravagant, tall hat. Another guest sits across from Han in front of his own table, laden with dishes of food. Other gentlemen sit or stand close by. The men are not attending to their food, however; instead, they pay rapt attention to the performance of a female lute player.

The scene presents an informal arrangement of seats and tables, with guests dining from numerous small dishes and plates, accompanied by wine — a mode of gentlemen's feast that will be discussed in greater detail in connection with *Evening Literary Gathering*. The food and drink consumed by the gentlemen in the opening episode sustains them through the long night of revelry presented in subsequent scenes of the long handscroll. In this painting the feast serves as a

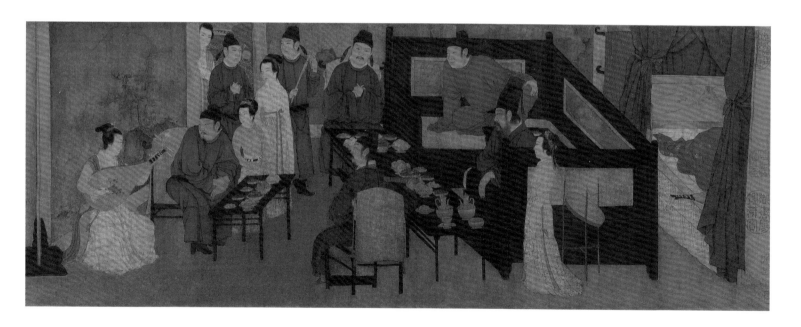

fig. 31 / Southern Song dynasty, after Gu Hongzhong (active 10th century), *The Night Revels of Han Xizai* (detail), late 12th or early 13th century. Ink and color on silk. Palace Museum, Beijing

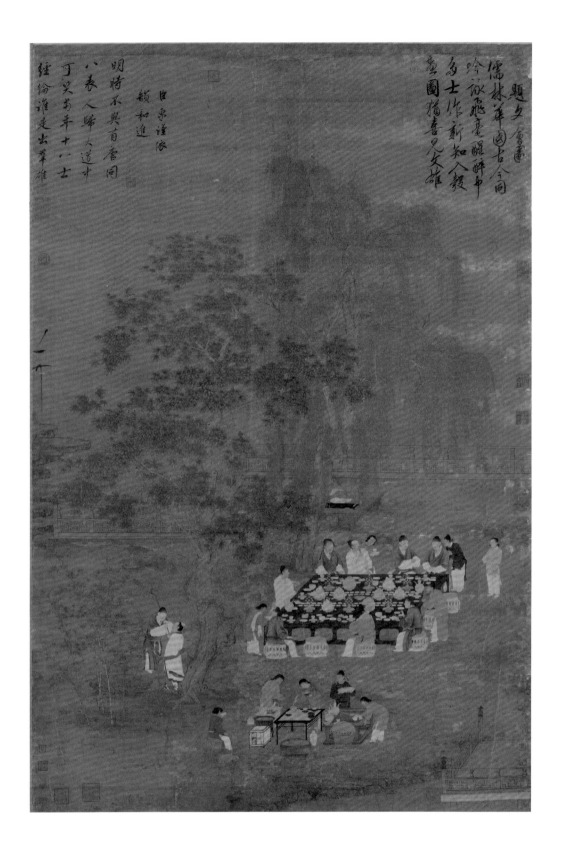

fig. 32 / Northern Song dynasty, attributed to Emperor Huizong (r. 1100–1126), *Literary Gathering*, with inscriptions by Huizong (right) and Cai Jing (left), early 12th century. Ink and color on silk, 184.4 × 123.9 cm. National Palace Museum, Taipei

prelude to the later events of the painting, events that must have reinforced Han Xizai's notoriety.

Han was reputedly a highly skilled statesmen. The painting's overt portrayal of his profligate behavior must have involved, on some level, political calculations. The background of the opening feast scene contains a hint of the depredations to follow. A view of a bed, its curtains pulled fully open, reveals rumpled bedclothes and a casually placed lute with its neck hanging over the side of the bed. The sexual encounter implied by the vignette, between a female lute player and a man who must be either Han Xizai himself or one of his guests, sets the tone for the rest of the painting. This is a remarkably frank portrayal of the sexual relations encouraged and engaged in between scholar-officials and the women who were held as household courtesans.[57] The feast is merely a nod to the conventions and etiquette of a gathering of gentlemen.

In *Literary Gathering* (see fig. 32), attributed to Emperor Huizong but likely painted by court artists under his supervision, the banquet is the main focus of the composition. The serene atmosphere of the painting could not be further from the mood of *The Night Revels of Han Xizai*. Two quatrains by Huizong and the government official Cai Jing (1047–1126) accompany the painting. Huizong's poem identifies the gentlemen in the scene as erudite scholars in his service:

> Learned scholars and our glorious land are the same past and present.
> Poets wield brushes and compose verses drunk and sober.
> Many new scholars have joined the literary company.
> We rejoice at meeting these great minds in painting.

Cai Jing's poem compares the men to the renowned Eighteen Scholars of the Tang:

> Times have changed since the Tang dynasty,
> And great scholars of the past have now departed.
> How amusing that the Eighteen Scholars of those years
> Must wait to see who is more commendable![58]

Both texts extol the virtues of the talented men who serve in Huizong's court, impressing upon the viewer the emperor's ability to attract the most cultivated literati to his service.

Except for a pair who stand aside in conversation, the gentlemen are all seated around a table set with an impressive array of large dishes and bowls. The banquet table is located in the clearing of a grand private garden framed by a pair of magnificent trees and a bamboo grove. Beyond the trees an elaborate balustrade runs the width of the painting, suggesting the viewer is only seeing a small portion of an immense garden, no doubt located on the grounds of a palace.

The setting of *Literary Gathering* is very likely Huizong's own palace garden. For this reason, it seems plausible to assign the identity of Huizong to one

of the figures. Presumably the host for the occasion, Huizong is perhaps the gentleman seated by himself on the left side of the table. Dressed in white robes, this figure holds out his right hand, palm up, in a gesture of invitation to the other guests. Although the painting appears to be merely a charming image of Huizong banqueting with a select group of learned scholar-officials, it nonetheless must have carried a strong political message. The painting is praising the entire class of gentlemen who serve his government. Moreover, if Huizong is indeed present in the image, by association he identifies himself as a learned gentleman, emphasizing his abilities as ruler. The contrived nature of the secluded scene is underscored by a comparison to a historical account of a typical banquet hosted by Huizong, which is described as a lavish, all-day event for many guests that took place throughout the entire palace, replete with a profusion of entertainers, fine food, and many rounds of wine.[59]

Emperor Huizong's paintings must be viewed, in some sense, as imperially sanctioned tools of the state, part of the cultural arsenal Huizong deployed to control and order the empire.[60] As such, his paintings were often created for specific political purposes and can thus be interpreted as concrete political statements. The challenge today is to determine the content of these statements, articulated in a language marrying literary and pictorial art. For Huizong's intended audience, however, the sophisticated political iconography of the feast scene in *Literary Gathering* would have been immediately recognizable.

Returning to the handscroll *Evening Literary Gathering*, we encounter a very different kind of banquet scene, one that emphasizes the purely social nature of a male gathering. As we begin to read the handscroll from the right, the painting opens with a garden footpath paved with an ornamental pattern of small stones emerging from behind a dense pine tree. Contrary to expectations, we are first greeted on the path by a pair of guests leaving the party rather than arriving (fig. 33). This ingenious motif alerts us to the slightly subversive nature of the work. The feast seems already to be winding down, and the guests are beginning to stumble home. The departing gentlemen require the help of four attendants. Two attendants support a gentleman hunched over their shoulders. Another, slightly less inebriated gentleman closes his eyes as he is guided by the third attendant. The fourth attendant holds a lamp aloft, lighting their way.

As we move along the scroll to the left three more scenes appear, each centered around a table covered with an assortment of vessels for food and drink. The first table features a pair of gentlemen deep in conversation (cat. 33). Directly across from them another guest slumps over the table, fast asleep. Yet another diner washes his hands with the help of an attendant. On the left side of the table a guest stands to toast a dignified seated figure holding a fly whisk, presumably the host, as attendants stand by to pour more wine (see fig. 41). The next table includes two men in somewhat argumentative poses: one brushes off the other's

fig. 33 / Gentlemen departing, detail of *Evening Literary Gathering* (cat. 33)

fig. 34 / Gentlemen at the second table, detail of *Evening Literary Gathering* (cat. 33)

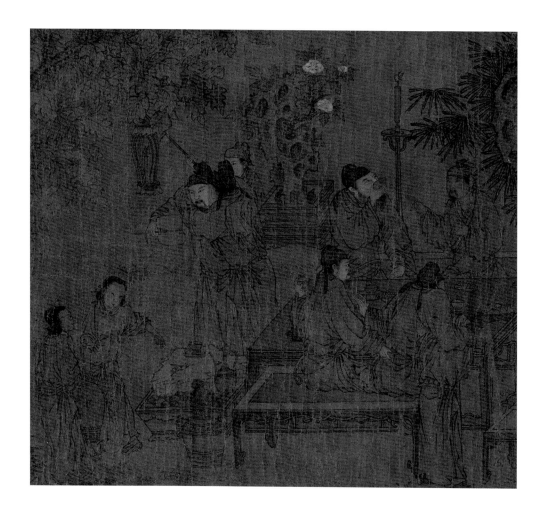

hand from his shoulder (fig. 34). Across from this rowdy duo, a weary-looking guest puts on his boot with assistance from a servant. Another gentleman samples food from the table. Two pairs of gentlemen are still seated at the last table (fig. 35), talking and drinking as one prepares to leave. A final pair of gentlemen wander over to the left of the table, with their arms around each other's shoulders for support. A host of male and female servants bustle around the scene, offering assistance to the feasters and bringing more supplies.

This brief description of the tables of partiers gives a taste of the kind of candid interactions that set the image apart from most other scenes of gentlemen feasting. The great majority of paintings of gentlemen feasting purport to focus on other things, as indicated by titles, colophons, or composition. Often the feast itself is only of secondary interest. In *Evening Literary Gathering*, the feast is the main event.

As mentioned above, the number of gentlemen attending the feast evokes the famous Eighteen Scholars of the Tang dynasty.[61] Before the Tang emperor

fig. 35 / The third table, detail of *Evening Literary Gathering* (cat. 33)

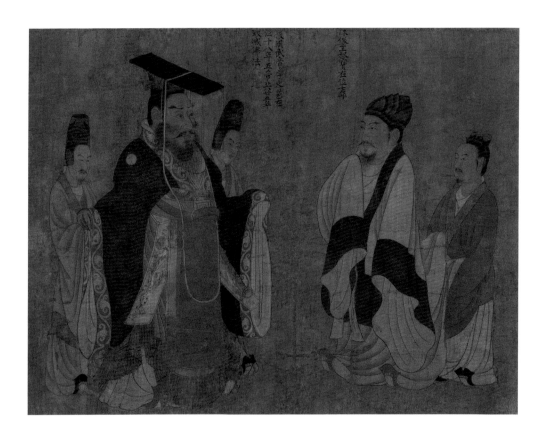

Taizong ascended the throne, he recruited eighteen learned men to serve him as academicians, a clear signal of his imperial aspirations. When he became emperor in 626, Taizong commissioned the court artist Yan Liben (ca. 600–673) to paint a composite portrait of the eighteen scholars in order to demonstrate his high regard for men of learning. We have some clues to the possible structure of the work based on the survival of another painting attributed to Yan Liben, *The Thirteen Emperors*, now in the Museum of Fine Arts, Boston (fig. 36). The work features full-length portraits of past emperors accompanied by their own entourages. Each grouping of figures, emperor and retinue, is set in its own spatial cell against a plain background, as was typical of Tang portraiture.

The Eighteen Scholars became a popular subject for painting during the Northern and Southern Song periods. The theme was in the repertory of the scholar-official painter Li Gonglin (ca. 1041–1106) and appears in works attributed to Emperor Huizong.[62] A Southern Song Eighteen Scholars painting in the style of Liu Songnian (active ca. 1175–after 1195), a court artist who served Emperor Ningzong (r. 1194–1224), survives in the collection of the National Palace Museum, Taipei (fig. 37).[63] The twelfth- or thirteenth-century painting, entitled *Five Tang Scholars*, appears to be the lone remnant of a set of four hanging scrolls. The same composition as in the painting appears among a group of four scenes

fig. 36 / Tang dynasty, attributed to Yan Liben (ca. 600–673), *The Thirteen Emperors* (detail), 7th century. Ink and color on silk. Museum of Fine Arts, Boston. Denman Waldo Ross Collection (31.643)

fig. 37 / Southern Song dynasty, attributed to Liu Songnian (active ca. 1175–after 1195), *Five Tang Scholars*, 12th or 13th century. Ink and color on silk, 174.7 × 106.6 cm. National Palace Museum, Taipei

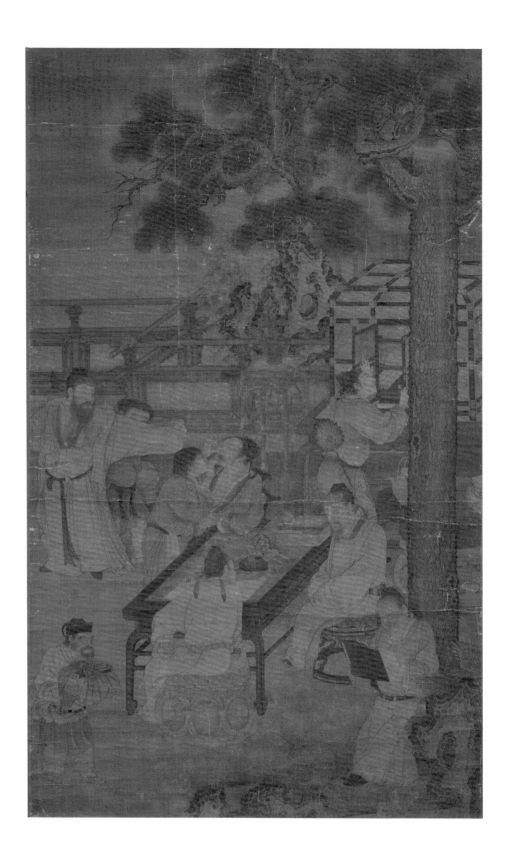

depicting the Eighteen Scholars in a handscroll also in the collection of the National Palace Museum, Taipei.[64] In the handscroll, each scene presents a group of four or five scholars in a garden setting, engaged in cultivated activities befitting their identity, such as viewing paintings and examining antiquities.

In the matching scene (see fig. 37), the men are presented in a luxurious garden filled with books and scrolls. In the background beyond a balustrade, we find a bamboo grove and a magnificent Taihu rock. In the foreground, the scholars and their servants gather under a pine tree. In the center of the composition, three scholars sit at a table set with scrolls and brushes: one, deep in thought, converses with a figure whose back is turned toward us, while a young attendant amusingly assists the third scholar with a matter of personal hygiene. In front of the table, on the right, a fourth scholar rests against a tree as he studies a scroll. To the left, an elderly attendant, short of stature, approaches with a bundle of reading material. Behind the table, an assistant opens a cabinet filled with books and scrolls. The fifth scholar, standing by the balustrade, disrobes with the help of a young attendant.

Yan Liben had been commissioned to paint portraits of men personally known to Emperor Taizong. The resulting painting would not only have commemorated the Eighteen Scholars but also captured their appearance as a historical document (see fig. 36). In contrast, Song dynasty paintings demonstrate how the theme was taken up by later artists who were less concerned with the portrayal of the Eighteen Scholars as individuals than with the opportunity to present generalized scenes of learned gentlemen at leisure. By the Song period, the Eighteen Scholars motif had already become a generic device to add a further layer of interest to the figures by associating them with renowned scholars of the past. Comic elements in the painting attributed to Liu Songnian also connect the theme to a long tradition of satiric depictions of scholars. Eighteen Scholars paintings were eventually subsumed within the larger category of "literary gatherings." (In Huizong's *Literary Gathering*, Cai Jing's inscription refers to the Eighteen Scholars.) The interconnections between the literary-gathering genre and the Eighteen Scholars theme are illuminated by the Yuan dynasty frontispiece and colophon attached to *Evening Literary Gathering* (cat. 33).

Upon unrolling *Evening Literary Gathering*, the viewer initially encounters a frontispiece written in seal script by Guo Guan (1250–1331) that gives the title of the painting as *Evening Banquet* (*Yeyan tu* 夜宴圖).[65] However, the 1360 colophon, written by Li Jiben, states that the image is an *Evening Banquet of the Eighteen Scholars*. To emphasize this characterization, he lists the scholars by name, noting that the origins of this painting lie in Yan Liben's Eighteen Scholars handscroll. The slight disagreement concerning the painting's title between the two Yuan period scholars who inscribed it may have arisen from the artist's unusual treatment of the subject.

Evening Literary Gathering portrays the conclusion of a feast during which all of the guests appear to have consumed copious amounts of alcohol. Some of the guests are already leaving or have fallen asleep. Others still appear quite alert and carry on animated conversations. Entirely absent from the scene is any visual indication of the cultivated activities typically portrayed in images of literary gatherings. The gentlemen do not inspect paintings, admire antiquities, compose poetry, perform music, or play chess. Neither a rolled scroll nor an ancient bronze is anywhere to be seen. By contrast, Huizong's *Literary Gathering* features a guest holding clappers along with a *qin* zither and an ancient bronze tripod, which are seen atop a platform behind the banquet table (see fig. 32). These are small but significant references to well-known literati pastimes.

The complete lack of acknowledgment of any traditional literati activities marks *Evening Literary Gathering*'s unique status within the genre. The gathering also omits the entertainments usually featured at a gentlemen's feast. No female dancers entertain the group, nor is there even a solo instrumentalist. Although the performers carry salacious connotations in *The Night Revels of Han Xizai*, musical and dance performances were often used to signify cultural sophistication or ritual propriety. In a banquet scene from the Southern Song handscroll *Odes of the State of Bin* (cat. 34), a dignified group of gentlemen is entertained by an ensemble of musicians and a dancer, indicating the harmonious relationship between the men and the musical rituals of the state.

Returning to *Evening Literary Gathering*, the title *Evening Banquet* chosen by Guo Guan in his frontispiece suggests his hesitancy to link the painting to the Eighteen Scholars theme. Held in a private garden without courtesans or musical performers, *Evening Literary Gathering* presents an outdoor feast whose sole objective is as a venue for the social interactions among the gentlemen. Filled with expensive ornamental Taihu rocks, the garden must belong to a wealthy household. The fine furniture and table settings, along with the presence of numerous servants, sixteen in total, also point to the high status of the host. As for food and drink, both are in abundance, particularly the latter. The painting ends with two maidservants struggling under the weight of a large vessel, likely a wine container, hinting that the party might get a second wind. Although scholars drinking to excess is a common motif in Chinese painting, it is often tied to a historic occasion or an elevated purpose, such as poetic composition.

If the artist is not presenting the straightforward image of the Eighteen Scholars that the colophon describes, then we must question what the subject matter of the painting really is and what function it may have served. We know little if anything about the artist responsible for the painting, nor do we have an account of the requirements of his patron. To attempt answers to our questions, the only recourse we have is comparisons with other paintings. A look at the portrayal of scholar-gentlemen in two other Yuan paintings, one by a member

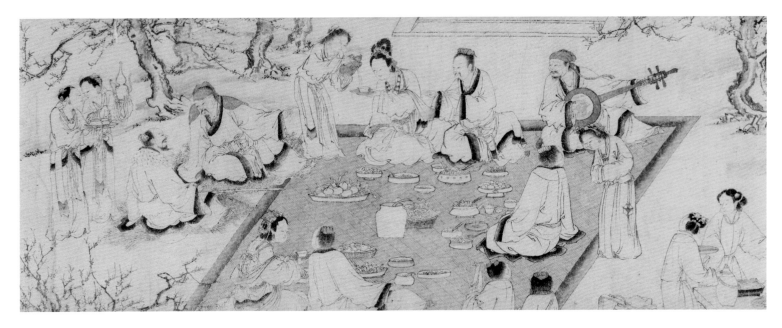

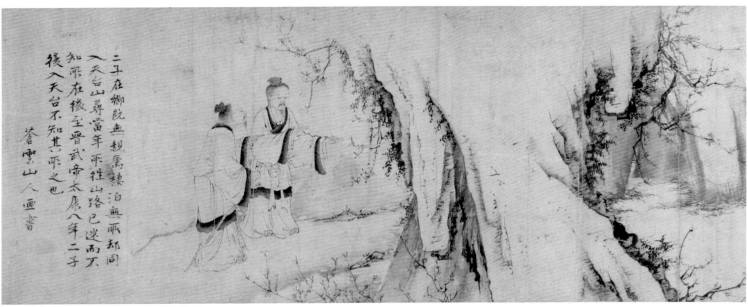

fig. 38 / Liu and Ruan attending a banquet of the immortals. Detail of Yuan dynasty, Zhao Cangyun, *Liu Chen and Ruan Zhao Entering the Tiantai Mountains*, late 13th or early 14th century. Ink on paper. The Metropolitan Museum of Art. Ex coll.: C.C. Wang Family, Gift of Oscar L. Tang Family, 2005 (2005.494.1)

fig. 39 / Exit from the realm of the immortals (right) and Liu and Ruan lost in the Tiantai Mountains (left). Detail of *Liu Chen and Ruan Zhao Entering the Tiantai Mountains*

of the Song royal clan and another by a painter active at the Yuan dynasty court, suggests the different subtexts that might have been at work in *Evening Literary Gathering*.

The first painting is a long narrative handscroll entitled *Liu Chen and Ruan Zhao Entering the Tiantai Mountains* (figs. 38–39).[66] The work presents, in pictures and text, the story of two Confucian gentlemen of the Eastern Han who set off to pick medicinal plants in the Tiantai Mountains of Zhejiang province. After filling their baskets with herbs, the pair find themselves lost and hungry. They descend the mountain and find a stream with food floating down it. Crossing the deep stream in search of a nearby domicile, the gentlemen happen upon a pair of enchanting ladies. The two ladies bring the gentlemen to their home, where a sumptuous outdoor feast takes place, attended by immortals bearing peaches of longevity (see fig. 38). Dissuaded by the ladies from leaving for half a year, the gentlemen finally bid farewell to the realm of immortals. Upon returning home, the men find that seven generations have passed. Alienated from their surroundings and now living under the reign of a new dynasty, the disillusioned men set out to return to the immortal realm. The inscription ends with the men disappearing into the mountains, the fate of their quest unknown.[67] The final image of the scroll shows the men's passage back to the immortals blocked by the mountain (see fig. 39).

The fantastical feast, set before a stairway in the courtyard of the two ladies, is worth returning to for a moment (see fig. 38). In the scene, the banquet is well underway. The two gentlemen, seated at the head and foot of a large straw mat, are served wine by the ladies. Four immortals, one strumming a *ruan* lute, are seated to the left and right of the gentlemen. They are attended by a host of maidservants. An array of different platters and bowls are spread out across the mat, including the famed peaches of immortality. The rustic setting of the picnic is far from the cultivated scholar's garden seen in *Evening Literary Gathering*. The magical occasion, filled with carefree immortals and enchanting ladies, belongs to the world of popular Daoism and male romantic fantasy.

The painting is signed Recluse Cangyun (*Cangyun shanren* 蒼雲山人). The colophon by Hua Youwu (1307–after 1386) identifies the painter as a member of the Song royal clan named Zhao Cangyun. Hua tells us the onetime famous artist never attempted to serve as an official, choosing instead to live in the mountains as a hermit.

The painting and colophon present us with a paradigmatic performance of Song loyalism under the Mongol regime. The Confucian protagonists in the painting, dislocated to a different dynasty and unable to escape from their estrangement, stand in for the disenchantment of the educated Han Chinese elite who lacked access to the higher levels of officialdom due to a Yuan bureaucratic structure in which they were subordinated or rejected altogether.

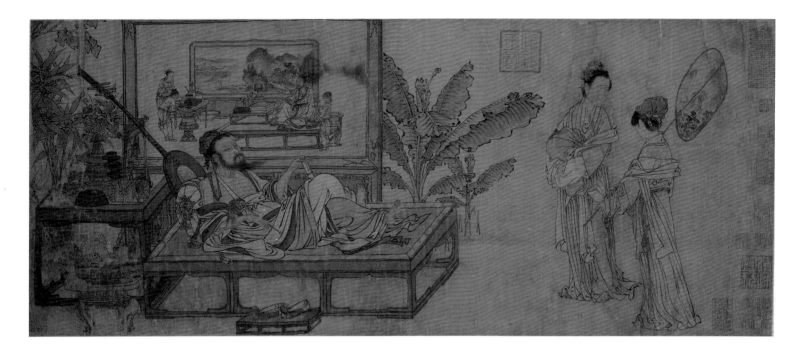

With the second Yuan painting, we move away from the realm of mountain hermits and into the sphere of the Yuan dynasty court. The handscroll *Whiling Away the Summer* (fig. 40), by Liu Guandao (active ca. 1275–1300), presents a leisurely gentleman reclining against a bolster on a bed placed in a garden filled with bamboo and banana plants. The man appears to be seeking respite from a hot summer's day: his slippers are off; his robes are loosened; a bowl of fruit sits on ice beside his bed; and a pair of female attendants stand before him, one holding a fan. The gentleman holds a fly whisk in one hand and a scroll in the other.[68] He has brought with him to the garden a full complement of scholarly accoutrements. On the bed and the table behind him, we find an inkstone, scrolls, an antique bronze bell, and a *ruan* lute.[69] Behind the bed, we look into a painting on a standing screen presenting a second image of the man. In the screen painting he sits on the same bed, in a study attended by three male servants. A small table beside him is set with brushes, books, and an inkstone. Another screen painting appears within the image — this time, a landscape.[70]

Liu Guandao was recorded to have worked in the court of the Yuan emperor Khubilai Khan (r. 1271–1294). As one of the painters employed by the Yuan court, Liu was responsible for imperial portraits and other subjects that appealed to his Mongol patrons. He is best known as a figural painter, but he also produced landscapes in the manner of the Northern Song master Guo Xi (ca. 1020–ca. 1090). The most famous painting attributed to Liu is *Khubilai Khan Hunting*, which portrays the ruler on horseback with a group of attendants.[71] (No subject appealed to the Mongol rulers so much as horses.) With

fig. 40 / Yuan dynasty, Liu Guandao (active ca. 1275–1300), *Whiling Away the Summer*, late 13th century. Ink and color on silk, 29.5 × 71.4 cm. The Nelson-Atkins Museum of Art, Kansas City. Purchase: William Rockhill Nelson Trust (48-5)

Liu Guandao's role as a court painter in mind, we may approach *Whiling Away the Summer* with an eye for its appeal to the audience he typically served. The elaborately descriptive work, which follows the Song figural-painting tradition (see cats. 21–22), holds none of the literati angst of Zhao Cangyun's scroll. Amid the host of erudite motifs presented in the painting, the carefree ease of the gentleman relaxing outdoors stands out. The figure could even represent a model of the perfectly detached mind of the reclusive scholar if not for his obvious attachment to the lady attendants standing before him.

These two Yuan paintings suggest possible approaches to interpreting *Evening Literary Gathering*. The central question before us is how we should read the painting. Is *Evening Literary Gathering* indeed a straightforwardly comic celebration of the camaraderie of the gentlemen attending the gathering, or instead a satiric indictment of dissolute literati? The question is difficult to answer without knowing the identity of the painter and the patron. If the artist belonged to the coterie of literati of which Zhao Cangyun was a part, we might be tempted to adopt a political view of the work, consonant with the sensibilities of *Liu Chen and Ruan Zhao Entering the Tiantai Mountains*.

Such a reading would observe that the gentlemen in *Evening Literary Gathering* have given up any pretense of engaging in the traditional cultivated activities of the literati. The men ignore their responsibilities, escaping from the burdens of life and taking refuge in one another's company. The men come together merely to banter, eat, and drink — the latter in particular. Throughout the painting, we see figures who have indulged in drink past the point of self-possession. Guests stagger home, fall asleep at the table, enter into altercations — all conduct that might seem worthy of reproach.

In this reading, an aura of disillusionment inflects the superficial charm of the scene. If we were to extend this political interpretation of the work, we would be forced to reflect on the general malaise that pervades the demeanor of these Yuan dynasty gentlemen. Ruled by Mongol emperors and lacking access to the prestige of officialdom, the gentlemen evince frustration with their diminished status. The painter's limiting of the guest count to eighteen allowed him to reinterpret the highly esteemed scholars of the Tang as eighteen dissolutes of the Yuan, abandoning scholarly pursuits as well as government service.

Another view would take the gentlemen in *Evening Literary Gathering* as bedfellows of the scholar *Whiling Away the Summer* in Liu Guandao's painting. In this interpretation, the work is seen as more purely comic than satiric, commemorating the joys and pitfalls of drink and banter among friends gathered for a feast. The key figure for this reading of the painting is the host, stationed at the first table (fig. 41). A fly whisk in one hand, the host acknowledges a guest who approaches with a toast. The self-possessed figure — an island of calm among the rowdy partiers — is a counterpart to the reclusive scholar in Liu Guandao's painting.

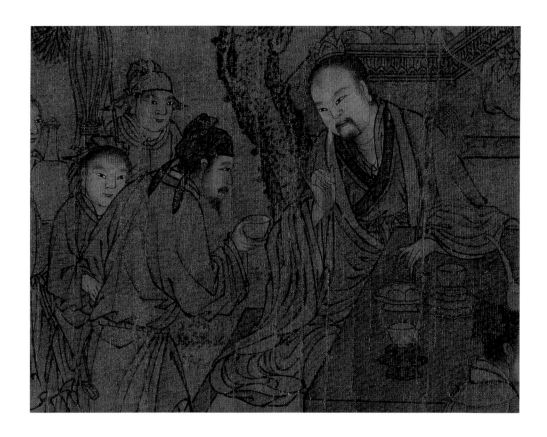

Further support for this reading comes from the stylistic similarity between *Evening Literary Gathering* and Liu Guandao's work. Before a signature was discovered within the painting in 1935, *Whiling Away the Summer* had been thought to be the work of the Southern Song court painter Liu Songnian. This specious attribution reminds us of the relative favor with which the tradition of Song figural painting was received at the Yuan court. The closeness of the two paintings suggests that their artists may have belonged to the same eclectic early Yuan court tradition. At the very least, *Evening Literary Gathering* could not be further removed from the mode of Yuan dynasty literati painting adhered to by Zhao Cangyun.

It is impossible to be certain of the intent behind *Evening Literary Gathering* without knowing more about the artist and his patron. Nonetheless, its apparent affinity to Liu Guandao's work suggests the possibility that the two paintings shared a similar kind of patron, whose interest lay in scenes of easy-going literati — erudition optional — whiling away their time. If the painting were indeed produced by an artist active at the Yuan court, its vision of scholar-gentlemen unencumbered by cares would also have carried a strong political subtext. Of course, still other interpretations of the painting are possible, and it should be noted that the comic and satiric readings considered here are not necessarily

fig. 41 / The host receiving a toast, detail of *Evening Literary Gathering* (cat. 33)

mutually exclusive. Nevertheless, if we were to draw a lesson from this review of tenth- to fourteenth-century paintings of gentlemen feasting, it would be that a gentlemen's feast is rarely just a feast: subtle political undercurrents were always potentially flowing just beneath the surface.

CONCLUSION

The centuries spanning the Liao, Jin, Song, and Yuan dynasties constitute a complex period that drastically reshaped the course of artistic patronage in China. On the one hand, extended periods of economic growth sustained the Song state and enriched the upper classes, ushering in a new age of artistic patronage underwritten by commissions from the state, religious institutions, and private individuals. On the other hand, political turmoil engendered by contact between Chinese states and their seminomadic neighbors to the north — contact that eventually resulted in the devastation of large parts of northern China and the complete submission of China to foreign rule — also deeply affected the nature of artistic patronage.

Throughout this period, feasts continued to lie at the heart of everyday life in China. They commemorated major life events, served as political theater, and satisfied religious obligations. These occasions, in turn, were critical in upholding and reordering the hierarchies — familial, religious, and political — around which society was organized. As such, tremendous artistic and financial resources were spent in supplying the necessary accoutrements for the feast. The objects in *The Eternal Feast* — ranging from the sumptuous textiles that clothed participants and furnished spaces to the sublime ceramic, lacquer, and metal vessels that delivered food and drink — convey the great scope of this tradition.

One of the most potent roles played by the feast was in relation to the afterlife. Many of the feast-related objects presented in this exhibition were originally buried in tombs for the benefit of the deceased. By the time of the Liao dynasty, the feast had come to occupy a complex role in preparations for the afterlife. This characteristic is seen most clearly in the depiction of feasts in Liao tomb art, exemplified by the set of wood-panel paintings from the Princeton and Cotsen collections (cats. 1–6). The feast preparation and attendant scenes in these panels project an image of a future feast that would not only provide nourishment to the deceased but also uphold their social rank in perpetuity.

As the importance of funerary feast scenes began to decline during the Song period, we find examples of the theme in paintings made for the living that explore new social and political dimensions. The early-twelfth-century painting *Palace Banquet* presents a grand banquet set in the inner quarters of a palatial

compound. In this rare example of ladies banqueting, the Song dynasty artist draws on both the figural-painting tradition of the Tang dynasty and more recent technical innovations in architectural painting. The fundamentally nostalgic image features plump figures styled in the fashion of Tang court ladies, with elaborate coiffures and long-flowing robes. However, the artist used the banquet setting to depart from the typical conventions of the court-lady painting genre. Positioning the viewer within the architecture of the inner quarters, the painter exploits the inherent organizational complexity of the large banquet to present a series of vignettes related to the occasion. These scenes, some with romantic overtones, convey a startlingly intimate view of the cloistered lives of court ladies. As an imagined banquet of the past that mixes romantic motifs with harmonious images of well-comported Tang dynasty ladies, *Palace Banquet* embodies the tension between the artist's competing obligations to entertain the patron while at the same time convey a socially acceptable didactic message of female conformity.

The Yuan dynasty handscroll *Evening Literary Gathering* depicts a party linked to the past by its allusion to the theme of the Eighteen Scholars of the Tang dynasty. The men are presented in an easygoing manner, enjoying the drink and banter afforded by the occasion of a feast. Without visual reference to the cultivated activities that would typically signify their literati identity, the painting's unusual treatment of its subject matter suggests political readings that correlate to the possible identities of the artist and the patron. This essay raises the possibility that the work may have been produced by a painter active at the Yuan court. Regardless, the scene's remarkably frank examination of the interactions among the gentlemen illuminates the ways in which the feast created and reinforced social bonds under highly gendered conditions.

One of the elements that connects these paintings of feasting to one another is the importance of the Tang dynasty as an artistic and cultural model for the artists and their audiences. The visual vocabulary of the painter responsible for the Liao dynasty wood-panel paintings is rooted firmly in the conventions of Tang mural painting. The figures of Tang court ladies in *Palace Banquet* speak both to the fundamental status of Tang ideals of femininity during the Song dynasty and to the continued influence of Tang figural painting. The reference in the Yuan dynasty painting *Evening Literary Gathering* to the theme of the Eighteen Scholars of the Tang dynasty also points to a fixation on the Tang as a paragon of cultural and political achievement.

These images of feasts from the tenth to the fourteenth century highlight some of the myriad ways in which artists adapted the theme to the changing requirements of their patrons as well as their own artistic goals. By linking the feast to the past even as they sought to address the present and the future, painters opened up new pathways for visual expression that redefined the artistic and cultural significance of the eternal feast.

1. For an overview of the art associated with Huizong, see Maggie Bickford, "Huizong's Paintings: Art and the Art of Emperorship," in *Emperor Huizong and Late Northern Song China: The Politics of Culture and the Culture of Politics*, ed. Patricia Buckley Ebrey and Maggie Bickford (Cambridge, MA: Harvard University Asia Center, 2006), 453–513.

2. Jacques Gernet, *Daily Life in China on the Eve of the Mongol Invasion, 1250–1276*, trans. H. M. Wright (Stanford, CA: Stanford University Press, 1962), 25. Gernet estimates the population of mid-thirteenth-century Hangzhou at over one million residents, dwarfing the size of contemporary cities in Europe.

3. For an overview of the Northern and Southern Song court painting traditions, see James Cahill, "The Imperial Painting Academy," in *Possessing the Past: Treasures from the National Palace Museum*, ed. Wen C. Fong and James C. Y. Watt (New York: Metropolitan Museum of Art, 1996), 159–99.

4. For an overview of Yuan imperial patronage of the arts, see Shane McCausland, *The Mongol Century: Visual Cultures of Yuan China, 1271–1368* (Honolulu: University of Hawaii Press, 2014).

5. The amateur pretensions of literati artists did not necessarily prevent them from drawing the bulk of their income from the largesse of their admirers, nor did it preclude them from court service. The distinction between amateur and professional painter as well as between literati and court artist was not always clear-cut. There was always a gap between rhetoric and reality. For an account of the financial realities behind the amateur ideal in later imperial periods, see James Cahill, *The Painter's Practice: How Artists Lived and Worked in Traditional China* (New York: Columbia University Press, 1994).

6. The distinction between amateur and professional painters that had emerged by the Yuan period began as a divide between court artists and scholar-officials in the Northern Song. As Wai-kam Ho writes, "There can be no doubt that among the many factors behind the rise of scholar-official painting in the late eleventh century, the one powerful impetus not to be neglected was the ardent desire of the scholar-artist to liberate and raise the art of painting from the stigma of a 'minor trade skill' by remodeling it (with an entirely new philosophic and aesthetic outlook) into a noble undertaking…respectable enough for the self-enjoyment and self-realization of the intellectuals." See Wai-kam Ho, "Aspects of Chinese Painting from 1100 to 1350," in *Eight Dynasties of Chinese Painting: The Collections of the Nelson-Atkins Museum, Kansas City, and the Cleveland Museum of Art* (Cleveland: Cleveland Museum of Art, 1980), xxix. The Mongol conquest of the Jin and Southern Song did not extinguish the artistic traditions that had developed at the two vanquished courts. Both northern and southern professionals found work under Yuan imperial patronage. Nonetheless, the revolutionary artistic ideas of the Yuan literati masters were to have the greatest impact on later Chinese painting. See Max Loehr, *Chinese Painting after Sung* (New Haven, CT: Yale University Press, 1967).

7. For the Yuan scholar-amateur tradition and its complicated relations to the Mongol court, see James Cahill, "The Yuan Dynasty (1271–1368)," in *Three Thousand Years of Chinese Painting*, ed. Richard M. Barnhart et al. (New Haven, CT: Yale University Press, 1997), 139–95.

8. For an overview of the Liao empire, see Denis Twitchett and Klaus-Peter Tietze, "The Liao," in *The Cambridge History of China,* vol 6., *Alien Regimes and Border States, 907–1368*, ed. Herbert Franke and Denis Twitchett (Cambridge: Cambridge University Press, 1994), 43–153.

9. Although Liao documents refer to the compensation as "tributes" (*gong* 貢), the wording of the agreement allowed the Song state to treat them as "annual payments" (*suibi* 歲幣), a less humiliating designation. See Hoyt Cleveland Tillman, "The Treaty of Shanyuan from the Perspectives of Western Scholars," *Sungkyun Journal of East Asian Studies* 5, no. 2 (2005): 135–55.

10. For the diplomatic and cultural relations between the Liao and Song states, see Tao Jing-shen, "Barbarians or Northerners: Northern Sung Images of the Khitans," in *China among Equals: The Middle Kingdom and Its Neighbors, 10th–14th Centuries*, ed. Morris Rossabi (Berkeley: University of California Press, 1983), 66–86; Herbert Franke, "Sung Embassies: Some General Observations," in Rossabi, *China among Equals,* 118–48. For trade relations between the Liao and Song, see Shiba Yoshinobu, "Sung Foreign Trade: Its Scope and Organization," in Rossabi, *China among Equals*, 89–115. For the history of the Shanyuan Covenant, see Wang Gungwu, "The Rhetoric of a Lesser Empire: Early Sung Relations with Its Neighbors," in Rossabi, *China among Equals*, 47–65.

11. For a detailed discussion of the shaping of Khitan identity, see Nicola Di Cosmo, "Liao History and Society," in *Gilded Splendor: Treasures of China's Liao Empire (907–1125)*, ed. Hsueh-man Shen (New York: Asia Society, 2006), 15–24.

12. Liu Xu et al., comps., *Jiu Tangshu* (Beijing: Zhonghua shuju, 1975), 1999:5350. For an overview of pre-dynastic Khitan burial customs, see François Louis, "Iconic Ancestors: Wire Mesh, Metal Masks, and Kitan Image Worship," *Journal of Song–Yuan Studies* 43 (2013): 91–115.

13. Louis, "Iconic Ancestors."

14. See Hebei sheng wenwu yanjiusuo, ed., *Xuanhua Liao mu, 1974–1993 nian kaogu fajue baogao* (Beijing: Wenwu chubanshe, 2001), 1:70. For Song burial practices, see Dieter Kuhn, "Decoding Tombs of the Song Elite," in *Burial in Song China*, ed. Dieter Kuhn (Heidelberg: Editio Forum, 1994), 15. For further information on Tang tombs, see Mary H. Fong, "Antecedents of Sui-Tang Burial Practices in Shaanxi," *Artibus Asiae* 51, nos. 3/4 (1991): 147–98.

15. The horizontal arrangement of the slats is noteworthy, as most surviving painted wooden panels from Liao dynasty tombs are formed of vertical slats. See Shen, *Gilded Splendor*, 206–9, 214–17.

16. The large quantity of vessels for a small gathering bespeaks a feast in which the libations flow freely. Although it is impossible to determine what drinks the feasters would be imbibing, wine and tea are the most likely possibilities.

17. Although sons were often responsible for the construction of their parents' tombs, others, including later descendants, sometimes shouldered the responsibility. Several of the Xuanhua tombs commissioned by the Liao official Zhang Shiqing, discussed below, provided for the reburial of grandparents or uncles. Zhang's outstanding role in the funerary provisions for his clan may be attributed, at least in part, to his great prestige within the family, as the only member holding an official title. For the Xuanhua tombs, see Hsueh-man Shen, "Body Matters: Manikin Burials in the Liao Tombs of Xuanhua, Hebei Province," *Artibus Asiae* 65, no. 1 (2005): 99–141.

18. Khitan men and women were skilled horse riders, an activity that required knee-length robes and tall boots regardless of gender. See Linda Cooke Johnson, *Women of the Conquest Dynasties: Gender and Identity in Liao and Jin China* (Honolulu: University of Hawaii Press, 2011), 35–37.

19. A painting from Xuanhua Tomb 4, which belonged not to a member of the Zhang clan but to Han Shixun (d. 1110), portrays a celebration for an elderly woman featuring a musician and attendants serving food and drink. See Hebei sheng wenwu yanjiusuo, *Xuanhua Liao mu*, 2:pl. 98.

20. Hebei sheng wenwu yanjiusuo, ed., *Xuanhua Liao mu bihua* (Beijing: Wenwu chubanshe, 2001), pl. 60; Shen, "Body Matters," 99.

21. See Hebei sheng wenwu yanjiusuo, *Xuanhua Liao mu*, pl. 34.

22. For an analysis of the tomb of Zhang Wenzao, including its syncretism, see Wu Hung, *The Art of the Yellow Springs: Understanding Chinese Tombs* (London: Reaktion, 2010), 224–33.

23. Four surviving fragments of the Southern Song dynasty handscroll are in the collection of the Museum of Fine Arts, Boston.

24. Henan sheng wenwu yanjiusuo, ed., *Mixian Dahuting Hanmu* (Beijing: Wenwu chubanshe, 1993). For a discussion of the Dahuting tombs, see Michèle Pirazzoli-t'Serstevens, "Two Eastern Han Sites: Dahuting and Houshiguo," in *China's Early Empires: A Re-appraisal*, ed. Michael Nylan and Michael Loewe (Cambridge: Cambridge University Press, 2010), 83–113.

25. Archaeologists tentatively identified the tombs as belonging to the Eastern Han official Zhang Boya and his wife. Tomb 1, thought to be Zhang Boya's, is one of the largest Eastern Han tombs yet discovered. The tombs are laid out as a domicile. Tomb 1 and Tomb 2 both consisted of a long passageway leading to a vestibule; an antechamber; and a large, vaulted central chamber corresponding to a reception hall. A room to the rear of the central chamber held the coffin. Two other side chambers corresponded to the kitchen and women's apartments; a third chamber corresponded to the carriage house, stable, and granary. The pictorial program of Tomb 1 was executed in stone relief, whereas Tomb 2 was decorated with a combination of polychrome and black-and-white mural paintings. Curtains and wooden panels thought to cover the walls of certain chambers in the tombs no longer survive. The pictorial programs of the tombs consist, in part, of images of the everyday life of an estate, including scenes of grain collection, food preparation, servants bringing food, guests arriving in carriages, and banqueting. See Pirazzoli-t'Serstevens, "Two Eastern Han Sites," 83–96.

26. For complicated ideological reasons, Song literati tombs began to eschew elaborate visual programs, breaking from the long tradition of pictorial tomb decoration that had developed from Eastern Han funerary art. The literati turn toward frugal burials was not necessarily followed in the tombs of other wealthy Song social groups, some of which continued to feature lavish pictorial decoration. See Jeehee Hong, *Theater of the Dead: A Social Turn in Chinese Funerary Art* (Honolulu: University of Hawaii Press, 2016), 9.

27. A musical ensemble, painted on the east wall of the chamber, opposite the couple's portraits, provided the meal's entertainment. See Su Bai, *Baisha Song mu* (Beijing: Wenwu chubanshe, 2002), pls. 4–5. The attendants in the scene parallel those in the Princeton panels (see cats. 1–2).

28. The tomb dates to 706, when Li Xian was reburied with honors by the Emperor Zhongzong (r. 684, 705–710). Sections of the murals were repainted in 711, when Li Xian's concubine was buried in the tomb. See Zhang Mingqia, *Zhanghuai taizi mu bihua* (Beijing: Wenwu chubanshe, 2002), 40–41.

29. See Hong, *Theater of the Dead*, 19.

30. Paul R. Goldin, "The Motif of the Woman in the Doorway and Related Imagery in Traditional Chinese Funerary Art," *Journal of the American Oriental Society* 121, no. 4 (October–December 2001): 539–48.

31. Nancy Shatzman Steinhardt, "The Architectural Landscape of the Liao and Underground Resonances," in Shen, *Gilded Splendor*, 47–48.

32. Steinhardt, "Architectural Landscape," 206–9.

33. The reconstructed box, with the horse and doorway panels serving as end panels, would measure roughly 103 by 204 centimeters. An inner-coffin box set in the Princeton collection (1995-101 a–m), which includes the other closed-doorway scene, would fit into this reconstructed outer-coffin box.

34. Charles D. Benn, *China's Golden Age: Everyday Life in Tang China* (New York: Oxford University Press, 2004), 20–22.

35. For a discussion of the dating and an analysis of the painting, see François Louis, "The 'Palace Concert' and Tang Material Culture," *Source: Notes in the History of Art* 24, no. 2 (2005): 42–49.

36. For an argument for the Song dynasty dating of the painting, see Zoe Song-Yi Kwok, "An Intimate View of the Inner Quarters: A Study of Court Women and Architecture in *Palace Banquet*" (PhD diss., Princeton University, 2013), 219–20.

37. For a study of Huizong's collecting, see Patricia Buckley Ebrey, *Accumulating Culture: The Collections of Emperor Huizong* (Seattle: University of Washington Press, 2008).

38. See *Xuanhe huapu* (Taipei: Taiwan Shangwu yinshuguan, 1971), 3:6, 10; 6:4; 7:5; 10:10; 16:7, 8, 18; 17:17, 18; 19:8.

39. Anita Chung, *Drawing Boundaries: Architectural Images in Qing China* (Honolulu: University of Hawaii Press, 2004), 9–44; Chen Yunru, "Jiehua zai Song Yuan shiqi de zhuanzhe: Yi Wang Zhenpeng de jiehua wei li," *Guoli Taiwan Daxue meishushi jikan* 26, no. 3 (2009): 135–92.

40. William Theodore de Bary, *The Message of the Mind in Neo-Confucianism* (New York: Columbia University Press, 1989), 1–23.

41. Kuhn, "Decoding Tombs of the Song Elite," 15.

42. In late-eleventh-century Liao tombs from Xuanhua, scenes of servants preparing tea, a beverage with strong connections to Buddhism, feature more prominently than scenes of food preparation. This emphasis may be attributed, in part, to the centrality of Buddhist beliefs in the religious thought of the Zhang and Han clans. Zhang Shiqing's epitaph discusses his devotion to Buddhism, including his recitation of Buddhist scriptures and donations to Buddhist monasteries. The murals in Zhang Shiqing's tomb also include a scene of Buddhist sutras being prepared for reading.

43. For the role of the Northern Song in the history of court painting, see Ho, "Aspects of Chinese Painting from 1100 to 1350," xxv–xxx. For Northern Song imperial ceramics, see Rose Kerr, *Song Dynasty Ceramics* (London: V & A Publications, 2004), 26.

44. Kwok, "An Intimate View of the Inner Quarters," 219–20.

45. The representation of the past and the tropes associated with images of Tang court ladies are further discussed in the catalogue entry for this painting (cat. 21).

46. Xu Daoxun, *Tang Minghuang yu Yang Guifei* (Beijing: Renmin chubanshe, 1990), 342–58; Virginia L. Bower, "Two Masterworks of Tang Ceramic Sculpture," *Orientations* 24, no. 6 (June 1993): 76.

47. For an in-depth discussion of the representation of architecture in *Palace Banquet*, see Kwok, "An Intimate View of the Inner Quarters," 36–105.

48. Maxwell K. Hearn, "Along the Riverbank," in Maxwell K. Hearn and Wen C. Fong, *Along the Riverbank: Chinese Paintings from the C. C. Wang Family Collection* (New York: Metropolitan Museum of Art, 1999), 59–71.

49. Hebei sheng wenwu yanjiusuo and Baoding shi wenwu guanlichu, eds., *Wudai Wang Chuzhi mu* (Beijing: Wenwu chubanshe, 1998), pl. 48.

50. Kwok, "An Intimate View of the Inner Quarters," 216–19.

51. Narrative readings of *Palace Banquet* have been offered by other scholars. For example, some interpret the painting as a depiction of celebrations related to the Seventh Eve Festival. See Hearn and Fong, *Along the Riverbank*, 58–71. For an argument against a narrative reading of the painting, see cat. 21 in this volume and Kwok, "An Intimate View of the Inner Quarters," 174–76.

52. Lara C. W. Blanchard, *Song Dynasty Figures of Longing and Desire: Gender and Interiority in Chinese Painting and Poetry* (Leiden: Brill, 2018), 126–37.

53. Priscilla Ching Chung, *Palace Women in the Northern Sung, 960–1126* (Leiden: Brill, 1981).

54. For the examples of Empress Liu (968–1033) and Empress Yang (see cat. 32), see Hui-shu Lee, *Empresses, Art, and Agency in Song Dynasty China* (Seattle: University of Washington Press, 2010). See also Heping Liu, "Empress Liu's *Icon of Maitreya*: Portraiture and Privacy at the Early Song Court," *Artibus Asiae* 63, no. 2 (2003): 129–90.

55. For a discussion of the origins of this genre, see James Cahill, *Pictures for Use and Pleasure: Vernacular Painting in High Qing China* (Berkeley: University of California Press, 2010).

56. For a comprehensive study of the scroll as it comes down to us today, see De-nin Lee, *The Night Banquet: A Chinese Scroll through Time* (Seattle: University of Washington Press, 2010).

57. Beverley Bossler, "Floating Sleeves, Willow Waists, and Dreams of Spring: Entertainment and Its Enemies in Song History and Historiography," in *Senses of the City: Perceptions of Hangzhou and Southern Song China, 1127–1279*, ed. Joseph S. C. Lam, Shuen-fu Lin, Christian de Pee, and Martin Powers (Hong Kong: Chinese University Press, 2017), 1–24.

58. The translations of both poems are by Patricia Buckley Ebrey. For a discussion of the painting and its inscriptions, see Patricia Buckley Ebrey, *Emperor Huizong* (Cambridge, MA: Harvard University Press, 2014), 209–10.

59. Bossler, "Floating Sleeves," 4.

60. Bickford, "Huizong's Paintings," 500.

61. For an overview of the topic, see Zhang Mengzhu, "'Shiba xueshi tu' yuanliu ji tuxiang yanjiu" (MA thesis, National Taiwan Normal University, 1998).

62. For a discussion of the Eighteen Scholars theme in Song painting, see Scarlett Jang, "Representations of Exemplary Scholar-Officials, Past and Present," in *Arts of the Sung and Yüan: Ritual, Ethnicity, and Style in Painting*, ed. Cary Y. Liu and Dora C. Y. Ching (Princeton: Princeton University Art Museum, 1999), 38–67. A copy of an Eighteen Scholars handscroll attributed to Huizong is in the National Palace Museum, Taipei.

63. For a discussion of the painting, see Jang, "Representations of Exemplary Scholar-Officials," 45.

64. For an illustration and discussion of the handscroll, see Jang, "Representations of Exemplary Scholar-Officials," 43–45.

65. For more on Guo Guan, see the catalogue entry for this painting (cat. 33).

66. For a discussion of the painting and its inscriptions, see Hearn and Fong, *Along the Riverbank*, 81–92, 148–51.

67. The inscription tells us that the gentlemen first set off on their journey into the mountains to collect herbs in the fifteenth year of the reign of Emperor Mingdi (r. AD 58–75) of the Eastern Han (AD 25–220). The inscription mistakenly refers to Mingdi's reign era as Yongan 永安 instead of Yongping 永平. (The earliest textual source for the story, the *Records of the Hidden and Visible Worlds* [*Youminglu* 幽明錄] of Liu Yiqing [403–444], gives the date as the fifth year of the Yongping era [AD 62].) The gentlemen return to the mountains to find the realm of the immortals in AD 287, the eighth year of the Taikang era (AD 280–289) of Emperor Wudi (r. AD 266–290) of the Western Jin dynasty (AD 265–317).

68. The presumed host in *Evening Literary Gathering* is also shown holding a fly whisk.

69. The same instrument is played by a figure at the banquet depicted in *Liu Chen and Ruan Zhao Entering the Tiantai Mountains*.

70. The handscroll is rife with allusions to famous sages and paintings. The double-screen motif is most closely associated with the Five Dynasties painter Zhou Wenju (see cats. 23–24). For a brief discussion of these allusions in the painting, see Maxwell K. Hearn, "Painting and Calligraphy under the Mongols," in *The World of Khubilai Khan: Chinese Art in the Yuan Dynasty*, ed. James C. Y. Watt (New York: Metropolitan Museum of Art, 2010), 218.

71. The painting, now in the National Palace Museum, Taipei, is dated to the spring of 1280, indicating the early date of Liu Guandao's service at the Yuan court.

Liao Coffin Box
Panels

These six painted wood panels, dating to the Liao dynasty, likely served as the walls of a rectangular coffin box. The precise arrangement of the panels is uncertain. The shorter ends of the box may have been composed of the two similarly sized panels depicting the horse and grooms and the doorway scene; the longer sides possibly consisted of a side-by-side pairing of one of the banquet-themed panels and an attendant scene.[1] This tentative reconstruction accords well with the dimensions of an outer coffin. Another set of Liao dynasty wood panels belonging to an inner coffin (fig. 42), also in the Princeton collection, would have fit comfortably into an outer coffin of this size.

The six panels are almost uniform in height, each measuring between sixty-seven and sixty-eight centimeters. Every panel is constructed of a stack of four horizontal wood planks of varying widths, the topmost plank generally the narrowest. The ends of each plank form a tenon meant to slot into the mortise joints of vertical posts, which would have secured the planks.[2] The surface of the panels was covered with a whitish-gray clay-based primer. The primer would have created a smooth, adherent surface on which to paint. The present mottled appearance of the panels seems to have been caused by oils from the wood seeping into the primer and causing it to stain. In several areas the primer has flaked off, resulting in further damage to the painting.

Unfortunately, almost nothing is known about the tomb occupant for whom the coffin panels were made or the artists who produced them. The only hints concerning the origin of the panels are found in the paintings themselves. In the panel featuring the four male attendants, the largest of the figures, standing on the far left, wears brown ankle-length robes cinched at the waist by a belt and a black hat with a small peak at the back. Based on the relative formality of the man's attire as well as his prominence within the composition, in terms of both positioning and scale, he appears to be the highest-ranking figure in the entire painting program of the six panels. The most likely identification for this attendant figure would be the sponsor of the tomb, perhaps the son of the tomb occupant.

Looking more closely at the figure, we find a host of features that help identify his ethnic and cultural affiliations. His wide cheeks, prominent nose, and thick eyebrows, similar to those of the three men standing behind him, mark his Khitan identity, as does his full beard, perhaps missing from the other male figures due to their youth. His right hand is curled into a thumb-raised fist encircled by the left hand, a distinctive gesture of respect.[3] The figure's Khitan features contrast with his dress: a high-collar and ankle-length robe cinched at the waist, and straw sandals. Unlike the Khitan youths behind him, who wear short robes and tall boots, the figure's attire seems more suitable to a rustic Chinese gentleman.

The two sturdy youths in green-and-brown robes to the right of the lead figure are clean-shaven, with their hair styled in typical Khitan fashion: closely cropped with a slightly longer fringe around the forehead and long forelocks past the front of their ears. The green-robed figure wears a hoop earring and holds his hands in the same respectful gesture as the lead figure. Both younger men wear knee-length robes cinched at the waist with fabric belts and tall boots. On the far right, the fourth and smallest figure is much less legible. He is dressed identically to the second and third figures but sports a soft hat tied under the chin. He also wears jewelry, a hoop earring and a simple bangle on his right wrist. It is also tempting to assume a familial relationship for the younger men in the image, perhaps grandsons of the deceased. However, the identification of any of the figures as descendants of the tomb occupant must remain conjectural. It is certainly also possible that all three of the figures depicted behind the lead figure are merely attendants or servants.

Three dogs accompany the scene. Below the second figure from the left is a short-legged, long-haired hound trotting along. Further right is a seated short-haired dog wearing a collar. Curled up behind the fourth man is a long-haired dog taking a nap. Along the far left of the panel, adjacent to the tenon, is a vertical band decorated in green and white, and other colors now faded. Resembling a painted column, this seemingly architectural motif also appears in the ladies' panel as well as some of the coffin posts that may have connected the panels.[4]

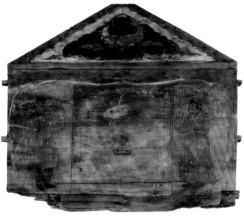

fig. 42 / Liao dynasty, *Endboard with Floral Motif* (above), *Endboard with Door and Attendants* (below), 10th–early 11th century. Wood with lacquer-based pigment, 48 × 57.8 × 2 cm (approx.), 55 × 65.6 × 2 cm (approx.). Princeton University Art Museum. Museum purchase, Fowler McCormick, Class of 1921, Fund (1995-101 a–e, j–m)

A similar hierarchical arrangement of figures is seen in the panel painting of four female attendants. Whereas the gentlemen all stand with their bodies turned to the panel's left edge, the ladies face in the opposite direction. Together, the panels form mirrored lines of standing attendants, similar to donor paintings seen in many caves at Dunhuang.[5] Following this logic, the largest figure in the ladies' panel, seen on the far right, might be the wife of the gentleman in the men's panel whom we tentatively identified as the tomb's sponsor. She is dressed and made up in the manner of a Tang dynasty lady. Her hairstyle echoes the fashion seen in the coiffures of *Palace Ladies Bathing Children* (cat. 22), a Song dynasty copy of a mid-Tang painting, with jeweled ornaments adorning the base of the top bun. Damage to the painting precludes a more detailed description of the jewelry. She wears loose, V-neck, long-sleeved robes cinched below her bust with a thin shawl tucked around her elbows, all in keeping with Tang costume. The robe is trimmed with a thick band of red-brown fabric, and the backs of her skirts are in the same dark hue. The top robe opens down the front, revealing toward the bottom an inner skirt with a large floral design with cusped border.[6] Throughout the Tang dynasty, shoes with an extravagantly upturned point at the end were de rigueur (see cat. 28). The thin, unadorned slippers worn by the lady in the Liao panel are more in line with Song dynasty fashion. Her feet do not appear to have been bound.

The lead figure carries a large conical bowl set in a cup stand, an offering possibly destined for the banquet. The other ladies in the scene also bear vessels: bowls on cusped stands. A ladle rests in the second lady's bowl (see cat. 13 for a similar utensil). The third lady carries a lidded bowl. As in the gentlemen's panel, the female figures following the highest-ranked lady are progressively smaller in stature and more simply attired. The same contrast also applies to the formal Chinese attire of the largest figure versus the Khitan dress of the smaller figures. The brown and uncolored V-neck robes of the two ladies to the left of the lead figure sport close-fitting sleeves and are cinched below the bust by a wide, long cloth belt tied in front. Close-fitting, high-neck undershirts are visible beneath their dresses. Simple shoes appear below the ankle-length robes. Their hairstyles are also Khitan: a short, straight fringe with the remaining hair swept back in a low, tight bun.

The fourth figure, farthest to the left, is unfortunately obscured by damage to the painting. The youthful figure bears a small lidded bowl and is dressed in clothing seemingly appropriate to a Khitan male: a knee-length robe fastened with a belt and tall, dark boots. Khitan women were skilled horseback riders, an activity that often called for male dress. The location of the belt suggests that the figure may be a woman dressed in men's clothing. The belt is cinched at the natural waistline, as opposed to the dropped-waist position seen in the figures wearing Khitan dress in the men's panel. Both the vertical band of decoration on the far right of the scene and the appearance of three dogs of different breeds below the women echo motifs seen in the men's panel.

Both attendant scenes seem to have been painted in a simple, two-step procedure that was used consistently throughout all the panels. First, the artist outlined the figures, objects, and landscape in ink, later filling in areas with color of a variety of pigments. Not all of the pigments survive. In the attendant panels, brown and bluish-green washes appear in the robes of the figures and the vertical decorated bands. Other hues, perhaps lighter or less saturated, have faded beyond recognition, making it difficult to determine which areas were intended to carry colored pigments and which were meant to remain in the white color of the primer. In many areas the pigments and primer have faded, leaving only the darkened brown tones of the wood grain. The complex drapery of certain figures' robes and sashes, drawn in confident black lines, suggests that even if these areas were intended to have carried a wash of pigment, the hue would have been light enough to allow these details to be legible.

The two panels portraying the outside banquet tables are described in detail in this volume's main essay.[7] The following comments will focus primarily on a general description of the figures and the objects. *Preparing for an Outdoor Banquet* presents a scene of five male figures busily engaged with the work indicated by the title. The pastoral location is depicted by a series of roughly outlined hills in the background, embellished with a few swirls of clouds and a flock of birds heading into the distance. In the foreground, two men move a fully set banquet table followed by two more attendants carrying large vessels. Another figure

Cat. 1 Liao dynasty
Coffin Box Panel: Gentlemen Attendants
10th–early 11th century
Wood with lacquer-based pigment
67 × 89.5 × 2 cm (approx.)
The Collection of Lloyd Cotsen

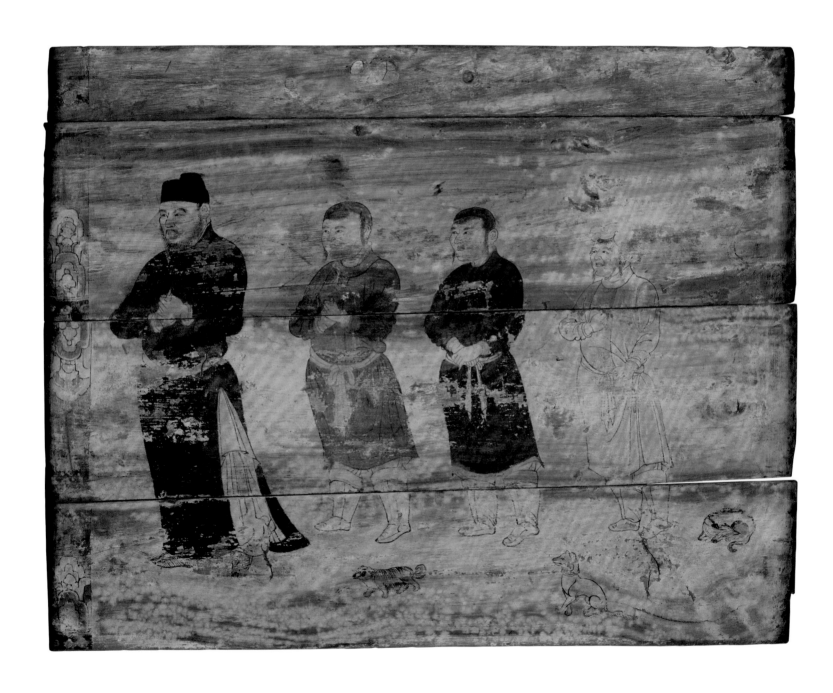

Cat. 2 Liao dynasty
Coffin Box Panel: Attendants Bearing Offerings
10th–early 11th century
Wood with lacquer-based pigment
67 × 89.5 × 2 cm (approx.)
Princeton University Art Museum.
Museum purchase, Fowler McCormick,
Class of 1921, Fund (1995-87)

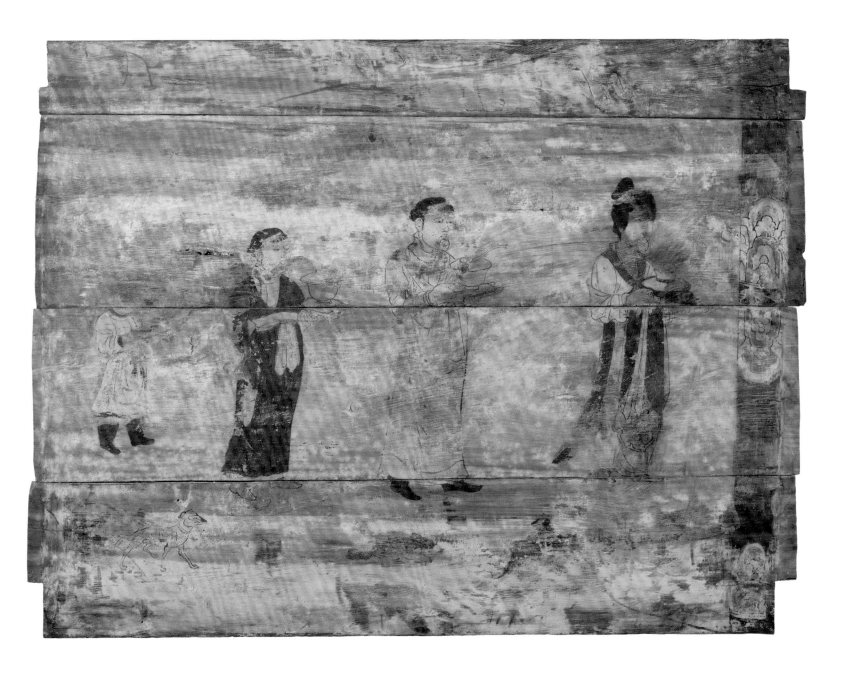

to their left directs the proceedings, gesturing with an outstretched arm as he shouts commands. The banquet table is set with an arrangement of vessels for beverages set on stands, including ewers, bowls, and cups. Counterparts for several of these objects are included in this exhibition (see cats. 8–11, 17).

The men are attired in a manner similar to the figures in Khitan dress in the previously discussed male attendants' panel. Their robes are hitched up into their belts to allow a greater range of movement. Three attendants, one moving the table with his sleeves rolled up and the other two carrying large, long-necked vases, are bareheaded, perhaps indicating their lower rank. They are portrayed in identical costumes of blue or uncolored robes and thick boots. Their Khitan hairstyles match those seen in the attendants panel. Two apparently higher-ranking men wear hats. The figure instructing the other attendants dons a soft black cap with straps tied above the head instead of under the chin. A whiskered man helping to carry the table wears a black hat; his straw sandals match those of the lead figure in the gentlemen attendants' panel. Three dogs, including a puppy, accompany the scene.

Positioned amid a similar landscape of hills, clouds, and birds as the previous panel, *Arranging an Outdoor Banquet* presents four men setting a banquet table with platters and bowls set on stands. The contents of the three bowls, two of which are lidded, are unclear. Two platters filled with food, one perhaps holding stone fruit, sit next to them. Approaching the table from the right, an attendant, clad in a robe, tall boots, and a soft black hat, bears a large bowl in one hand and a pot in the other. At the center of the image, two figures are busy setting the low banquet table. A clean-shaven man with a hat fastened by straps running under his chin kneels to the left of the table, his right leg stretched out in front of him. With a bowl in his right hand, he looks across the table to a figure gesturing toward him. Kneeling by the table on the right, this bearded figure, dressed in a blue robe, boots, and black hat, seems to be providing instructions for the setting of

the table. He points with his left hand in the direction of the table, extending the open palm of his right hand toward the vessels. The expressive faces of the two kneeling figures suggest a wry rapport. On the far left, another whiskered figure in blue robes looks back at the three other attendants, overseeing their work. Three lively dogs flit around the men set in their chores.

Unlike the attendant panels, which present figures with an almost hieratic austerity, the banquet preparation scenes, with their humble goings-on, provide the artist with ample opportunity to render lively action and engaging personalities. In both panels the faces and body language of the figures, communicated with an economy of simple black-ink lines, suggest the work of an artist (or artists) with a talent for careful characterization.

The finely painted panel *Four Figures Flanking a Doorway* centers on a single closed portal set on a low masonry platform and surrounded by a symmetrical arrangement of trees, dogs, birds, and pairs of male figures. The heavy red doors feature black ironwork handles, studs, and hinges. A red lintel overhangs the thin walls framing the doors. Four narrow steps lead up the platform to the doorway, which appears to be unconnected to any wall or building. Doors are a common motif in funerary paintings, symbolizing the transition between the realm of the living and the afterlife.[8]

A pair of boys sit flanking the doorway, their youth indicated by their small stature. Both sport the Khitan hairstyle worn by figures in the other panels. The boy on the right strums a square-bodied, long-necked lute. On the opposite side of the door, a blue-robed boy chews on a stick. A pair of dogs strike alert poses next to each boy. The youths' casual demeanor contrasts with the more earnest expressions of the pair of standing figures. The man on the left holds his hands clasped together as he gazes at the doorway. His Khitan garb and hairstyle match those of the two boys. The goateed figure on the right wears a soft black hat fastened under the chin. He leans forward slightly with his arms raised and his hands clasped together in the same distinctive gesture of respect as that of the lead figures in the gentlemen attendants' panel. Two lush trees with closely spaced leaves stand behind each man.

In the sky above the door lintel, two pairs of elegantly drawn cranes and magpies take flight. The geometry of the parallel diagonal bodies of these talismanic birds no doubt owes something to the motif's popularity in woven textile designs. A Liao fragment included in this exhibition features a similarly arranged pair of facing cranes (cat. 19). However, the most famous and elaborate realization of the "bird rising over architecture" compositional conceit is surely the painting attributed to the Song dynasty emperor Huizong (r. 1101–1126) entitled *Auspicious Cranes*. Dated 1112, it portrays a baroque formation of twenty cranes above a grand palace roof encircled by clouds.[9]

The sixth panel features a splendidly caparisoned horse and two grooms, a popular theme in Liao funerary art.[10] Horses were vital possessions among the seminomadic tribes that lived in the vast steppe region to the north of China. A nomadic lifestyle necessitated constant movement across great tracts of land. For that the Khitan needed strong, sturdy horses as well as superior riding skills. Their proficiency in hunting and fighting on horseback enabled them to pose a serious military threat to their Chinese neighbors to the south.

This imposing steed is presented riderless, presumably awaiting the tomb occupant for their journey onward.[11] Colored with a wash of deep-brown pigment, the horse bears a typical Khitan saddle with a sumptuous textile draped over it. Probably intended to depict a thickly woven carpet, the saddlecloth's multicolored design features a standing bird with outstretched wings over a background of swirling blue, green, and white clouds and a wide, ornamented border with large hanging tassels. The horse has cropped ears and a docked tail bound with ribbon, signs of the steed's careful grooming.

The horse's bridle is held by a mustachioed groom outfitted in a black hat, robe, and straw sandals. A band of cross-hatched fabric runs down the length of the front of his robe, an embellishment to the outfit that possibly reflects a high rank in accordance with his important duties. He holds a

crop in his left hand. Behind the horse stands a clean-shaven second groom. Clearly the junior attendant, he wears a similar but simpler outfit. A tiny pot suspended by a thin cord hangs from his right hand. Above the scene, three small red-and-black-cloud scrolls adorn the top board of the panel.

There is no sign that colored pigment once covered the outfits of either of the grooms. The calligraphic flair with which the artist rendered their drapery suggests that any obscuring wash of dark pigment may have been undesirable. The artist's skilled draftsmanship is on display throughout the image, from the sinuous legs and upturned hoof of the horse to the commanding expression of the lead groom, demonstrating the high level of artistic achievement attained by Liao painting workshops.

NOTES

1. Other Liao coffin-endboard panels in the Princeton collection feature doorway scenes (see fig. 42).

2. A number of vertical timbers with mortise joints in the Princeton collection were likely used in the assembly of this coffin (1995-91–97).

3. See p. 40 in this volume.

4. See Princeton University Art Museum 1995-91–97.

5. Dunhuang, in Gansu province, is home to a largely Buddhist site that includes hundreds of caves with brightly colored sculpture and wall painting dating roughly from the middle of the fourth to the fourteenth century. Many date to the Tang dynasty. See Caves 61, 62, 220, and 285, among many other examples (Robert Sharf, "Art in the Dark: The Ritual Context of Buddhist Caves in Western China," in *Art of Merit: Studies in Buddhist Art and Its Conservation*, ed. David Park, Kuenga Wangmo, and Sharon Cather [London: Courtauld Institute of Art, 2013], 38–65). See also a painting from the Library Cave at Dunhuang now in the British Museum (1919,0101,0.54).

6. A similarly attired lady with decorative underskirts is seen on a Liao dynasty painted wood panel excavated in Sumuzuoai village, Balin Right Banner, Chifeng city, Inner Mongolia (see Shenzhen bowuguan and Neimenggu bowuyuan, *Qidan Feng Yun: Neimenggu Liaodai wenwu zhenpin zhan* [Beijing: Wenwu chubanshe, 2011], 96). It is also possible, though less likely, that the fabric belongs to a decorative sash hanging in front of the outer robe. For decorative sashes, see the female figures in *Tejaprabha Buddha and the Five Planets*, 897, from the Library Cave, Dunhuang, now in the British Museum (1919,0101,0.31).

7. See pp. 39–40.

8. A comparable closed-doorway scene is found in another Princeton Liao panel (fig. 42). See also Princeton University Art Museum 1995-99 a–d.

9. For a discussion of the painting, see Peter C. Sturman, "*Cranes above Kaifeng:* The Auspicious Image at the Court of Huizong," *Ars Orientalis* 20 (1990): 33–68.

10. See the tomb of the Princess of Chen and her husband at Sibugetu village, Qinglongshanzhen, Naiman Banner, Inner Mongolia, Liao dynasty, 1018 (Xu Guangji, *Zhongguo chutu bihua quanji*, 10 vols. [Beijing: Kexue chubanshe, 2012], 3:90). See also Tomb 1 at Baoshan village, Dongshaburitaixiang, Ar Horqin Banner, Inner Mongolia, Liao dynasty, 923 (Xu, *Zhongguo chutu bihua quanji*, 3:73).

11. See p. 47 in this volume.

Cat. 3 Liao dynasty
Coffin Box Panel: Preparing for an Outdoor Banquet, 10th–early 11th century
Wood with lacquer-based pigment
67 × 115 × 2 cm (approx.)
Princeton University Art Museum.
Museum purchase, Fowler McCormick,
Class of 1921, Fund (1995-90)

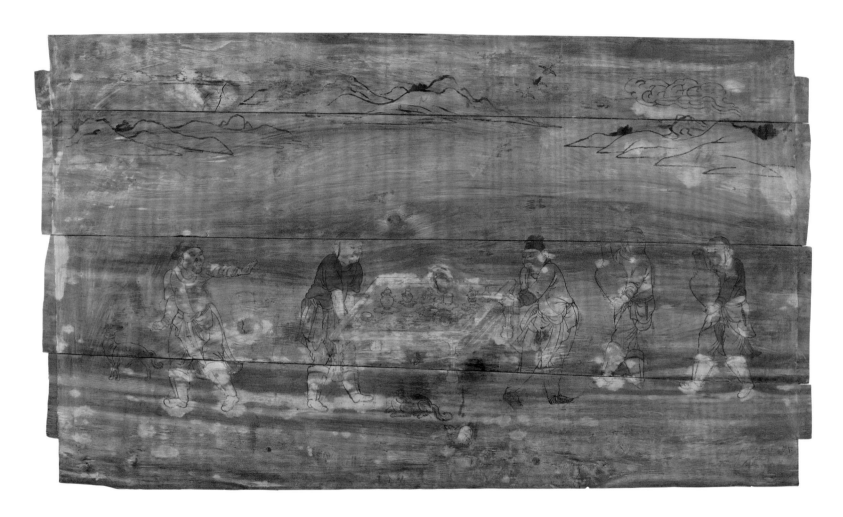

Cat. 4 Liao dynasty
Coffin Box Panel: Arranging an Outdoor Banquet
10th–early 11th century
Wood with lacquer-based pigment
67 × 115 × 2 cm (approx.)
Princeton University Art Museum.
Museum purchase, Fowler McCormick,
Class of 1921, Fund (1995-86)

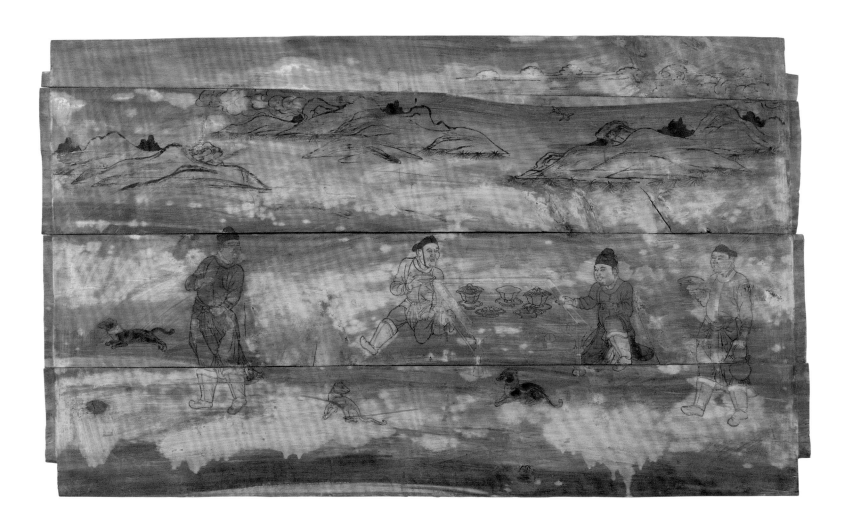

Cat. 5 Liao dynasty
 *Coffin Box Panel: Four Figures Flanking
 a Doorway*, 10th–early 11th century
 Wood with lacquer-based pigment
 67.3 × 102.3 × 2.1 cm (approx.)
 Princeton University Art Museum.
 Museum purchase, Fowler McCormick,
 Class of 1921, Fund (1995-89)

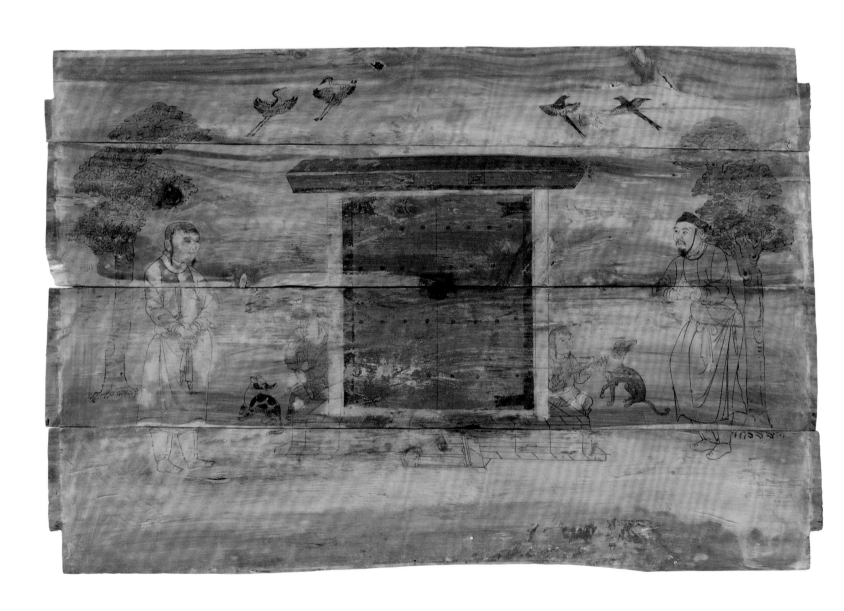

Cat. 6 Liao dynasty
 Coffin Box Panel: Horse and Grooms
 10th–early 11th century
 Wood with lacquer-based pigment
 68 × 102.9 × 2.4 cm (approx.)
 Princeton University Art Museum.
 Museum purchase, Fowler McCormick,
 Class of 1921, Fund (1995-88)

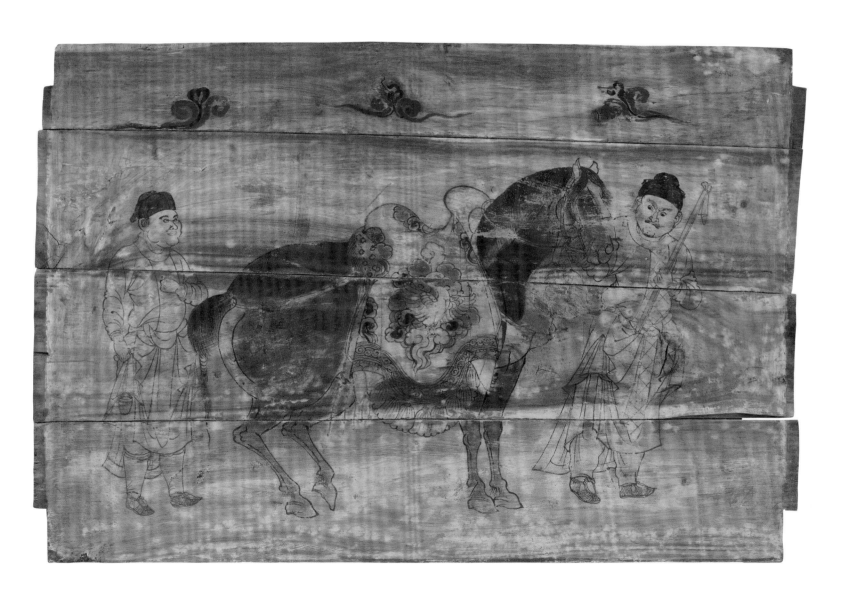

Cat. 7 Ming dynasty
After a Southern Song court painter
*Eighteen Songs of a Nomad Flute: The Story
of Lady Wenji*, early 15th century
Handscroll; ink, color, and gold on silk
28.6 × 1196.3 cm (painting);
29.2 × 1544.5 cm (overall)
The Metropolitan Museum of Art, New York.
Ex coll.: C.C. Wang Family,
Gift of The Dillon Fund, 1973 (1973.120.3)

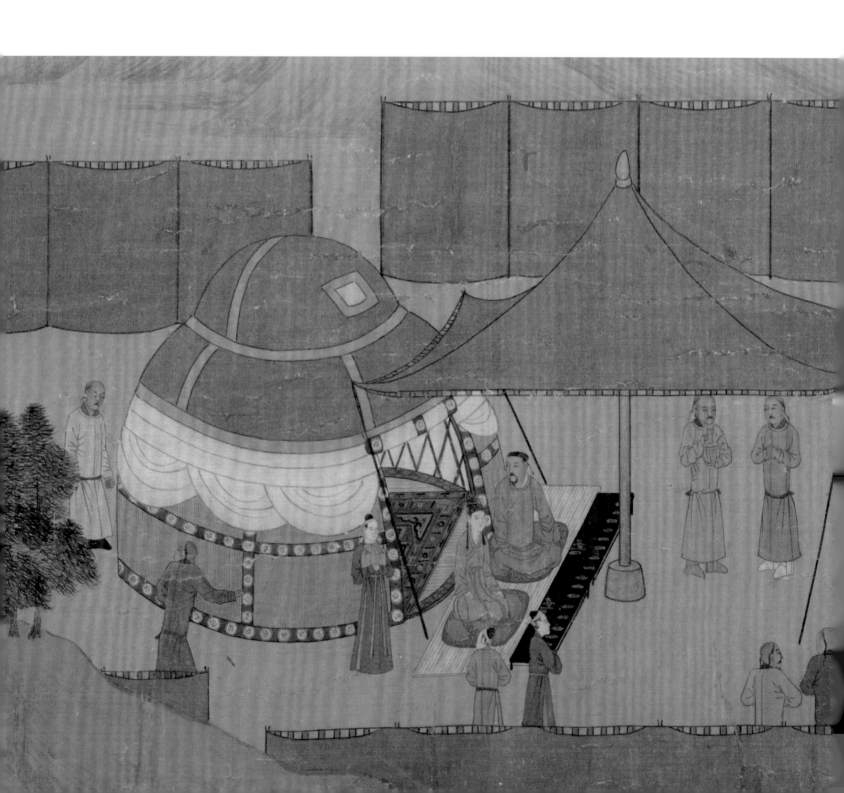

These three feast scenes belong to a scroll illustrating a song cycle composed by the eighth-century poet Liu Shang. Liu's verses retell the story of Cai Wenji, daughter of a prominent Han dynasty official. Lady Wenji was taken from her home in AD 195 by invading Xiongnu tribesmen. A captive for twelve years in Xiongnu territory in present-day Inner Mongolia, she was compelled to marry a chieftain, with whom she bore two sons before being ransomed and returned home to China, leaving behind her Xiongnu husband and children.

This scroll, which dates from the early fifteenth century, is a copy of a painting produced by court artists working at the behest of the Southern Song emperor Gaozong (r. 1127–1162).[1] For a Song dynasty audience, the well-known story of Lady Wenji was an integral part of the cultural memory surrounding the centuries-old tensions between the Chinese and their tribal neighbors to the north. By the early twelfth century, these tensions again reached a crisis point, leading to a war between the armies of the Song dynasty and the formerly allied Jurchen-led Jin dynasty. Beginning in 1125 the Jin invaded the Song, laying siege to the Song capital, Kaifeng, taking the city two years later. Amid the plundering of Kaifeng the Jurchen army took hostage the Song imperial family, including the former Emperor Huizong (r. 1101–1126) and his newly enthroned son. Huizong's ninth son, however, fled south, establishing a new Song capital at Hangzhou, where he reigned as Emperor Gaozong. With half of Song territory now lost and most of Huizong's family captive to northern invaders (he died after eight years as a Jurchen captive), the anguish and humiliation suffered by Lady Wenji would have resonated deeply with the first Southern Song emperor.

There are many historical layers to the present work. It depicts a third-century autobiographical story of northern nomads written by a Chinese lady, retold in the verses of a Tang dynasty poet and represented using the visual language

available to a Song dynasty painter, and finally copied by a Ming dynasty artist. In this scroll the nomadic captors of Lady Wenji are portrayed as Khitans, former nomadic antagonists of the Song, who were themselves overrun by the Jurchens in the early twelfth century.[2] The Song dynasty artist of the original scroll clearly had some insider knowledge of these northern tribesmen. The figures and activities in the feasts presented in the third, fifth, and seventh scenes are consistent with representations in Khitan art, including Princeton's Liao coffin panels (cats. 1–6).

The third scene (p. 95, bottom) comes at an early point in Lady Wenji's captivity. The temporary camp is viewed from the side. Wenji and her husband sit next to each other on cushions placed on a carpet in front of a pair of adjacent low tables. These tables are set with a long row of neatly arranged small plates. A matching service set consisting of a cup on stand, plate, and chopsticks is placed before each diner. The formal quality of the arrangement, including Chinese utensils, perhaps hints either at the Xiongnu chieftain's desire to impress his new wife or the artist's concessions to his Chinese audience. Several attendants stand by, one carrying a large metal ewer. The number of small plates on the table point to a meal of several different dishes. The scene shares parallels with the feast depicted in the Princeton Liao panels. Both take place out of doors, with participants seated on the ground and attended by several servants. In a break with Khitan practice, however, the Chinese artist depicts Lady Wenji seated to the left of her husband, the traditional Chinese seating arrangement for husband and wife.[3]

The fifth scene (p. 94) changes to a different location, but again we find a similarly organized feast. The frontal vantage point has also shifted to align with the central axis of the camp. Fewer attendants now wait upon the Khitan chief and Lady Wenji, suggesting the two are sharing a more intimate meal—a feeling echoed by the mundane goings-on of the camp portrayed beyond the view of the couple. In the lower left of the scene, shielded behind one of the camp's many large curtains, we see an outside kitchen with one seated servant preparing food and another tending to a cauldron of stewing meat.[4] Above to the right, the couple's riding horses graze before a curtain enclosing wagons and cattle.

The last feast scene (p. 95, top) illustrates the seventh song: "Concert in the Steppe." For this feast, Lady Wenji and her husband are joined by five guests seated in two rows, forming a U-shaped arrangement. Although most of the figures seated before the couple seem to be playing musical instruments, they are nonetheless seated before low tables laid with small dishes and individual settings in the manner of guests. The concert is clearly a prelude to the meal. One attendant approaches from behind the tent bearing two haunches of meat on a platter. Another stands in front of the canopy holding a metal ewer, which is also shown in the other feast scenes.

NOTES

1. The Southern Song scroll now only survives in four fragments, without inscriptions, in the collection of the Museum of Fine Arts, Boston (28.62, 28.63, 28.64, 28.65). See pp. 42–45 in this volume. The calligraphy of the poems inscribed next to the paintings in this Ming dynasty copy are modeled on the style of Emperor Gaozong. The inscriptions appear to have been at least partially traced rather than written freehand. See the introduction to Robert A. Rorex and Wen Fong, *The Story of Lady Wenchi: A Fourteenth Century Handscroll in the Metropolitan Museum of Art* (New York: New York Graphic Society, 1974); translations of the poems accompanying each painting in the scroll are given in Rorex and Fong, *The Story of Lady Wenchi*. During his reign, Emperor Gaozong sponsored the production of multiple narrative handscrolls illustrating classical texts and famous historical subjects as part of a government propaganda program honoring his restoration of the Song dynasty. See also *Odes of the State of Bin* (cat. 34).

2. The uneasy truce between the Southern Song and the powerful Jin dynasty would have made it politically inadvisable to directly portray Lady Wenji's captors as Jurchen. See Wu Tong, *Tales from the Land of Dragons: 1,000 Years of Chinese Painting* (Boston: Museum of Fine Arts, Boston, 1997), 146.

3. Tong, *Tales from the Land of Dragons*, 146.

4. The Ming copyist failed to depict the stick used by the servant to stoke the cauldron's fire, seen in a fragment from the original painting now in the Museum of Fine Arts, Boston; see fig. 20.

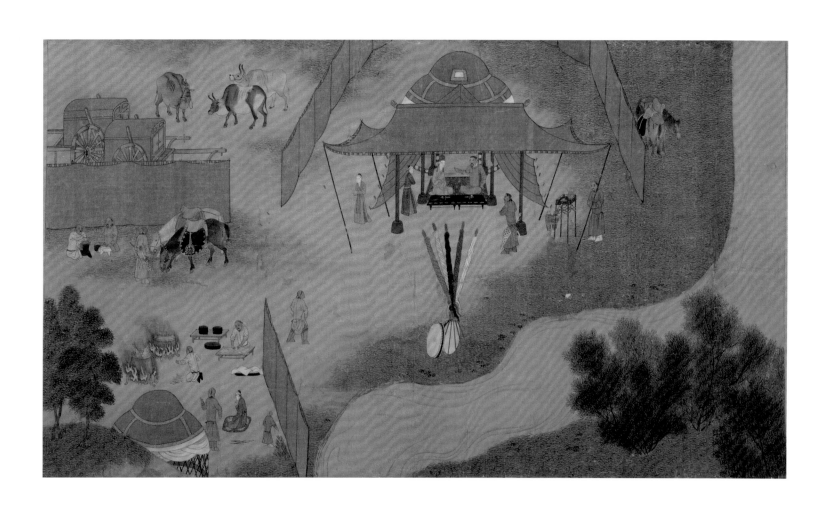

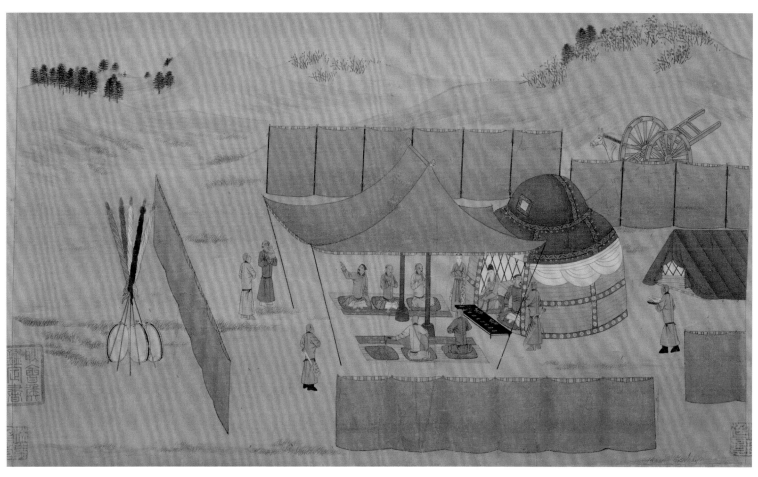

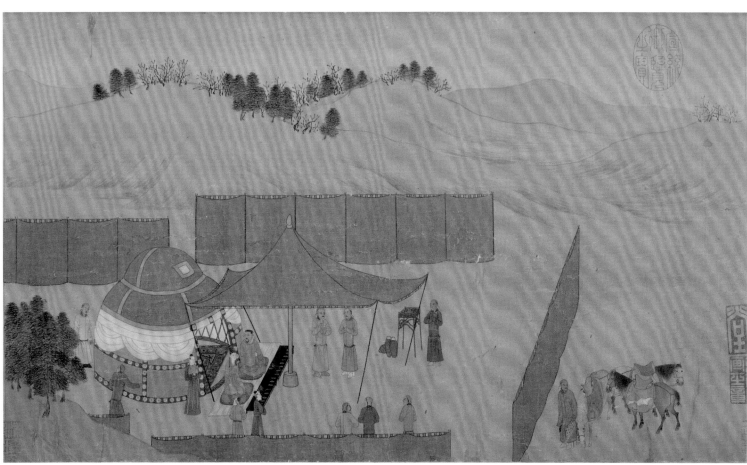

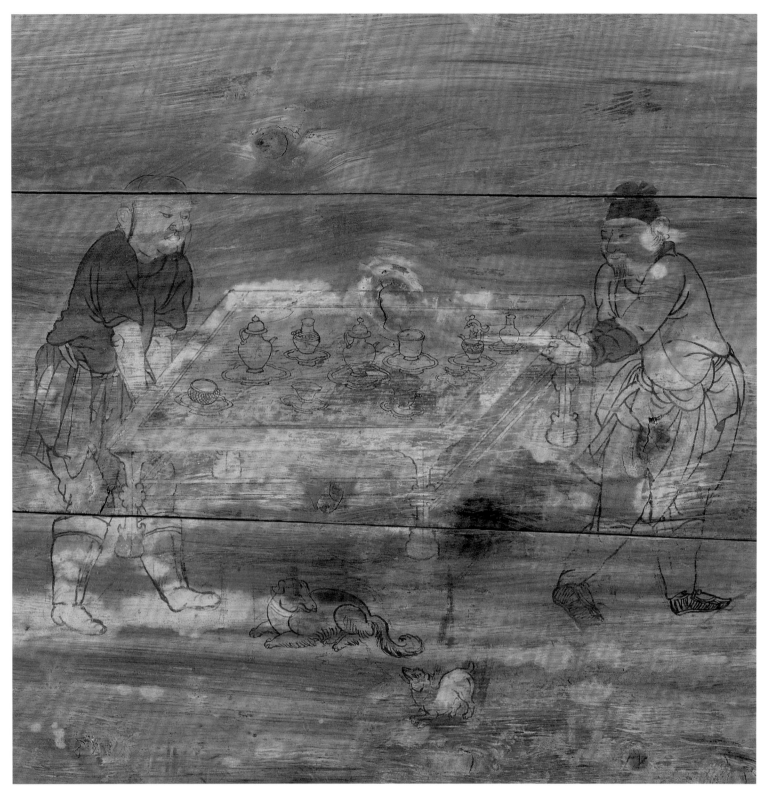

fig. 43 / Detail of *Preparing for an Outdoor Banquet* (cat. 3)

Lobed Wine Cups on Matching Stands

These two lobed wine cups on matching stands, one in silver and one in porcelain, attest to the popularity of the form during the Song period. The use of matching cup-and-stand sets had already become widespread during the Tang dynasty. Although some of the finest surviving examples from the Tang are metalware, the prestige material of the time, by the Song dynasty porcelain sets had surpassed metalware versions in popularity among the elite class.

This silver set demonstrates the continued appreciation for fine metalware after the fall of the Tang. Deep vertical grooves around the circumference of the cup delineate the five lobes that give the cup its floral character. Set on a flared ring foot, the stand echoes the cup's design, with five notches along the rim. At the stand's center, a band of lotus petals encircles the recessed pedestal on which the cup sits. The top of the pedestal is shaped as a lotus seedpod with incised details. An undeciphered glyph, likely an artisan or workshop mark, is incised on the bottom of the cup.

The porcelain wine cup and stand are examples of *qingbai* ("bluish white") ware produced at the Hutian kilns in the southern province of Jiangxi.[1] This set's translucent icy-blue glaze and its thinly potted form attest to the great skill of *qingbai* potters. Six petal-shaped lobes sprout from a delicately proportioned ring foot. The cup sits on a dish-shaped stand set atop a tall pedestal base of six petals with trefoiled cutouts.[2] The cusped rim of the stand echoes the six-petal theme of the cup and base.

The use of similar cups with stands in the Liao is amply illustrated in *Preparing for an Outdoor Banquet* (cat. 3). A porcelain cup and stand strikingly similar to this one is depicted in the painting at the center of the nearest row of objects on the table (fig. 43). To its left in the same row is a metal cup and stand. The appearance of fine porcelain and silverware in the painting speaks to the Liao elite's taste, shared by their Song counterparts, for luxury tableware.

NOTES

1. For close examples, see Regina Krahl, *Chinese Ceramics from the Meiyingtang Collection*, 2 vols. (London: Azimuth Editions, 1994), 1:317n593; and *Tōkyō Kokuritsu Hakubutsukan zuhan mokuroku: Chūgoku tōji hen* (Illustrated Catalogues of the Tokyo National Museum: Chinese Ceramics), 2 vols. (Tokyo: Tōkyō Bijutsu, 1988), 1:99, cat. 390.

2. A slight difference in glaze color between the cup and the stand may have resulted from their having been fired in different kiln positions.

Cat. 8 Northern Song dynasty
Flower-Shaped Wine Cup and Stand
Silver with repoussé and chased decoration
H. 4.4 cm, diam. 8.6 cm (cup);
H. 3.1 cm, diam. 15 cm (stand)
Princeton University Art Museum.
Museum purchase, Fowler McCormick,
Class of 1921, Fund (2002-136 a–b)

Cat. 9 Northern Song dynasty
Flower-Shaped Wine Cup and Stand
Qingbai ware; porcelain with sky-blue glaze
H. 4.4 cm, diam. 11.1 cm (cup);
H. 4.1 cm, diam. 14.6 cm (stand)
Princeton University Art Museum.
Museum purchase, Fowler McCormick,
Class of 1921, Fund (2002-135 a–b)

Cat. 10 Five Dynasties–Northern Song dynasty
Inscribed Green-Glazed Ewer and Cover
10th–11th century
Glazed stoneware
H. 21.5 cm, diam. 14.1 cm
Princeton University Art Museum.
Museum purchase, Hugh Leander Adams,
Mary Trumbull Adams, and Hugh Trumbull
Adams Princeton Art Fund (2018-135 a–b)

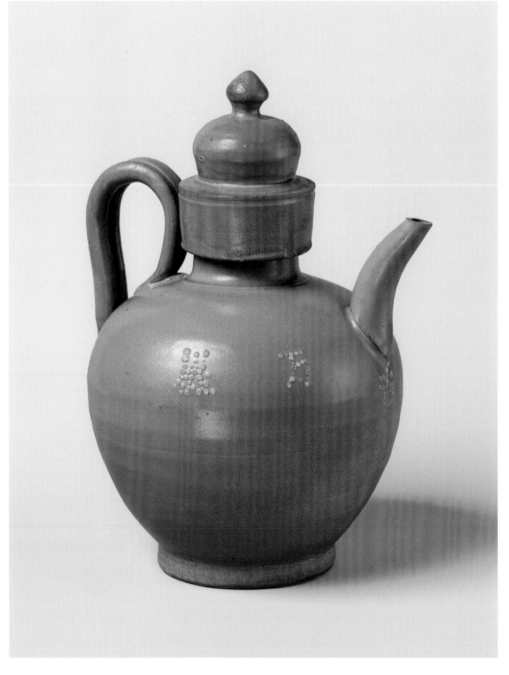

Ceramic ewers such as this one — with a small, round body and a lid in the shape of a double dome resembling a Buddhist stupa — enjoyed a period of popularity during the tenth and eleventh centuries.[1] The form of these objects was inspired by earlier Tang dynasty metal vessels.[2] Reminders of the ewer's ancestors can be found in visible joins between the body, spout, and strap handle that imitate the techniques of the metalsmith. This ewer appears to have been the product of the Yue kilns of southeastern China, famed for their green-glazed wares.

The ewer carries a five-character inscription executed in a white slip with two characters appearing on each side of the ewer and one character below the spout. The text is written in a combination of two different scripts. Two characters on one side are executed in a standard calligraphic script. The remaining characters are written in a more unusual stippled or dotted script. The single character under the spout (吉 *ji*) may be read as "good fortune." The two pairs of characters flanking the spout (千秋 *qian qiu* and 萬歲 *wan sui*) may be translated as "a thousand autumns" and "ten thousand years." Read together, the inscription presents an auspicious wish — "May you enjoy good fortune forever and ever" — and helps to identify this vessel as a funerary object.

Two ewers nearly identical in shape and size to this vessel are seen on the table in *Preparing for an Outdoor Banquet* (cat. 3) (see fig. 43), suggesting that this ewer may have been one of a pair. In the painting the ewers are placed on stands, as are all the vessels on the table. The beverage featured in this scene is possibly tea, which was linked to Buddhist practices, a connection underscored by the ewer's stupa-shaped lid. Ewers like this may have been used to hold hot water for pouring into individual teabowls. Ground tea leaves would be whisked in the hot water and then served. The depiction of ceramics from southeastern China in a Liao tomb panel points to the extensive trade networks between the Liao and Song empires.

NOTES

1. For an almost identical ewer, see *Zhongguo taoci chaju: Chaju wenwuguan Luo Guixiang zhencang* (Hong Kong: Xianggang shizhengju, 1991), 120–21, cat. 29. See also Zhang Bai, ed., *Zhongguo chutu ciqi quanji*, vol. 9, *Zhejiang* (Beijing: Kexue chubanshe, 2008), 167, cat. 167; *Zhongguo taoci quanji*, vol. 6, *Tang and Five Dynasties* (Shanghai: Shanghai renmin meishu chubanshe, 1999), 148, no. 147 (with description on p. 251). An incised example may be seen in Regina Krahl, *Chinese Ceramics from the Meiyintang Collection*, 2 vols. (London: Azimuth Editions, 1994), 1:180–81, cat. 312. Another incised ewer with a parrot design is in the Metropolitan Museum of Art (1979.502).

2. An example of a silver Tang ewer sharing several common features with the present ceramic ewer is in the British Museum (1926, 0319.3).

Cat. 11 Liao dynasty–Northern Song dynasty
Basket-weave Bowl, 10th–11th century
Chased silver
H. 6.3 cm, diam. 9.8 cm
Princeton University Art Museum.
Museum purchase, Hugh Leander Adams, Mary
Trumbull Adams, and Hugh Trumbull Adams
Princeton Art Fund (2018-134)

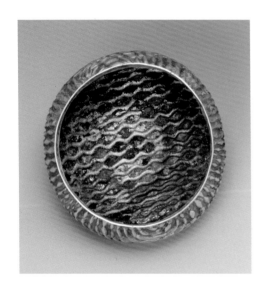

The bulbous body of this delicate silver bowl is decorated with concentric undulating bands in high relief. The bands, which center on two foci on opposite sides of the vessel just below the lip, cover the entire body of the vessel, forming a basket-weave pattern. The straight vertical lip carries its own alternating pattern of smooth and notched horizontal bands.

Metal bowls of similar design were first produced in the late ninth century, during the waning years of the Tang dynasty, and were sometimes referred to as "reed baskets" (*pulan* 蒲籃) or "willow dippers" (*liudou* 柳斗). Baskets woven from cheap plant materials were among the most basic of all containers. The silversmith's decision to execute a basketry design on a precious metal object intended for an elite patron is striking. Examples of bowls of similar shape decorated with basket-weave patterns survive in both fine metalware and ceramics from the ninth to the thirteenth century.[1] Some of the metalware examples were found in Song territory, but the closest parallel is a matching pair of silver bowls discovered in a large hoard unearthed in 1978 at You'ai village, Baiyinhan township, Balin Right Banner, Inner Mongolia.[2] The hoard was limited to valuable objects likely buried for safekeeping by a wealthy family in the latter part of the Liao dynasty, a period of political unrest.

An object depicted in *Preparing for an Outdoor Banquet* (cat. 3) is strikingly similar in shape and design to this bowl (see fig 43). If the bowl in the painting was indeed based on a silver prototype, then we may glean some insights into the use and display of this object. The basket-weave bowl in the painting is shown atop a lobed stand on a table set with a combination of other dining and drinking vessels in other materials, all placed on stands. The appearance of the silver bowl in the painting also suggests the high status of the tomb occupant. Liao funerary practices generally restricted the use of vessels in precious metals to the Khitan nobility.[3]

NOTES

1. For a Liao ceramic example, see Hebei sheng wenwu yanjiusuo, ed., *Xuanhua Liao mu: 1974–1993 nian kaogu fajue baogao*, 2 vols. (Beijing: Wenwu chubanshe, 2001), 2:pls. 145.3, 145.4. A ceramic example is illustrated in Regina Krahl, *Chinese Ceramics from the Meiyintang Collection*, 2 vols. (London: Azimuth Editions, 1994), 1:208, cat. 368. Examples are also known in jade, including one in the Sackler Gallery of Art, Washington, DC; see *Bulletin of the Museum of Far Eastern Antiquities* 36 (1963): pl. 26.2.

2. See *Zhongxing jisheng: Nan Song fengwu guanzhi* (Beijing: Zhongguo shudian, 2015), 32–33; see also R. L. Hobson, "A T'ang Silver Hoard," *British Museum Quarterly* 1 (1926): 18–21, pl. Xa.

3. See François Louis, "Shaping Symbols of Privilege: Precious Metals and the Early Liao Aristocracy," *Journal of Song–Yuan Studies* 33 (2003): 71–109.

Cat. 12 Liao dynasty
 Lobed Dish
 Silver with gilding and embossing
 H. 1.9 cm, diam. 12.4 cm
 Asia Society, New York. Mr. and Mrs. John D.
 Rockefeller 3rd Collection (1979.116)

The design of this small, gilded silver dish marries a wide range of artistic traditions from the Tang dynasty, the Liao, and Central Asia. The wide, eight-petal rim and corresponding lobed interior walls of the bowl directly recall metalware shapes from Central Asia. However, the decoration along the rim and upper part of the bowl follow popular Tang motifs, including scrolling, interlocking vines with birds interspersed among the foliage. The scene filling the belly of the vessel is unusual and possibly derived from a Khitan prototype. Three slender figures are depicted, one on horseback with arms raised and two on foot, amid a landscape of softly rolling hills. The standing figures brandish weapons and seem to engage in combat with two long snakes, as other four-legged animals roam their surroundings. The interplay of different artistic traditions in the shape, decorative motifs, and technical execution of the dish reflects the ways in which Liao workshops synthesized the eclectic tastes and complex cultural identity of Khitan patrons.

The precious metals used to create this vessel, along with the considerable skill required of its maker, attest not only to the material investment made by the Liao ruling class in fine metalwork but also to the technical and artistic sophistication of the silversmiths they employed. Vessels such as this dish were among the most prized possessions of the Khitan ruling class, a state of affairs no doubt connected to the overwhelming importance of gold and silver, both government-controlled commodities, in the Liao economy. Two large bowls with metal lids seen in the Liao panel *Arranging an Outdoor Banquet* (cat. 4) are of similar workmanship to this dish and illustrate the central role such vessels played in Liao banquet settings (see pp. 80–81).

Cat. 13 Liao dynasty
Ladle
Wood
L. 27.9 cm
Princeton University Art Museum.
Gift of James J. Lally (2019-36)

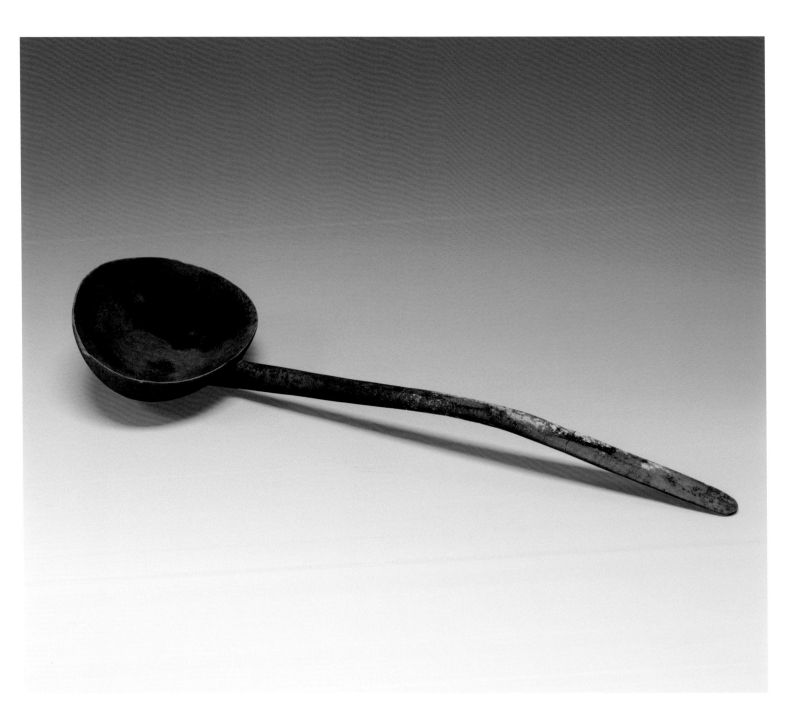

A description of a Liao feast that took place in 1009 near the Liao southern capital (present-day Beijing) was recorded in a Song dynasty embassy report. Submitted by the official Lu Zhen, who had traveled to Liao territories on a diplomatic mission, the report describes Liao cuisine and banquet practices: "First came camel gruel, served with a ladle. There was boiled bear fat, mutton, pork, pheasant, and rabbit, and there was dried beef, venison, pigeon, duck, bear, and tanuki [a raccoon dog], all of which was cut into square chunks and strewn onto a large platter. Two Tartar youths wearing clean clothing, each with napkins and holding a knife and spoon, cut all the various meats for the Han [the Chinese] envoys to eat."[1]

Khitan dining generally involved eating solid food with one's hands. The report indicates that accommodations were made for the Song emissaries, who would have used chopsticks. This ladle was likely used in the same way as described in the report, for serving gruel or similar fare rather than as a utensil for personal use. In *Attendants Bearing Offerings* (cat. 2), the second lady holds a bowl with a similar ladle in it. The shape of the ladle also matches a depiction from a late Liao dynasty tomb painting, excavated in 1990, in which three Khitan men prepare to serve food for a feast, two holding ladles over a large bowl (fig. 44).[2]

The ladle's slender, arched handle and wide, oval reservoir were carved from a mottled reddish-brown wood. Liao tombs have yielded many examples of large-scale wood objects, including coffins (see cats. 1–6), furniture, and even architectural structures, but few examples of small domestic objects survive in the material. This object hints at the widespread use of finely made wood implements for dining and other aspects of daily life that must have been a common feature of elite Liao material culture.

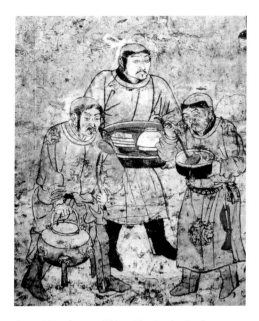

fig. 44 / Liao dynasty, *Khitan Men Serving Food*, 11th century. Mural from a Liao tomb, Dishuihu, Balin Zuoqi, Inner Mongolia.

NOTES

1. Nicolas Tackett, *The Origins of the Chinese Nation: Song China and the Forging of an East Asian World Order* (Cambridge: Cambridge University Press, 2017), 47.

2. *Zhongguo mushi bihua quanji*, 3 vols. (Shijiazhuang: Hebei jiaoyu chubanshe, 2011), 3:pl. 35.

Cat. 14 Liao dynasty
 Bottle, late 10th century
 Ding ware; oyster-white glaze over
 grayish-white porcelain
 H. 26.1 cm, diam. 16 cm
 Princeton University Art Museum.
 Gift of the American Research Center in Egypt
 through the courtesy of the Department of
 Antiquities of the United Arab Republic (y1966-3)

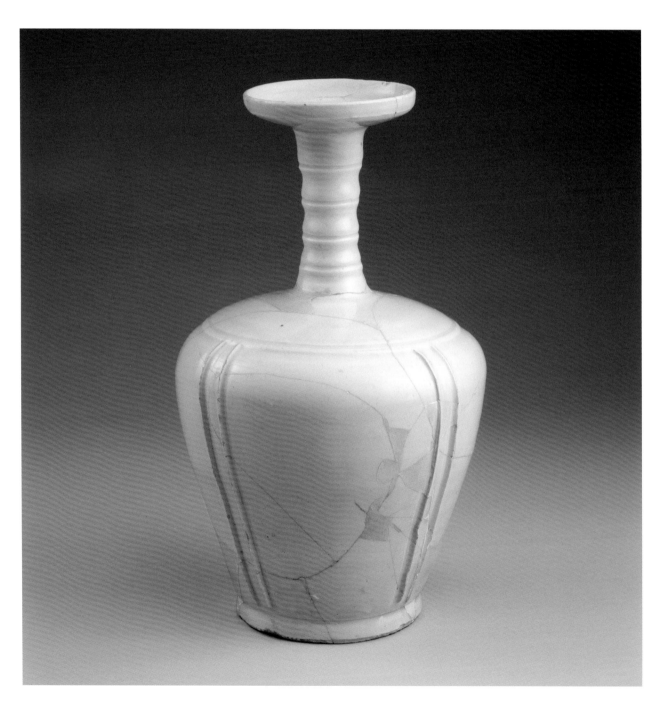

This elegant bottle would have been used by attendants to pour drinks for guests during Liao banquets. In a Liao burial context, bottles of this type would have been part of a varied assemblage of vessels and dining ware intended to store and serve the food and drink required for the afterlife of the tomb occupant.

Four pairs of widely spaced vertical ribs divide the ovoid body of the bottle, which sits atop a shallow ring foot. Rising just above the high shoulder of the vessel, the ribs are capped by a delicate horizontal band. The slender, undulating neck, ornamented with horizontal grooves, opens to a flared, dish-shaped lip. This bottle was reconstructed from thirty-six fragments discovered in 1965 in an undisturbed waste pit in Fustat (now Cairo), Egypt. The finely potted porcelain sherds stood out among the numerous Chinese green-glazed ceramic fragments discovered at the site, marking the bottle's rarity. In form and material, the bottle resembles fine white porcelains produced at Ding ware sites during the Liao dynasty near Beijing and in Liaoning province in northeastern China. The warmth of the distinctive cream-colored Ding ware glaze is attributed to a switch from wood to coal fuel, which began in the tenth century and allowed for both higher temperatures and an oxidizing atmosphere in the kiln.[1]

Although the object's Liao origin seems clear — the bottle is comparable to a white ewer with a small spout excavated from a tenth-century tomb of a Khitan lady — the circumstances of the bottle's journey to Egypt remain obscure.[2] It may have been traded overland via the Silk Road, which was controlled by the Liao during the tenth century. A maritime route originating from a Song-controlled port is also a possibility though less likely given the Song government's prohibition on overseas trade with the Liao.

NOTES

1. See Rose Kerr and Nigel Wood, *Science and Civilisation in China*, vol. 5, *Chemistry and Chemical Technology*, part 12: *Ceramic Technology* (Cambridge: Cambridge University Press, 2004), 159.

2. Feng Yongqian, "Yemaotai Liao mu chutu de taociqi," *Wenwu* 12 (1975): 44.

Animal-Head Ewers and Pitchers

Chicken-head ewers first appeared in the Eastern Jin dynasty (317–420) and were produced at the Yue kilns in Zhejiang province.[1] Although the impetus for the design is unclear, it was most likely related to the symbolic connotations of the animal; the Chinese word for "chicken" (雞 *ji*) is homophonous with "auspicious" (吉 *ji*) and, perhaps due to this linguistic connection, the animals were thought to possess protective powers. In the Eastern Jin, the squat bodies of chicken-head ewers still recalled the plump proportions of the animal. Over time the form continuously evolved, until by the middle of the eighth century the shapes of the vessels had greatly diversified, and potters had begun to dispense with the chicken-head-shaped spout entirely. By the late Tang, artists had re-embraced bird-head decor for different parts of the vessels, with a particular interest in more exotic fowl, such as pheasants, peacocks, and, most popular, phoenixes. Although phoenixes were revered in China, the interest in ewers with phoenix heads was also tied to the importation of fine silver and gold phoenix-head ewers from Persia.

Cat. 15 is an early example of a phoenix-head ewer that dates from the eighth century. The potter formed the distinctive ovoid head at the top of the vase's long, tapered neck. The upward, curling head feathers identify the mythological creature, a fantastic composite bird that embodies a multitude of auspicious meanings, including faithfulness and benevolence. This ewer is also an early example of Tang dynasty white ware, which was popularized by the highly regarded products of northern Xing kilns. In a burial context, this vessel may have been intended to hold beverages for feasting in the afterlife.

Another vessel that would have served the afterlife feast is the unusual *Phoenix and Dragon Pitcher* (cat. 16). The body of this avian-themed vessel features wings carved in relief and decorated with incised patterns. A trio of back feathers rises from the body to the lip of the spout. The handle is formed in two parts: a double loop joined at the base flanks the slender neck of a dragon arching up to the spout, where its long, open jaws clamp to the rim. The sculpted head and neck of the bird, almost certainly a phoenix, emerge from the side of the vessel opposite the handle. The two imaginary animals, phoenix and dragon, were commonly paired auspicious motifs. Finely sculpted ewers of this size were known from Liao regions. These vessels employ a *sancai* 三彩 (tri-color) glaze of green, amber, and cream similar to that widely used in the Tang dynasty.

In the Song dynasty, fierce-looking phoenix heads are found on ewers of varying sizes, such as this diminutive one seen in cat. 17. An example of *qingbai* ware, which first appeared in the Northern Song period, produced by kilns in Jiangxi province, this ewer has a white body and a clear glaze with a subtle blue-green hue. A nearly identical ewer appears on the table depicted in the Liao panel *Preparing for an Outdoor Banquet* (cat. 3, see fig. 43), suggesting that the ewer would have been placed on a stand when used in a banquet setting. The appearance of this vessel type in a Liao funerary painting points to the shared repertoire of tableware on both sides of the Liao-Song border.

NOTES

1. The Princeton University Art Museum collection includes an example of this early form (2004-448).

Cat. 15 Tang dynasty
Ewer with Phoenix Head, 8th century
Ceramic with white glaze
H. 16.4 cm, diam. 19.5 cm
Private Collection

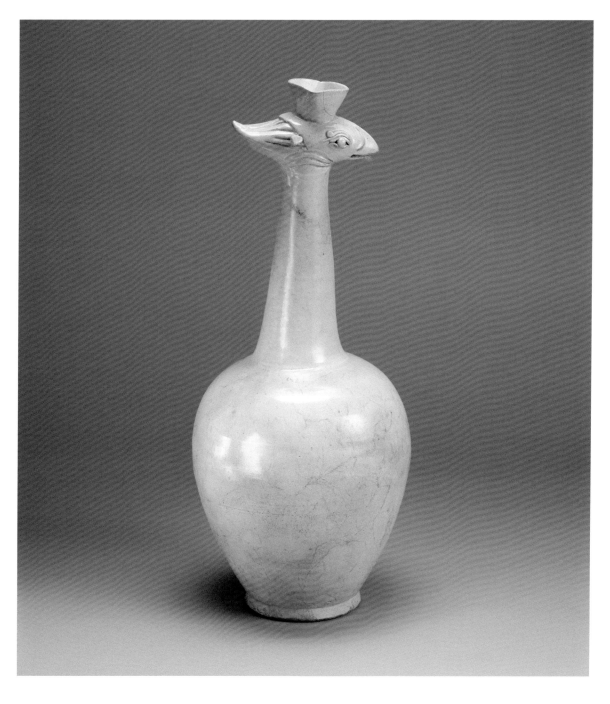

Cat. 16 Liao dynasty
Phoenix and Dragon Pitcher
Sancai ware; ceramic with green,
amber, and cream glaze
23 × 21 × 14 cm
Princeton University Art Museum.
Prime Fund Purchase (y1930-45)

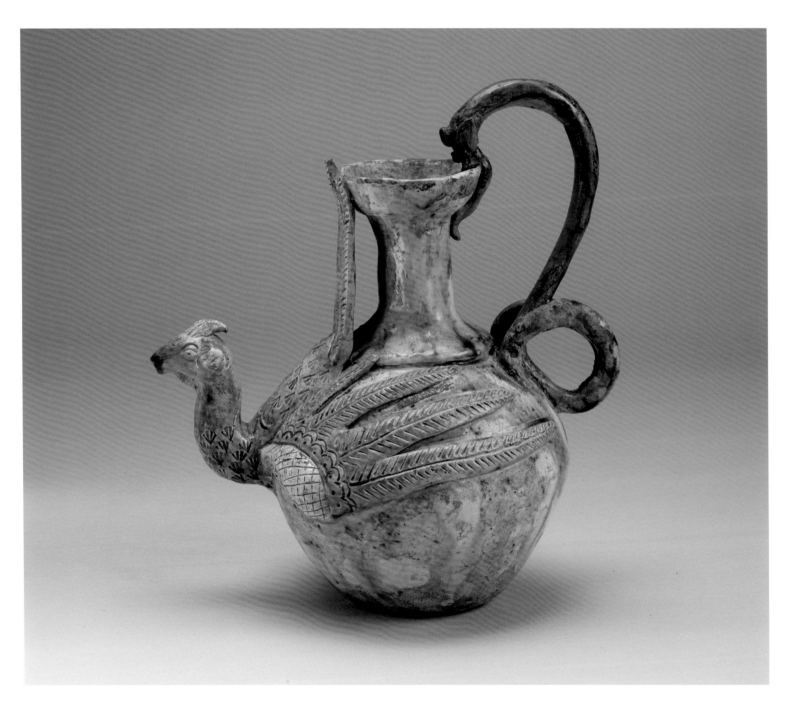

Cat. 17 Song dynasty
Small Ewer with Phoenix Head
Qingbai ware; porcelaneous ware with light
green-blue glaze
13.3 × 9.5 × 7 cm
Princeton University Art Museum.
Gift of Nelson Chang, Class of 1974, in honor
of Mr. Herbert Rosenfield and Mrs. Audrey
Rosenfield on the occasion of his 45th Reunion
(2019-97)

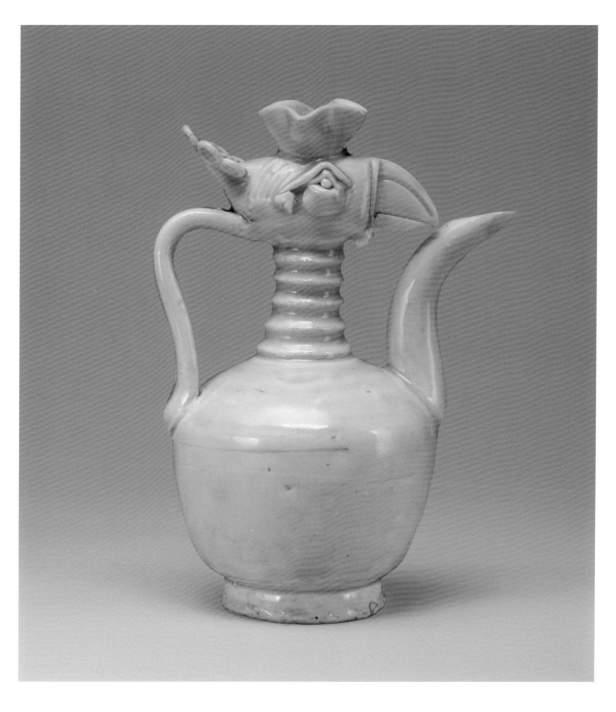

Cat. 18 Tang dynasty
 Basin
 Sancai ware; ceramic with green,
 amber, and cream glaze
 H. 7.4 cm, diam. 30.9 cm
 Princeton University Art Museum.
 Gift of James Freeman, Class of 1965,
 in honor of Cary Y. Liu, Class of 1978
 and Graduate School Class of 1997
 (2000-276)

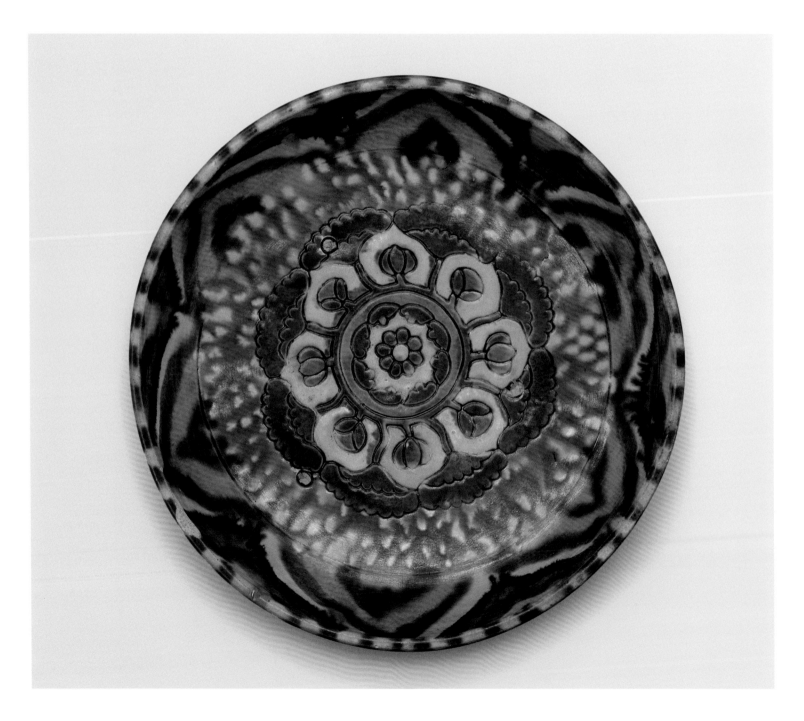

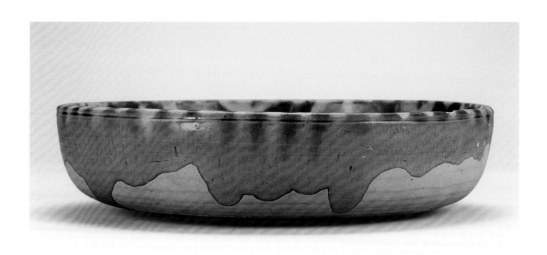

This basin is formed with steep sides resting on an unglazed flat bottom. The inside of the basin is decorated with green, amber, and cream lead glazes. At the center of the design, concentric lotus petals and leaves surround a stamped lotus rosette. An amber band with white mottling in reserve separates the center design from a band of alternating triangular petals extending to the rim. On the exterior of the basin, a wave of amber glaze flows from the rim partway down the sides of the vessel, leaving the ceramic body below it exposed.

Among the large corpus of surviving tomb ceramics from the Tang dynasty, a basin of this size and shape is relatively rare. The high quality of its *sancai* (tricolor) glaze is also noteworthy. After the fall of the Tang, *sancai* glazing continued to be favored by potters in Liao territories, as illustrated by the Liao *Phoenix and Dragon Pitcher* (cat. 16).

Cat. 19 Liao dynasty
*Fragment from a Garment: Flowers,
Cranes, and Clouds*, 10th century
Weft-faced compound twill, silk
46.6 × 37.1 cm
The Cleveland Museum of Art. John L.
Severance Fund (1995.112.2.a)

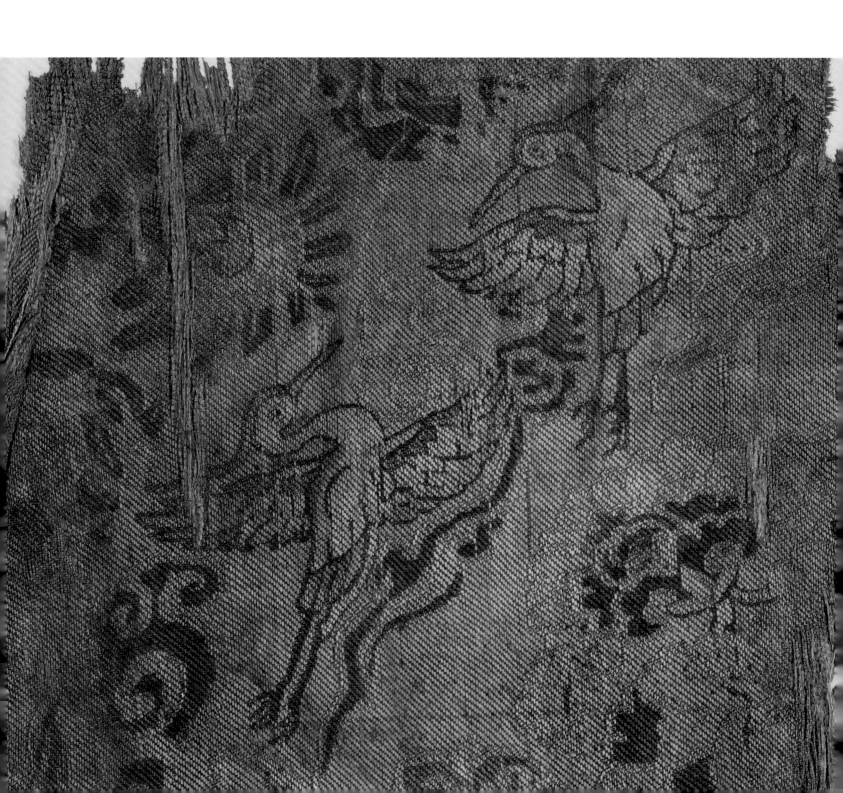

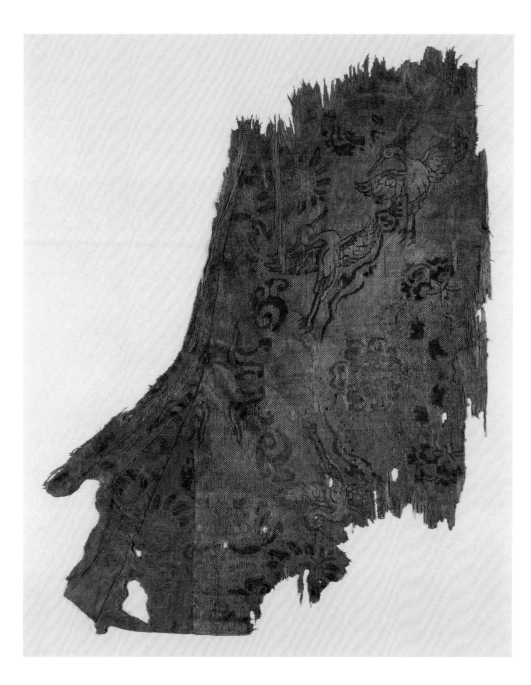

During the founding decades of the Liao dynasty, large numbers of Chinese textile craftspeople, some brought to Liao territory as captives, were recorded working in Liao workshops. The products of these workshops reveal an array of influences, including from North, Central, and West Asia, reflecting both the vast reach of Liao territory and the complex history behind Tang and Song textile designs and techniques. The mixing of Chinese and non-Chinese motifs is a hallmark of Liao textile design, as is the cross-fertilization of motifs between different mediums, most notably metalwork.

This fragment was part of a padded outfit that was lined with silk and filled with silk batting. The unstable conditions of the Liao tomb in which the garment was buried caused extensive deterioration. Only small fragments survive, making it difficult to reconstruct the garment's overall shape. Evidence from a different fragment shows the outfit had included a metal belt.[1] The full pattern of the woven decoration is also difficult to discern, but it seems to center on a large floral medallion surrounded by pairs of birds in mid-flight, smaller floral patterns, and swirling clouds. The design evolved from a more tightly arranged version that was popular in the late Tang period.

The original garment, with its complex pattern, brightly colored threads, and metal belt, would likely have been an impressive costume for the special occasion of a feast, which no doubt demanded luxury displays of all kinds. This sumptuous clothing is also a reminder of other categories of Liao textile that do not survive in the material record. Intricate fabrics for furnishings, awnings, and tents would have created impressive settings for Liao banquets.

NOTES

1. Other fragments are in the Cleveland Museum of Art (1995.112a–c). An additional fragment is reproduced in James C. Y. Watt and Anne E. Wardwell, with Morris Rossabi, *When Silk Was Gold: Central Asian and Chinese Textiles* (New York: Metropolitan Museum of Art, 1997), 44–45.

Cat. 20 Liao dynasty
Headpiece
Silk embroidery
22.3 × 53.8 cm
The Cleveland Museum of Art.
Gift of Lisbet Holmes
(1995.109.1)

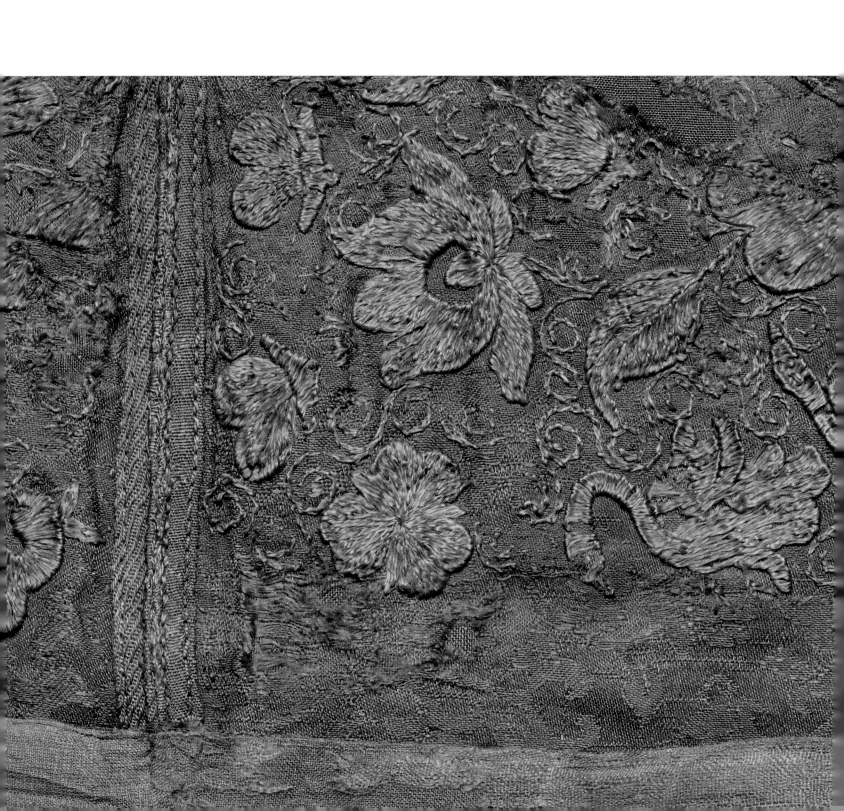

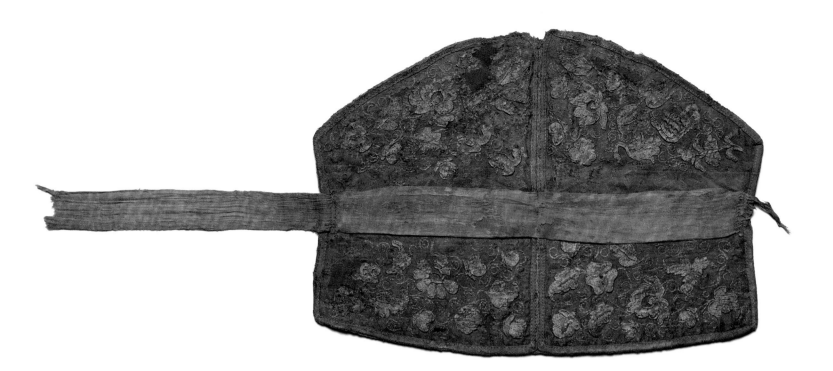

Headpieces such as this were designed to be wrapped around the forehead, creating a tall, frontal display of fine embroidery encircling a lady's coiffure. Worn by women of high status in Liao territories and across northern China, they would have been an important component of adornment for feasts and other special social events. The figure of Lady Wenji in *Eighteen Songs of a Nomad Flute: The Story of Lady Wenji* (cat. 7) is depicted wearing a headpiece of similar shape and ornamentation in all of the handscroll's feast scenes. An example in gold from a sixth-century tomb attests to the early origin and enduring popularity of the form.[1]

The design of this headpiece is embroidered in two colors set on a green silk ground. The four quadrants carry motifs of intertwined flowers, including lotus, chrysanthemum, and prunus, linked by thinly stitched scrolling stems and enlivened with butterflies shown in profile. The lotus-pond theme of the decoration is further enriched by a pair of long-necked waterfowl, likely geese, appearing in the upper right section. One goose looks forward, the other back in a motif also found in Liao tomb paintings.[2] The pair of animals in the upper left section is no longer fully legible.

NOTES

1. Helmut Brinker and François Louis, *Chinesisches Gold und Silber: Die Sammlung Pierre Uldry* (Zurich: Museum Rietberg Zürich, 1994), no. 121, 141; James C. Y. Watt and Anne E. Wardwell, with Morris Rossabi, *When Silk Was Gold: Central Asian and Chinese Textiles* (New York: Metropolitan Museum of Art, 1997), 180.

2. For a technical analysis of the textile, see Watt and Wardwell, with Rossabi, *When Silk Was Gold*, 180.

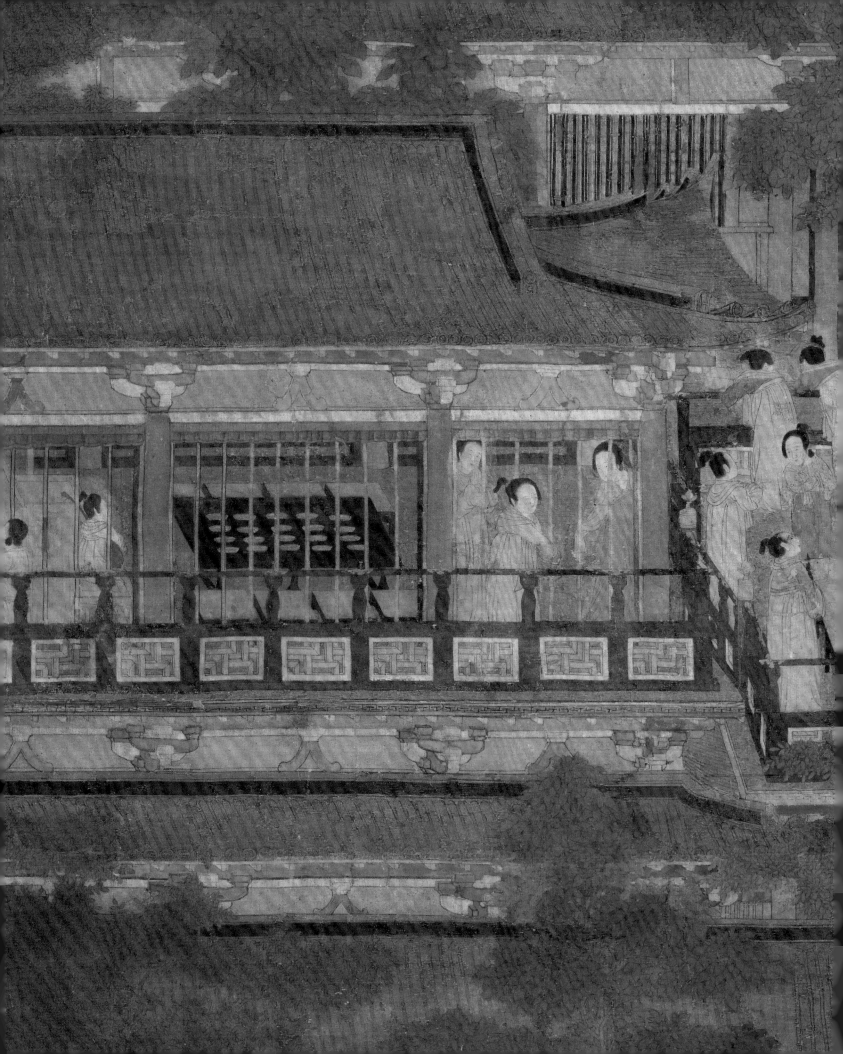

LADIES
BANQUETING
IN SECLUSION

cats. 21–32

Cat. 21 Song dynasty
 Palace Banquet, early 12th century
 Hanging scroll; ink and color on silk
 161.6 × 110.8 cm (painting);
 315 × 112.7 cm (overall with mounting)
 The Metropolitan Museum of Art, New York.
 Ex coll.: C. C. Wang Family, Gift of Oscar L.
 Tang Family, 2010 (2010.473)

Palace Banquet, a large hanging scroll dating to the early to mid-twelfth century, is painted in ink and brightly colored pigments on two vertically joined lengths of silk.[1] The painter, whose identity is no longer known, utilized a sharply tilted ground plane to present an elevated view into a large compound, revealing tree-lined passageways and finely appointed interiors. The compound is brought to life by the presence of thirty female figures of varying ages.

The palatial dimensions of the compound allude to an imperial or at least princely affiliation. Moreover, the exclusion of any male figures from the scene suggests that the portion of the complex portrayed in *Palace Banquet* must be the inner quarters of the residence, a cloistered domestic space reserved for the ladies of the household.

The architecture of the painting provides the framework for the composition, creating a series of spatial cells in which different figural scenes of varying size and importance play out.[2] Each scene relates to the main theme of the painting, the activity surrounding an imminent banquet.[3]

Near the top of the painting, a long, horizontal outer wall extends beyond the picture frame on both sides. Above the wall lies an expanse of unpainted silk, a subtle indication of the isolation of the female figures: nothing lies beyond the walls of the compound; their world is within. Along the far right of the rear wall, a lady and a blue-robed maidservant wait to admit a visitor. The lady maneuvers the door beam, while the

maidservant holds the lock. Below them an open door leads to the main courtyard, which stretches down the right side of the painting and along the bottom. Two maidservants wearing similar blue robes lark about in the courtyard not far from a lotus pond just visible in the bottom-right corner of the painting. One holds a fan, the other grasps a branch of lotus flowers as she reaches for a butterfly; the gestures of both figures present motifs of romantic love.[4] A pair of ladies looking down from a second-floor music pavilion hail the maidservants. In the center of the pavilion, four incense burners in the shape of a lioness and three cubs are set on a carpet. An array of instruments, including *pipa* lutes, a zither, and possibly flutes or clappers, lie inside their covers atop two tables, awaiting the arrival of a group of musicians (see cat. 43).[5] The lower section of a large drum on a stand is also visible.

The pavilion links to an open banqueting terrace in which a group of women mingle around carefully laid tables. The ladies are joined by a pair of small girls and a maidservant. The tall table covered with blue fabric on the right holds a large, ornate incense burner and related paraphernalia (see cat. 27). Stools and a large bench surround the two adjoining dining tables to the left. The smaller table is set with a large metal bowl surrounded by small objects, some in the shape of half-open lotus flowers. The larger table is covered by a profusion of small dishes set in neat rows (see cats. 25–26). Four small ewers are placed in each corner.

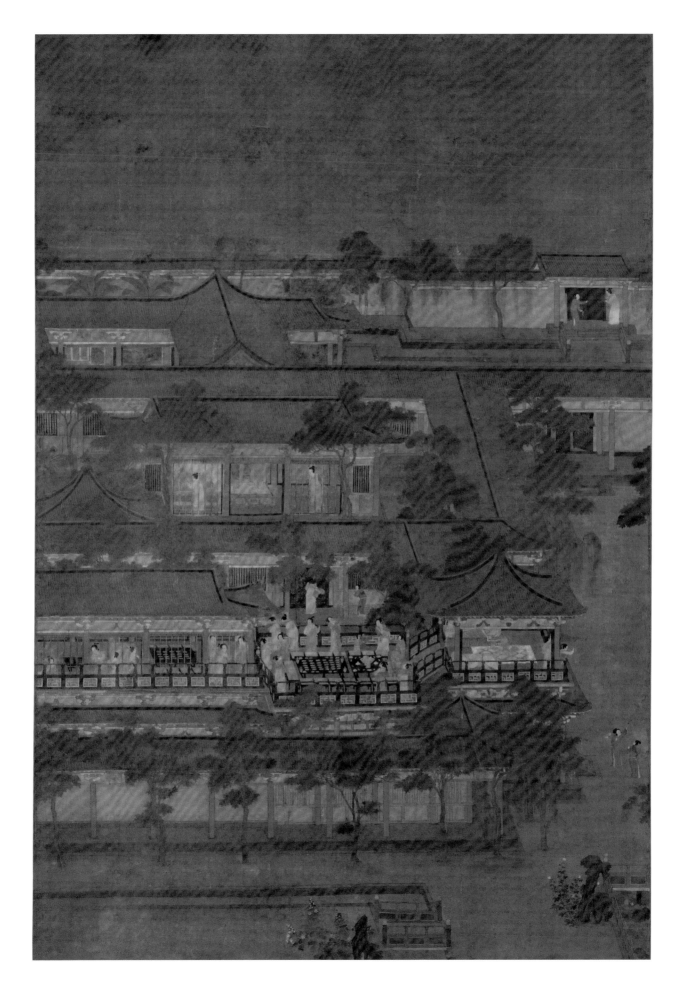

toward her. This attendant claps her hands in an effort to awaken the lady, who is surely the highest-ranking woman of the quarters. The other attendant stands to the right of the hall's entrance, holding an elaborate multitiered lamp.

Several of the painting's details help identify aspects of the setting. The lamp carried by the attendant points to the early evening hour of the banquet. The lush foliage, including hibiscus flowers, seen along the bottom edge of the painting indicates the summer season. Finally, the banana trees growing toward the back of the compound suggest the geographic location. Cultivated only in subtropical or tropical climes, the trees mark the setting as southern China. This location would accord well with the early- to mid-twelfth-century date of the painting, a time when the Southern Song regime had established its capital in the southern city of Hangzhou.[6]

The painting does not portray a contemporary Song dynasty scene, however, but a tableau from the past: the imagined inner quarters of a Tang dynasty palace. The soft, round bodies of the ladies as well as their attire and coiffures all accord with Tang dynasty fashions (see cats. 22–24, 28).

Despite the painting's wealth of detailed figural scenes, efforts to connect the image to narratives from surviving literary sources have been unsuccessful. The lack of an inscription describing the painting's subject matter makes it challenging even to match the image to any specific occasion.[7] Indeed, searching for an overall narrative interpretation for the painting may obscure the artist's original intent. Most of the scenes or vignettes within the painting seem to be pictorial encodings of notions about the lives of Tang court women rather than specific stories belonging to a central narrative. The larking maidservants, with their fan, butterfly, and lotus flowers, are often-encountered motifs symbolizing romantic love. The lady sleeping late in the day, suggesting a nocturnal dalliance the night before, is a clear erotic trope.[8] Only the generic theme of an impending banquet, in which all the women in the painting may in some way be presumed to participate, relates the various scenes dispersed throughout the compound.

More tables are laid inside the hall to the left of the banqueting terrace. A larger table surrounded by stools is arrayed with neatly placed dishes. Ewers and dishes are placed on another, smaller table. Ladies in the hall and on the front terrace chat with one another, while a musician sitting on a couch-bed inside the hall strums a *pipa* lute.

The banqueting areas are all placed in the same prominent horizontal register in the foreground of the compound, drawing the viewer's attention immediately to the main theme of the painting. As the viewer delves further into the architectural complex, another subtle episode appears.

Behind the outdoor banqueting terrace, a lady carrying a red cloth bundle knocks on a door as a maidservant stands to the side. They wait to gain entry into the most important of the compound's buildings, a five-bay hall. Inside this hall two attendants wait upon a sleeping court lady, whose presence under a mound of bedclothes at the left of the hall is indicated by an attendant gesturing

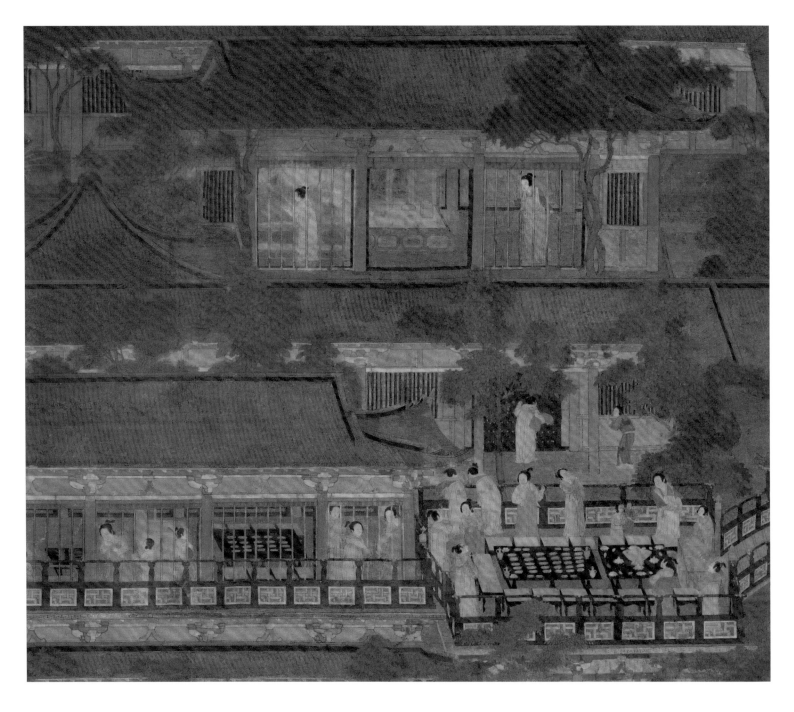

Both the complex interrelation of architecture and figural scenes in *Palace Banquet* and the nature of the ladies' activities it portrays are exceptional. Comparisons with two earlier compositions included in this exhibition and modeled after Tang and Five Dynasties court-lady paintings help illuminate the significance of *Palace Banquet* in the development of the genre.

Tang paintings of beautiful court women emphasize their wealth, femininity, and comportment. One of the earliest artists who excelled in the genre was Zhou Fang (active ca. 780–ca. 810). A Song dynasty copy of one of his paintings, *Palace Ladies Bathing Children* (cat. 22), reveals some of the fundamental characteristics of his oeuvre. Zhou's paintings typically involve spacious layouts that avoid large groups of tightly arranged figures. Even when presented in small groupings, his ladies are clearly meant to be examined individually by a viewer committed to savoring each one. Presented with sometimes-remote facial expressions, the ladies' elaborate coiffures, ornate jewelry (see cat. 30), and sumptuous flowing robes (see cat. 31) take center stage. The theatricality of the ladies' presentation belies the fact that Zhou's paintings neither present a narrative nor portray identifiable persons.

The court-lady paintings of Zhou Wenju (active ca. 950–975) represent a further evolution of the genre. A Song dynasty copy of his *In the Palace* (cats. 23–24) reveals some of these important innovations. No longer is there an emphasis on the careful admiration of individual ladies set within small groups. Instead, the artist presents a densely arranged composition featuring an enormous number of women whose poses form a catalogue of imagined domestic activities, most of which carry overt allusions to romantic desire.

During the Song period, paintings of court ladies continued to be extremely popular, as indicated in part by the ubiquitous copies of works in the genre from previous dynasties. By the Song, however, court-lady paintings had also begun to incorporate new developments in Chinese art from other genres, most importantly, in the case of *Palace Banquet*, architectural painting.[9] In this image, the scale of the female figures is greatly reduced relative to the size of the overall image. The action between the figures, as well as their setting, now holds as much as if not more importance than their individual depiction.

The painting still shares the themes of tranquility and domestic isolation with earlier works in the genre. The artist even includes some of the motifs of pent-up romantic desire that so often composed the raison d'être of a patron's commission. However, in *Palace Banquet* we also begin to see a new intimacy in the interrelation of the female figures. The artist presents a scene in which the relationships between the women and their activities carries an interest beyond their individual romantic value to the male patron who generally held the power to commission such a work. By capturing a moment amid the busy preparations for a banquet and situating it within a vast architectural complex, the artist brings the genre of court-lady painting into the broader realm of the Song figural-painting tradition, known for its portrayals of pastoral gatherings of literati gentlemen and teeming scenes of everyday urban life.

NOTES

1. For a comprehensive overview of *Palace Banquet* and a discussion of the artist's possible background, see Zoe Song-Yi Kwok, "An Intimate View of the Inner Quarters: A Study of Court Women and Architecture in *Palace Banquet*" (PhD diss., Princeton University, 2013).

2. The virtuosity and scale of the architecture portrayed in *Palace Banquet* has few peers among contemporary paintings. For a study of the architecture and its place in the history of the genre, see Kwok, "An Intimate View of the Inner Quarters," 36–105.

3. For an analysis of the banquet preparations, see pp. 55–57 in this volume.

4. Ellen Johnston Laing, "Notes on *Ladies Wearing Flowers in Their Hair*," *Orientations* 21, no. 2 (February 1990): 39. For another painting presenting these motifs, see *In the Palace* (cats. 23–24).

5. For the role of music and other performing arts in banquets, see cat. 43.

6. Evidence for the painting's dating is discussed in Kwok, "An Intimate View of the Inner Quarters," 219–20.

7. A seal in the lower left corner belonged to C.C. Wang (1907–2003), a well-known collector and connoisseur. It consists of eight characters in two rows that read: *Wang Jiqian haiwai jian mingji* 王季遷海外見名跡 (masterpieces viewed by Wang Jiqian overseas). Some have suggested the painting is a depiction of the Seventh Eve Festival, an event during which women practiced needlework and celebrated with food and drink. But the identification of the action of two ladies supposedly doing needlework is problematic; they seem more likely to be engaged in other tasks. See Kwok, "An Intimate View of the Inner Quarters," 159–70. For the Seventh Eve interpretation, see Maxwell K. Hearn and Wen C. Fong, *Along the Riverbank: Chinese Paintings from the C.C. Wang Family Collection* (New York: Metropolitan Museum of Art, 1999), 59.

8. An important aspect of court-lady paintings was the portrayal of women yearning for love. In the case of imperially commissioned works, that yearning would be directed toward the emperor. However, the same dynamic would hold for any male patron who requested scenes of court ladies from a painter.

9. The buildings, walkways, and courtyards in *Palace Banquet* cover nearly the entire surface of the painting and present an extremely complicated, if occasionally convoluted, architectural structure. Only an artist reasonably well versed in the genre of architectural painting would have attempted such a challenging composition.

Cat. 22 Song dynasty
After Zhou Fang (active ca. 780–ca. 810)
Palace Ladies Bathing Children, 11th century
Handscroll; ink and color on silk
30.5 × 48.6 cm (painting);
31.6 × 111.8 cm (overall with mounting)
The Metropolitan Museum of Art, New York.
Fletcher Fund, 1940 (40.148)

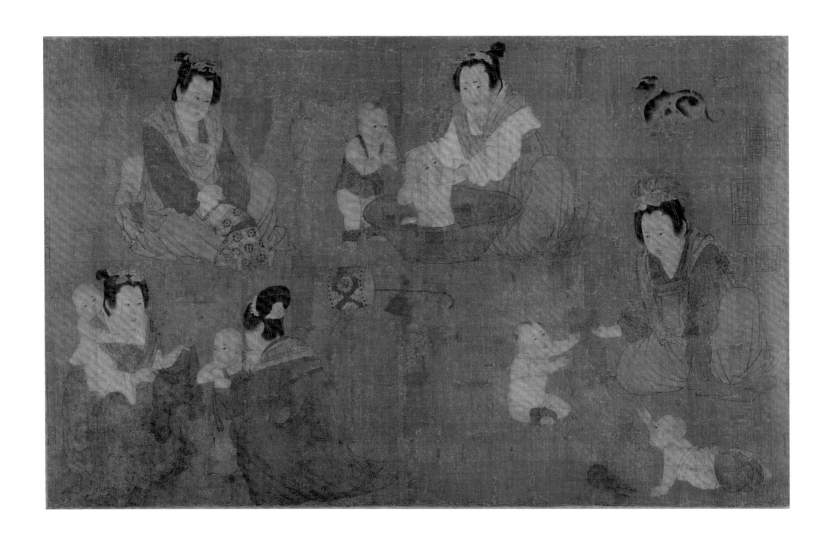

Designed to beguile the male patrons who commissioned them, Tang dynasty paintings of court ladies were visual odes to the physical beauty and refined comportment of the cloistered inhabitants of the palace's inner quarters.[1] The genre rapidly grew in popularity throughout the dynasty, reaching new heights under the brushes of the mid-Tang court artists Zhang Xuan (active 713–742) and Zhou Fang (active ca. 780–ca. 810). Few if any of their original paintings survive, but their enduring influence on later artists is attested by the many copies of their compositions that circulated among collectors. *Palace Ladies Bathing Children* is an example of such a copy. Produced sometime in the eleventh century, it was based on a painting by Zhou Fang.[2] As an image connected to one of the most famous painters of court ladies, the work is an important representation of the artistic tradition from which later paintings in the genre, such as *Palace Banquet* (cat. 21), descend.

In contrast to *In the Palace* (cats. 23–24), which presents an overtly romantic image, *Palace Ladies Bathing Children* is instead suffused with a charming domesticity. The painting focuses on the novel theme of mothers and children, showing five court women affectionately tending to eight small children.[3] The plump bodies, splendid coiffures, opulent jewelry, and elaborately patterned robes of the ladies match the fashions found in eighth-century tomb sculpture (see cats. 28–29). The subtle expressions on their faces provide only a hint of the personalities behind them. The portrayal of the children is equally restrained.

Set within a groundless, undefined space, a convention common in other Tang dynasty figure paintings, the figures are depicted in four distinct groups arranged in a loose circle. Each group presents a scene related to the routine of bathtime. The clockwise sequence portrayed by this quartet of vignettes begins in the upper left with a pair of toddlers hoping to avoid the bath.[4] Here, a lady comforts a child buried in her lap, while another nestles behind her with eyes covered. To their right, reluctance is replaced by delight as the bathing begins. A lady efficiently cleans one toddler in a splendid, large metal basin, pinching the little

one's nose to clear it, while the other child stands to the side, splashing water on the bather. In the lower right two partially dressed children play with a lady, one seated and the other crawling with a ball just out of reach to the left. Both look toward something in the lady's outstretched hand; the one closest already grasps an item. Damage to the painting makes it difficult to discern the object of their attention. In the lower left the sequence concludes with two ladies working to dress one child, while another climbs on one of their backs. An attentive black-and-white dog sits in the upper right corner. A drum and clapper appear untouched in the middle of the image.

NOTES

1. Lara C. W. Blanchard, *Song Dynasty Figures of Longing and Desire: Gender and Interiority in Chinese Painting and Poetry* (Leiden: Brill, 2018), 1–11.

2. See Wen C. Fong, *Beyond Representation: Chinese Painting and Calligraphy, 8th–14th Century* (New Haven, CT: Yale University Press, 1992), 21–26.

3. The status of the women is unclear. They have sometimes been identified as maidservants, but their elegant adornment and attire suggest the artist may instead have been presenting an idealized image of formal ladies engaged in routine domestic chores, a common trope for this genre of painting. Another bathtime scene appears in a Southern Song dynasty album leaf in the collection of the Freer|Sackler Gallery (F.1935.8), demonstrating the continued appeal of the theme.

4. See Fong, *Beyond Representation*, 24.

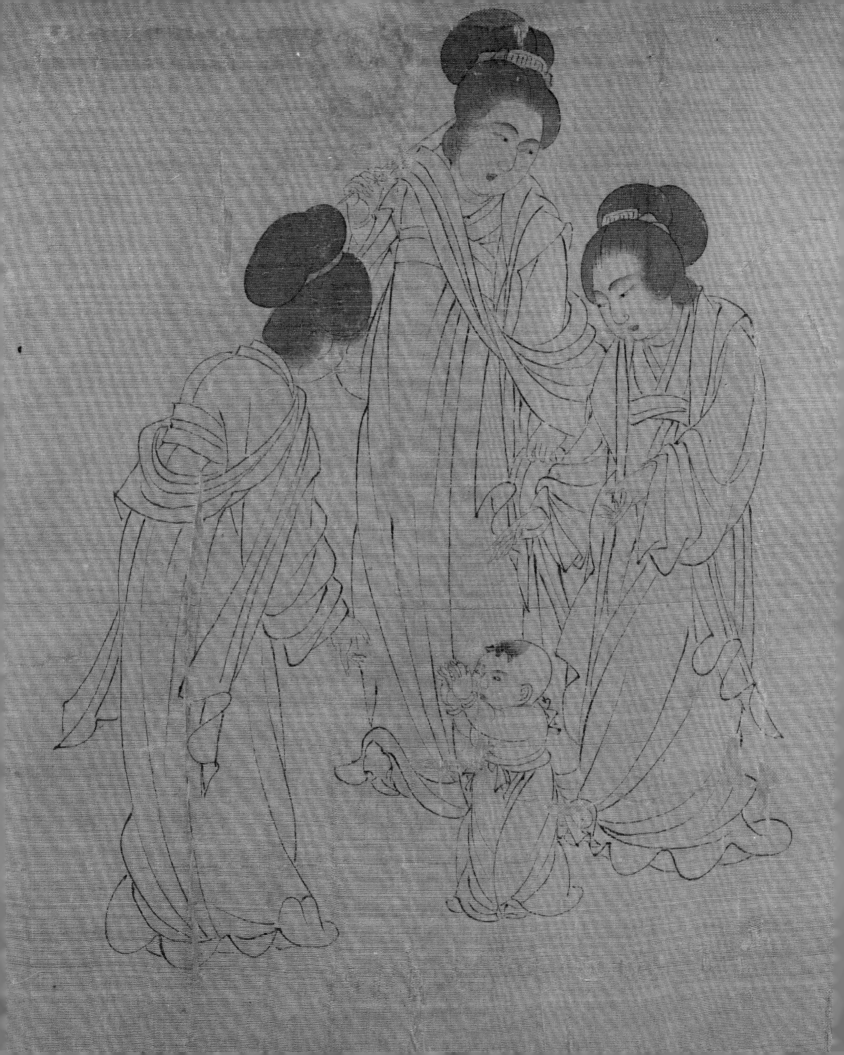

In the Palace
Handscroll Paintings

These two paintings belong to a longer handscroll that at some point in its history was split into four separate scrolls.[1] The opening of the painting is now in the Bernard Berenson collection at Villa I Tatti outside of Florence, Italy (fig. 45). The Cleveland Museum of Art scroll (cat. 23) comprises the next portion, followed by another section held in the Harvard Art Museums (fig. 46). The final scenes are contained in the Metropolitan Museum of Art scroll (cat. 24). The complete composition, reconstructed by joining together these four sections (read from right to left, as is typically the case with Chinese handscroll paintings), includes about eighty female figures accompanied by children, a male portrait painter, and a figure that seems to be a eunuch.[2] The main source of information on the painting is a colophon attached to the Cleveland scroll written by the scholar-official Zhang Cheng, a nephew of the renowned Song painter Li Gong-lin, who pioneered the ink-outline painting technique, called *baimiao* 白描, used in the painting.[3] Dated 1140, the colophon describes the work as a copy of an authentic painting by Zhou Wenju made as a gift to Zhang Cheng.[4]

Active in the tenth century, Zhou is often hailed as the last great practitioner of the genre of court-lady painting. His name is frequently paired with that of Zhou Fang (see cat. 22) and Zhang Xuan, the two eighth-century painters who made the genre famous. Zhou Wenju was active during a chaotic period following the end of the Tang dynasty that saw, in quick succession, the rise and fall of five dynasties in the north and the division of the south into ten kingdoms. One of these ten southern states was known as the Southern Tang dynasty (937–976), a prosperous kingdom whose capital was located in present-day Nanjing. Zhou served the Southern Tang as a court painter. It is likely that he painted the original version of *In the Palace* for Li Yu (r. 961–976), the final ruler of the kingdom, famous for his highly accomplished lyric poetry.

The women of *In the Palace* are shown enjoying the leisure and refined pastimes afforded to them by the opulent court of Li Yu.[5] The opening of the original painting, contained in the Berenson scroll (fig. 45), features a court painter working on a portrait of a concubine, her elaborate headdress indicative of her high rank. Behind the lady sitting for the portrait, a group of ladies lark about with fans chasing butterflies, a theme connected to romantic love.[6] A scene of several ladies preparing to bathe concludes the Berenson scroll portion. The painting continues with the section contained in the Cleveland Museum of Art's scroll. This section begins with a small concert followed by a large group of ladies playing with children, a theme continued in the next portion of the work, seen in the Harvard section. Here, we find a performance by a larger ensemble followed by a long scene of women at their toilette — an erotic trope — that continues into the final portion of the painting, contained in the section from the Metropolitan Museum of Art. This final portion ends with a group of figures clustered behind a seated lady who admires a painting held up for her viewing pleasure. Perhaps intended to be the completed portrait that the artist was working on at the opening of the painting, the motif of the painting within the painting creates a figurative bookend for the private activities of the inner quarters portrayed in Zhou's work.[7]

In the Palace's unfolding sequence of enchanting scenes is perhaps best understood as projections of the theme of love and desire. The portrayed women belonged to the household of the emperor, and it is the emperor who would have been the intended audience for the painting and its evocation of romantic desire. In viewing this painting, the emperor would not only have seen a representation of the beautiful women of his court, he would also have found in it a visual affirmation of the ladies' collective feelings of fidelity to and desire for him, an experience that other viewers of the work or later copies would have shared vicariously.[8]

Cat. 23 Song dynasty
After a work attributed to Zhou Wenju
(active ca. 950–975)
In the Palace, before 1140
Handscroll; ink and slight color on silk
28.5 × 168.6 cm (painting); 29.7 × 306.1 cm (overall)
The Cleveland Museum of Art. John L. Severance
Fund (1976.1)

Cat. 24 Song dynasty
After a work attributed to Zhou Wenju
(active ca. 950–975)
In the Palace, before 1140
Handscroll; ink and slight color on silk
26 × 146.7 cm (painting); 27.1 × 914.1 cm (overall)
The Metropolitan Museum of Art, New York.
Purchase, Douglas Dillon Gift, 1978 (1978.4)

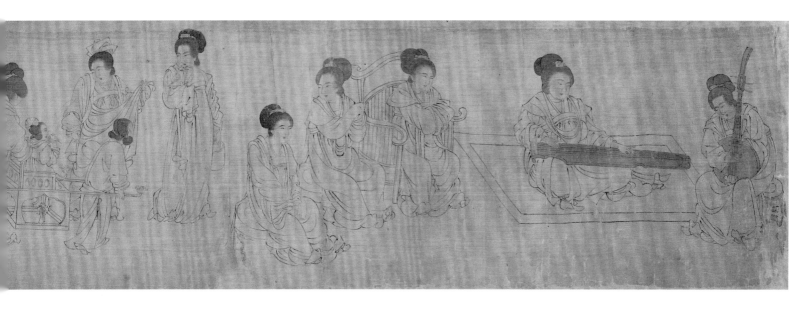

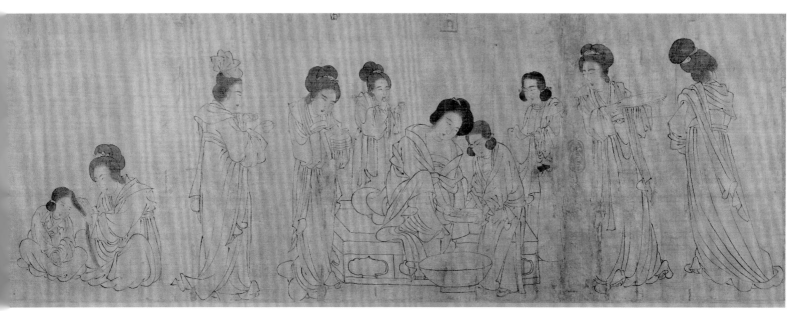

fig. 45 / *In the Palace*, before 1140. Handscroll; ink and slight color on silk, 28.5 × 168.6 cm (painting), 29.7 × 306.1 cm (overall). Villa I Tatti, Florence. Berenson Collection

fig. 46 / *In the Palace*, before 1140. Handscroll; ink and slight color on silk, 25.7 × 177 cm. Harvard Art Museums/Arthur M. Sackler Museum. Francis H. Burr Memorial Fund (1945.28)

NOTES

1. Wai-kam Ho, Sherman E. Lee, Laurence Sickman, and Marc F. Wilson, *Eight Dynasties of Chinese Painting: The Collections of the Nelson-Atkins Museum, Kansas City, and the Cleveland Museum of Art* (Cleveland: Cleveland Museum of Art, 1980), 27–29. The Metropolitan Museum of Art's collection includes a nineteenth-century Japanese copy (42.61) of the entire composition that differs in a few details; for example, the male eunuch in the painting has been replaced by a young maid. The sketch was probably part of the instructional materials of a Kanō-school workshop. Inscriptions on the figures' clothing indicating the colors that should be applied reflect the vibrant palette popular in Edo period (1603–1868) painting. The sketch not only corroborates the ordering of the four surviving *In the Palace* segments but also raises the question of how the composition came to be known in Japan. Many copies of the work must have existed in order for them to have circulated at such great distance.

2. Lara C. W. Blanchard, *Song Dynasty Figures of Longing and Desire: Gender and Interiority in Chinese Painting and Poetry* (Leiden: Brill, 2018), 35.

3. The colophon's authenticity is not certain. Similar passages appear in a colophon for a different painting also signed by Zhang Cheng. Additionally, some of the seals may be dubious additions; see Blanchard, *Song Dynasty Figures of Longing and Desire*, 34.

4. The austerity of the ink-outline technique used for the copy would have stood in stark contrast to the richly colored court style of the original. The choice of technique may have been informed by Zhang Cheng's familial connection to Li Gonglin. The undertones of propriety associated with the technique might also have been thought more appropriate for a scholar-official audience given the overtly erotic themes of the original. See Blanchard, *Song Dynasty Figures of Longing and Desire*, 31–32. Limitations of time and money may also have favored the relatively expeditious ink-outline technique for the copy.

5. See Wen C. Fong, *Beyond Representation: Chinese Painting and Calligraphy, 8th–14th Century* (New Haven, CT: Yale University Press, 1992), 34–39.

6. Ellen Johnston Laing, "Notes on *Ladies Wearing Flowers in Their Hair*," *Orientations* 21, no. 2 (February 1990): 39.

7. See Blanchard, *Song Dynasty Figures of Longing and Desire*, 51.

8. For an in-depth discussion of the construction and reception of romantic themes in the work, see Blanchard, *Song Dynasty Figures of Longing and Desire*, 29–53.

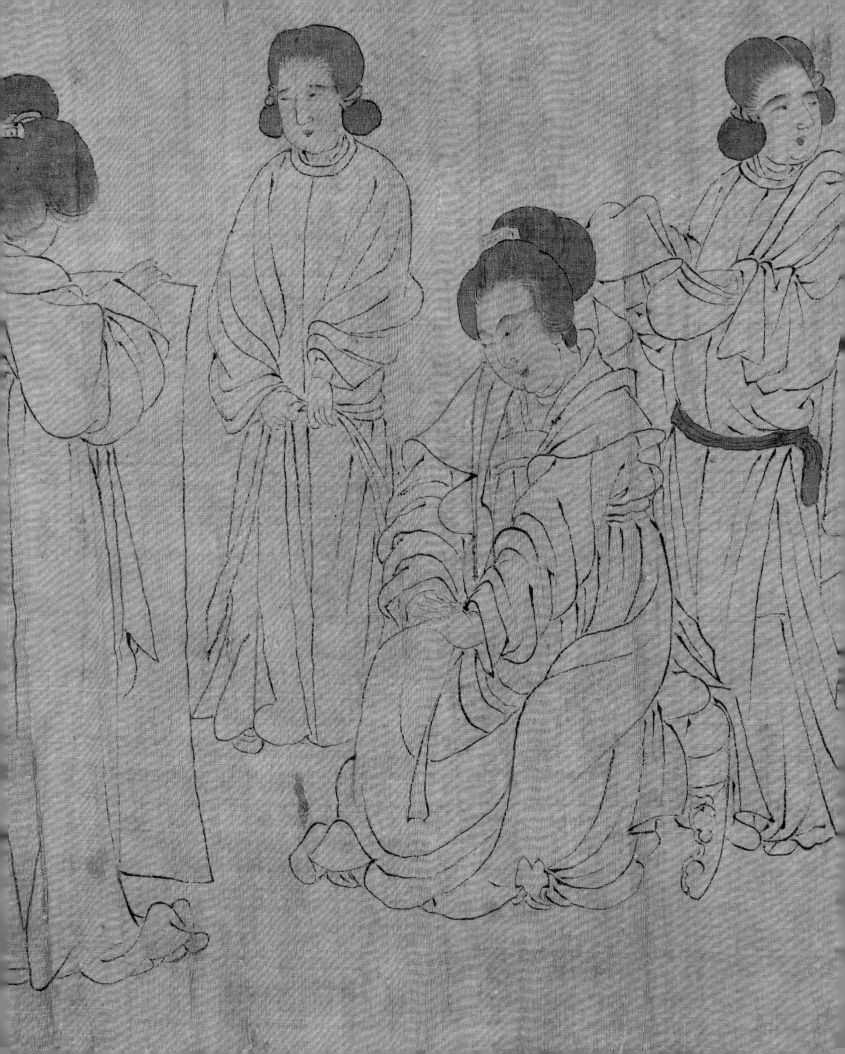

Cat. 25 Southern Song dynasty–Yuan dynasty
Service with Decoration of Flowers and Birds
late 13th–early 14th century
Silver with chased and punched decoration
and gilding
diam. 11.1–19 cm
The Metropolitan Museum of Art, New York.
Purchase, the Vincent Astor Foundation Gift,
1997 (1997.33.1–.3, .5, .6)

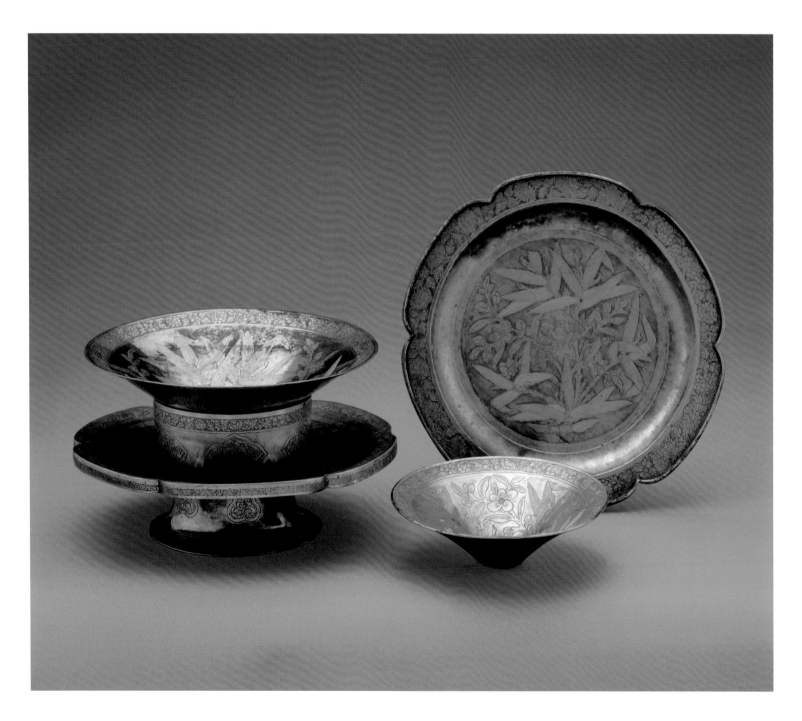

Many silver dishes, bowls, cups, and cup stands survive from the Song dynasty (see cat. 8), but extensive service sets of comparably fine craftsmanship are extremely rare. The Tang dynasty is usually thought of as the heyday of fine metalware production in China. During the Tang a taste for gilt silverwares in shapes and decor based on models from Central Asia, the region from which such objects were first imported into China, led to a period of tremendous artistic and technical achievement. This service demonstrates that the high standards set during the Tang were upheld in metal tableware produced by later silversmiths, who also introduced artistic innovations of their own.

In this assemblage, dating from either the late Southern Song or the early Yuan, the shapes of the vessels are a mix of Central Asian and Chinese designs. However, the decorative program is purely Chinese in origin, featuring finely chased birds and flowers — a motif popular in painting and other decorative arts during the Song. Birds perch on branches, while butterflies flit about leafy bamboo stalks intertwined with peonies, peach blossoms, and other flowers. Each of the rims features a wide band carrying a design of flowers, fruits, and leafy stems. The vessel shapes are also seen in Song and Yuan porcelain and lacquer designs (for example, cats. 9 and 39).

A sumptuously decorated set such as this must have been intended for important feasts and gatherings. *Palace Banquet* (cat. 21) provides an illustration of how they would have been used. All three of the outdoor tables of the ladies' banquet feature metalware, including small dishes, ewers, and large vessels. Although the vast majority of tableware from the Song and Yuan periods only survive as single objects, this service set, as well as the matching and complementary tableware featured in *Palace Banquet*, must have been the standard for elite banquets.

Cat. 26 Northern Song dynasty
 Foliate Dishes with Scalloped Rim
 12th century
 Qingbai ware; porcelain with sky-blue glaze
 H. 3.6 cm, diam. 13.3 cm (2001.44);
 H. 3.8 cm, diam. 13.6 cm (2001.45)
 Harvard Art Museums/Arthur M. Sackler
 Museum. David A. Ellis Oriental Art Fund
 (2001.44, 2001.45)

The eight-petaled chrysanthemum design of these *qingbai* dishes is well known from other examples that survive from the Song period.[1] Their simple form; delicate, thin body; subtle pale glaze; and minimal incised decoration embody the aesthetic of Song dynasty potters and their patrons. Matching dishes such as these would likely have formed part of a larger set. These two dishes are roughly similar in size and color to a few dozen dishes set in neat rows on the dining tables in *Palace Banquet* (cat. 21). In the painting these small dishes are arranged so that several are in arm's reach of each diner, allowing her to choose from a variety of delicacies throughout the meal.

Qingbai ware were produced at kilns in the famed ceramic-production site of Jingdezhen in Jiangxi province (see also cat. 9). *Qingbai* was made with porcelain stone containing significant amounts of kaolin, a clay mineral whose plasticity allowed potters to form vessels with thin walls in delicate forms. *Qingbai* ware's distinctive icy-blue hue resulted from the particular proportion of iron and calcia in the glaze combined with firing in wood-fueled kilns, which provided the necessary reducing (oxygen-poor) atmosphere for the color to develop.[2]

NOTES

1. Eumorfopoulos Collection, Victoria & Albert Museum (C. 97-1939, C. 47-1965); British Museum (1947-12.75a–b). See Stacey Pierson, ed., *Qingbai Ware: Chinese Porcelain of the Song and Yuan Dynasties* (London: Percival David Foundation of Chinese Art, 2002), 77, 78.

2. See Nigel Wood, *Chinese Glazes: Their Origins, Chemistry, and Recreation* (London: A & C Black, 1999), 53–54.

Cat. 27 Western Han dynasty
 Incense Burner (xianglu)
 Bronze
 H. 20 cm, diam. 13.5 cm
 Princeton University Art Museum.
 Museum purchase from the C.D. Carter
 Collection, by subscription (y1965-28)

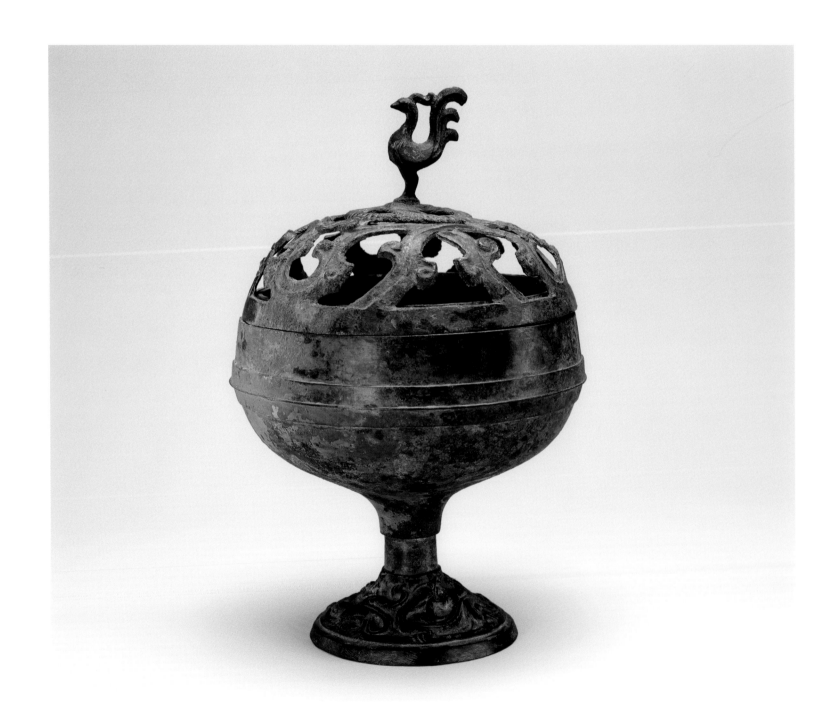

This incense burner is the earliest object in *The Eternal Feast*, dating from the Western Han dynasty. Its inclusion underlines the long history and importance of incense in China.[1] The burning of herbs and plants to create aromatic smoke was an integral component of religious life in both Daoism and Confucianism, as well as Buddhism. The latter introduced several new ingredients and practices that likely originated in South Asia, including aloeswood, "an incense as central to the fragrances of Asia as frankincense was in the incenses of the West."[2]

Apart from the uses of incense in a religious setting, the importance of incense burning and other aromatics in the daily life of the elite during the Tang period is amply recorded in the literature.[3] Its continued ubiquity into the Song dynasty is attested by the numerous silver and ceramic incense burners that survive from the period. An impressive set of gilt incense-related objects is seen in the outdoor terrace of *Palace Banquet* (cat. 21; see fig. 47). Occupying an entire table, the set includes a large domed burner placed atop a dish with flaring lotus leaves circling the rim, and set on a high stand. Two incense containers, along with scissors and other implements, are also depicted.

This bronze incense burner has an openwork cover of undulating cloud tendrils, which would allow smoke to billow forth unimpeded. The cover's handle is a sculpted bird whose head plumage connects to the three plumes of its tail. The cover and bowl fit neatly together in the shape of a ball. The bowl sits on a slender stem balanced on a flat, circular foot. Four dragons in low relief cover the base. The overhead view of the back of each writhing dragon changes to a profile view for the head, allowing a glimpse of their gaping jaws. The feet of the dragons rest on a band above the ring foot, their claws overlapping it.

fig. 47 / Detail of *Palace Banquet* (cat. 21)

NOTES

1. For an illuminating discussion of the varieties and uses of aromatics in the Tang dynasty, see Edward Schafer, *The Golden Peaches of Samarkand* (Berkeley: University of California Press, 1963), 155–75.

2. John Kieschnick, *The Impact of Buddhism on Chinese Material Culture* (Princeton, NJ: Princeton University Press, 2003), 277.

3. See Schafer, *Golden Peaches of Samarkand*, 157.

Cat. 28 Tang dynasty
Standing Court Lady, mid-8th century
Earthenware with traces of cold-painted pigments
38.8 × 13.5 × 12 cm
Harvard Art Museums/Arthur M. Sackler
Museum. Gift of Anthony M. Solomon (2003.202)

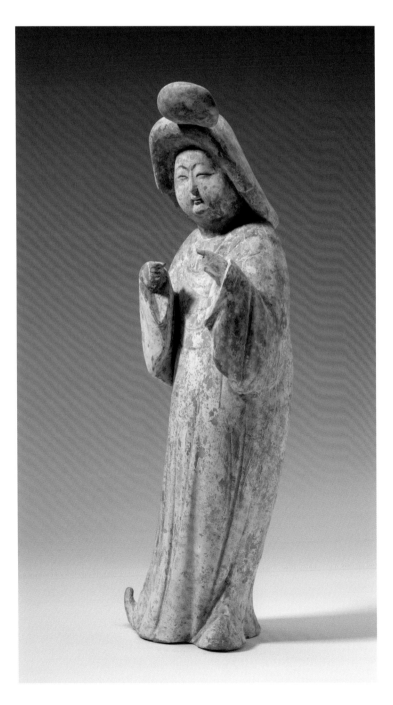

During the Tang dynasty the production of earthenware tomb figures, which were placed in burial chambers to accompany the deceased to the afterlife, must have supported a large market. A profusion of these mass-produced objects survives today, providing some of the most revealing visual evidence of Tang dynasty life. From glum servants to proud warriors, foreign-born camel herders to fashionable ladies, Tang tomb figures illustrate the wide range of identities that populated the Tang empire.

This court lady's plump figure is covered with loose robes that fall from her shoulders to the floor, resting atop her upturned shoes. Long, billowy sleeves hang down from her arms. She stands with her left hip jutting outward, a seemingly swaying stance that gives the figure a beguiling contour. Her round face is framed with a magnificent coiffure that collects at the crown into a loose bun overhanging her face. Her elbows are bent with her wrists raised together and index fingers pointing toward each other. The motive for this unusual gesture is unclear, but the sculptor's intention

may have been to portray her mid-action, raising her forearms to shake back her long sleeves and free her hands. Her rounded figure, clothing, and hairstyle all represent the height of fashion among court and elite women of the mid-eighth century. These fashions were thought to have been popularized by Yang Guifei, Emperor Xuanzong's (r. 713–756) favored consort, who possessed a famously plump figure.

This tomb figure is the type of court lady that inhabits the elaborate residence depicted by the unknown painter of *Palace Banquet* (cat. 21). The ladies in the painting share the same rounded figures and similar, albeit simpler, hairstyles. Both the ladies in the painting and this tomb figure represent an idealized image of Tang period court ladies meant to charm their viewers.

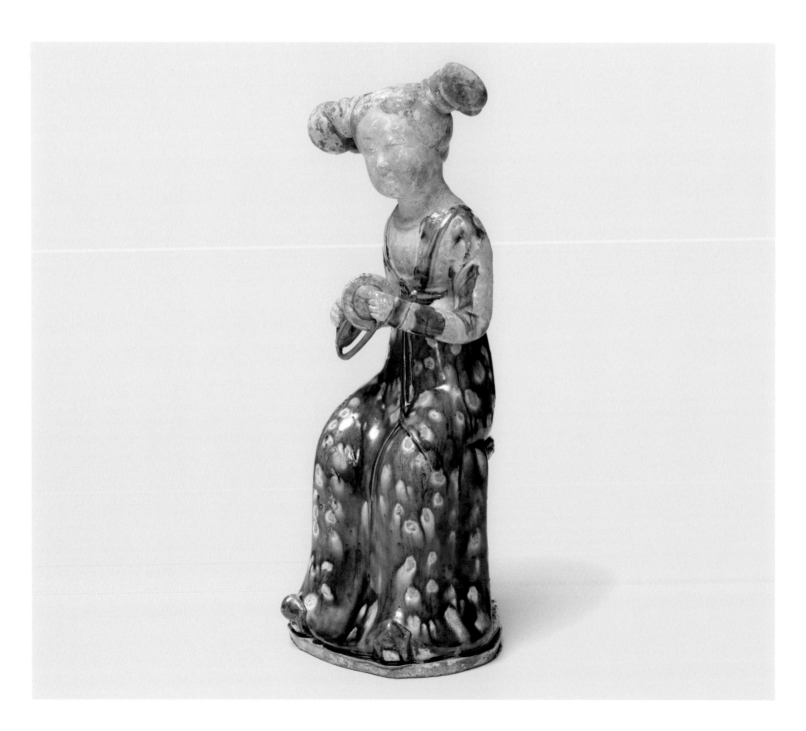

Female-only musical ensembles are frequently seen in Tang and Song dynasty art. This tomb figure of a court lady likely belonged to an orchestra that accompanied a wealthy tomb occupant. She is portrayed seated, a noteworthy feature. Stools and chairs that raised one's body off the ground were introduced into China by way of Buddhist practices from India.[1] Chairs are first mentioned in textual sources during the Tang dynasty but only became widespread in the Song period. A Tang dynasty musician seated on a chair, as opposed to the floor, would have been part of a household whose wealth permitted the most modern of furniture arrangements (see cat. 43 for musicians seated on the floor).

This tomb figure is also magnificently dressed for her performance. Her hair is arranged in a popular "twin bun" style common in depictions of younger or lower-ranked court women. However, this iteration of the form is highly elaborate, with each bun of a significant size and formed of intricately braided strands. The high status of the tomb occupant is also underscored by the decoration of the figure's high-waisted dress, which is a sumptuous example of Tang period *sancai* (tricolor) glaze. The rare cobalt-blue pigment, imported from Persia, was seldom used in *sancai* glazing due to its expense.

The musician's instrument is a cymbal (see cat. 43 for another cymbal player). Small pairs of cymbals were known as *tongbo* 銅鈸. They were probably introduced into China from West or Central Asia sometime before the founding of the Tang dynasty, after which they quickly grew in popularity.[2]

NOTES

1. John Kieschnick, *The Impact of Buddhism on Chinese Material Culture* (Princeton, NJ: Princeton University Press, 2003), 223–36.

2. Grove Music online, http://www.oxfordmusiconline.com/grovemusic/view/10.1093/gmo/9781561592630.001.0001/omo-9781561592630-e-0000043141. Compare to examples of small cymbals, *tongbo*, dating from the Qing dynasty in the Metropolitan Museum of Art (89.4.11a, b) and in the Museum of Fine Arts, Boston (17.2160a–b).

Cat. 30　Tang dynasty
Hairpin with Mandarin Ducks and Lotuses
late 8th–9th century
Beaten silver with gilt finial
L. 28.5 cm, W. 5.7 cm, D. 0.4 cm
Princeton University Art Museum.
Gift of J. Lionberger Davis, Class of 1900
(y1966-86)

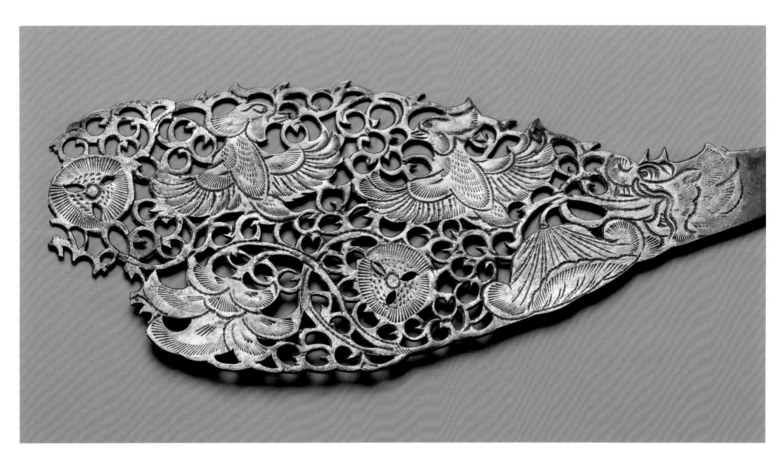

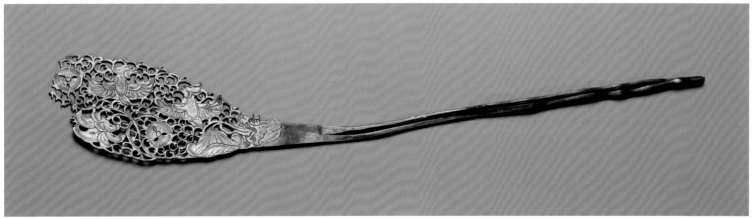

Court women and wealthy fashionable ladies of the Tang and Song dynasties would not have attended a feast without ornamenting their coiffures with an array of hairpins, flowers, or other adornments. The women of *Palace Ladies Bathing Children* (cat. 22) even go about the mundane tasks of bathing and caring for children while wearing multiple hairpins made of precious materials. By the height of the Tang period in the eighth century, hairpins had evolved from simple designs into elaborate and elegant works of art, such as this example. Fashions changed in the Song period, but the basic form of metal hairpins remained the same: a long, narrow pin crowned by an ornate finial design, executed in delicate openwork and repoussé techniques.[1]

This silver hairpin consists of a long, split pin leading to a gilded openwork finial. The decoration of the finial appears to issue from the open mouth of a dragon and is formed of small, tightly curled vine scrolls. Hanging from the vines are lotus pods and flower blossoms. These floral motifs are the backdrop for a pair of mandarin ducks, symbols of good fortune and fidelity, which appear mid-flight, with their wings spread and heads turned toward each other. Numerous examples of hairpins with similar ornamental motifs survive in modern collections, indicating the popularity of the design.[2]

NOTES

1. For a Song dynasty hairpin, see Julia M. White and Emma C. Bunker with Chen Peifen, *Adornment for Eternity: Status and Rank in Chinese Ornament* (Denver: Denver Art Museum, 1994), 173.

2. See Bo Gyllensvärd, *Chinese Gold, Silver, and Porcelain: The Kempe Collection* (New York: Asia Society, 1971), cat. 63. See also Hugh Scott, *The Golden Age of Chinese Art: The Lively T'ang Dynasty* (Rutland, VT: C.E. Tuttle & Co., 1966), pl. 41.

Cat. 31 Northern Song dynasty
Textile Fragment with Boys in Floral Scrolls
11th–12th century
Silk twill damask (*ling*)
47 × 16.5 cm
The George Washington University Museum
and The Textile Museum. Aquired by George
Hewitt Myers in 1934 (3.215)

This textile fragment exemplifies the kind of richly ornamented fabric that would have been used in the costumes of court ladies. Although the women in *Palace Banquet* (cat. 21) are not painted on a scale enabling the viewer to discern the types of fabrics they wear, evidence from other paintings of Tang and Song dynasty ladies reveals a variety of intricately patterned textiles used for their dresses, jackets, and scarves.[1]

This fragment is a silk twill damask, known as *ling* 綾, that was first produced during the Tang dynasty. By the Song and Yuan periods, it had become one of the most popular types of woven silk. The characteristic parallel diagonal ribs and reversible pattern of twill damask is visible in this fragment, one of a handful that survive from the same length of fabric.[2] The textile features an elegant floral scroll linking flowers and lotus pods or pomegranates with figures of little boys peeking out through the floral elements. The pairing of boys and pomegranates or lotus pods is a rebus for male offspring that plays on the shared character for "seed" and "son" (子 *zi*) and would have been an appropriate theme for a lady's dress.[3]

This textile was discovered in Rey, Iran, alongside ceramics from southern Chinese kilns, suggesting that both categories of artifact had traveled via a maritime trading route.[4] The design, undoubtedly popular among Chinese elites (a thematically similar textile fragment was discovered in a Northern Song tomb in Hengyang, Hunan province), must also have appealed to a Persian audience who may have found the floral-scroll pattern congenial given its kinship to earlier forms of ornament in West Asia.[5]

NOTES

1. One of the few Song dynasty archaeological sources for the design of full garments is the tomb of Lady Huang Sheng (d. 1243). Located in the southern province of Fujian, it contained mostly lighter fabrics suitable to the local tropical climate. See Fujian sheng bowuguan, *Fuzhou Nan Song Huang Sheng mu* (Beijing: Wenwu chubanshe, 1982).

2. The collection of the George Washington University Museum and the Textile Museum contains two other fragments from this piece, and a fourth fragment is in the collection of the Metropolitan Museum of Art (52.8).

3. For a discussion of the motif, including its possible Buddhist connections, see James C. Y. Watt and Anne E. Wardwell, with Morris Rossabi, *When Silk Was Gold: Central Asian and Chinese Textiles* (New York: Metropolitan Museum of Art, 1997), 26–27.

4. See Watt and Wardwell, with Rossabi, *When Silk Was Gold*, 48.

5. For the Hengyang tomb's textiles, see Chen Guo'an, "Qiantan Hengyangxian Hejiazao Bei Song mu fangzhipin," *Wenwu* 12 (1984): 80, fig. 2, and plate VI 5, 6.

Cat. 32 Southern Song dynasty
Yang Meizi (1162–1232)
Quatrain on Autumn
Album leaf; ink on silk
35.3 × 53 cm (sheet)
Princeton University Art Museum.
Bequest of John B. Elliott, Class of 1951
(1998-75 b)

四時餚物遣人忙

識破常居快樂鄉

九日籬邊雛泠落

菊花開後乃重陽

This album leaf, containing an inscription of a four-line poem, attests to both the existence of female calligraphers and the high level of their artistic achievement. It was written by one of the few women whose work survives, Empress Yang, the consort of Emperor Ningzong (r. 1195–1224). The work's survival no doubt owes much to the extreme fame of its writer.[1] Empress Yang's handwriting pays homage to the calligraphy of both Emperor Gaozong (r. 1127–1162) and Yan Zhenqing (709–785), one of the most celebrated calligraphers of the Tang dynasty. In this poem, the empress writes about the Double Ninth Festival, which fell on the ninth day of the ninth lunar month and was celebrated by climbing hills or tall towers to admire distant vistas:

On festival days of the four seasons people busily hurry; / From this one knows we are living in a happy domain. / The ninth day approaches, yet beside the fence it is lonely; / Only when the chrysanthemums blossom will the Chongyang Festival arrive.[2]

Calligraphy and painting, the twin pinnacles of fine art in imperial China, were almost entirely the province of men. The veneration of calligraphy as a high art form, in particular, was deeply dependent on the social status of its practitioners. In the Bronze Age, calligraphy was the domain of anonymous court scribes and workshop artisans. After the fall of the Han dynasty, flamboyant gentry officials took up fine handwriting, elevating the art form in part by closely associating their identities with it. By the Tang dynasty, finely written inscriptions by famous calligraphers were coveted by admirers of the art form, regardless of the content of the texts. Tang dynasty Emperor Taizong (r. 626–649) was such a devotee of Wang Xizhi (303–361), the most famous of all early calligraphers, that he emulated Wang's scripts in his own handwriting and endeavored to collect every surviving example of Wang's work.

By the Song period, calligraphy had become a necessary skill for the emperor and the entire scholar-official class. Fine handwriting was built into the imperial examination system by which government office was achieved. And in the world of letters and poetry, calligraphy had become an indispensable representation of one's social identity to the point where even one's ethical character could be judged by it. For literati gentlemen, who made up the official class, the writing of poetry in an expressive hand was a frequent pastime at parties and feasts. The activities of elite women for similar occasions is less known, but considering that many were well educated and also trained in calligraphy, it seems plausible that a ladies' banquet might also have been a site for the performance of beautiful writing.

Seals

Empress Yang Meizi 楊妹子 :
1. "Yang xing zhi zhang" 楊姓之章
2. *Kun* trigram (three broken bars), square relief seal (left, bottom)

Collectors

An Guo 安國 (1481–1534)
Wu Yuanhui 伍元蕙 (1834–1865), four seals
Unknown
Pan Yanling 潘延齡 (late Qing dynasty)

Colophons

Luo Tianchi 羅天池 (1805–1856; *jinshi* degree, 1826).
Chen Qikun 陳其錕 (*jinshi* degree, 1826)
Wu Yuanhui 伍元蕙 (1834–1865)
Pan Shicheng 潘仕成 (1804–1873; *juren* degree, 1832)

NOTES

1. Hui-shu Lee, "The Emperor's Lady Ghostwriters in Song Dynasty China," *Artibus Asiae* 64, no. 1 (2004): 61–101.

2. Translated by Robert E. Harrist Jr. See Robert E. Harrist Jr., Wen C. Fong, et al., *The Embodied Image: Chinese Calligraphy from the John B. Elliott Collection* (Princeton, NJ: The Art Museum, Princeton University, 1999), 116.

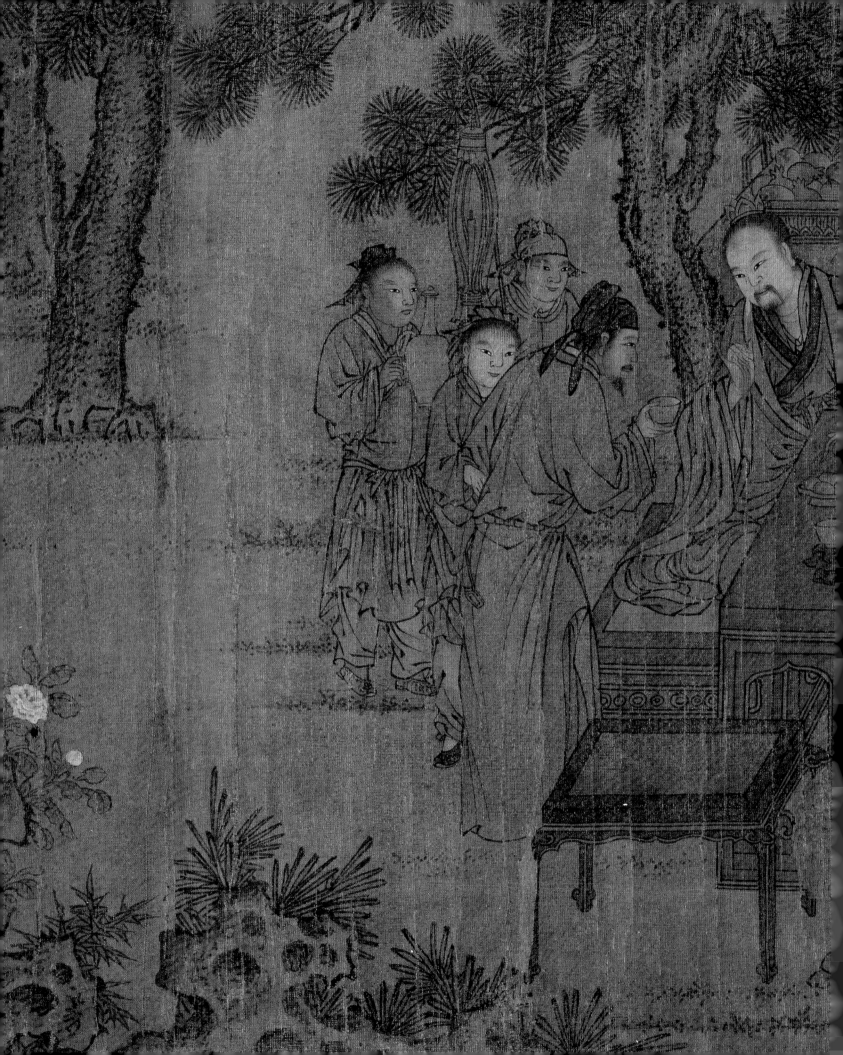

GENTLEMEN
FEASTING
AS SCHOLARLY
BUSINESS

cats. 33–46

Cat. 34 Southern Song dynasty
Ma Hezhi (active mid–late-12th century) and assistants
Odes of the State of Bin, mid-12th century
Handscroll; ink, color, gold, and silver on silk
27.8 × 663.3 cm (painting);
351.1 × 1398.3 cm (overall with mounting)
The Metropolitan Museum of Art, New York. Ex coll.:
C. C. Wang Family, Purchase, Gift of J. Pierpont
Morgan, by exchange, 1973 (1973.121.3)

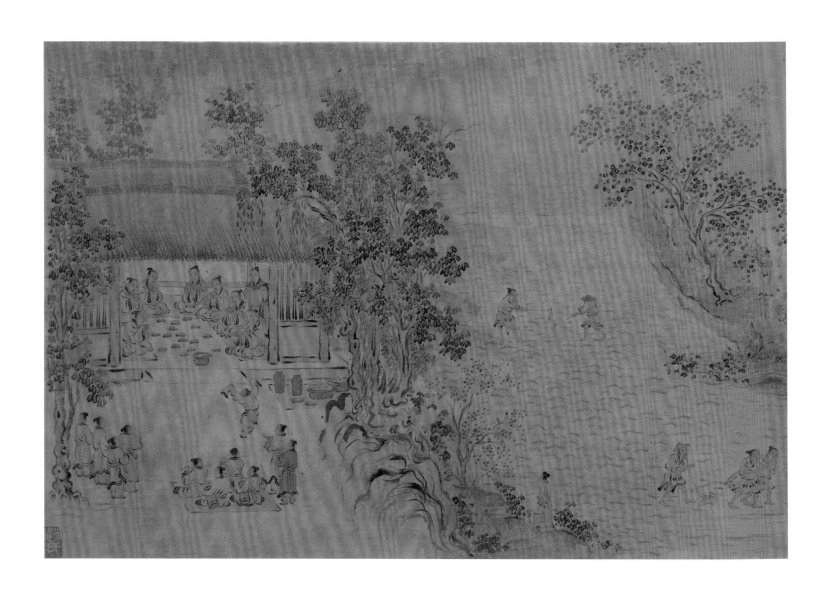

Not much is known about the life of Ma Hezhi. A gifted painter active during the reign of the Southern Song emperor Gaozong (r. 1127–1162), his fame lies primarily in his connection to an imperial project to illustrate the *Book of Odes* (*Shijing* 詩經), a collection of 305 folk songs, courtly odes, and religious hymns dating to the first millennium BC.[1] Traditionally thought to have been compiled by Confucius as models for ethical personal behavior and proper governance, the archaic, often abstruse verses of the *Book of Odes* formed the subject of earlier court-sponsored painting projects during the Six Dynasties and the Tang. Only a portion of the paintings commissioned by Gaozong survive today. This scroll illustrates *Odes of the State of Bin*, one of fifteen books from the classic, devoted to the popular songs of different states.

Charged with designing illustrations for an edifying Confucian classic, Ma Hezhi and his assistants created a tableau of idealized country life.[2] The scroll opens with agricultural scenes illustrating "The Seventh Month," a poem recounting the works and days of the seasons; a detail of the image is shown here.[3] Among the vignettes we see women picking and gathering mulberry leaves to feed silkworms, illustrating the following bucolic verse:

In the silk-worm month they gather the mulberry-leaves, / Take that chopper and bill To lop the far boughs and high, / Pull towards them the tender leaves.[4]

Beyond the mulberry grove, men plow a field. The scene culminates in an illustration of the concluding verses of the poem, which describe a village feast celebrating the local lord:

In the tenth month they clear the stack grounds. / With twin pitchers they hold the village feast, / Killing for it a young lamb. / Raise the drinking-cup of buffalo horn: / "Hurray for our lord; may he live for ever and ever!"[5]

The simple architecture, lack of furniture, and plain attire of the guests identify the feast as taking place during some unspecified earlier period. In contrast to the revelry pictured in *Evening Literary Gathering* (cat. 33), this feast is decidedly sober.

A group of seven gentlemen sit on the floor inside a simple thatched-roof structure. They are seated on three sides of a mat, each with hands clasped around a small cup raised halfway to his mouth. This motif of synchronized action is seen in other clusters of figures throughout the scene.

A small dish appears on the mat in front of every guest. Several other small plates filled with food are set in the center. To the right of the gentlemen, two servants stand in attendance. Pairs of large bowls and pitchers, alluded to in the poem, are placed just outside the building. A dancer with his arms raised and sleeves flung out performs in front of the guests (see cat. 44 for a figure of a dancer). Musicians on flutes, drums, and other instruments accompany him. Another group of men standing to the side of the musicians take in the performance. The carefully coordinated decorum of the figures, combined with the feast's rustic setting, gives the scene a feeling of contrived harmony fully in keeping with the didactic interpretation of the ancient poem the artist was required to illustrate.

NOTES

1. The survival of fragments from multiple twelfth-century versions of the scrolls suggests that duplication, presumably in service of the propagandistic nature of the work, was an essential feature of the original commission. For a study of the project, see Julia Murray, *Ma Hezhi and the Illustration of the "Book of Odes"* (Cambridge: Cambridge University Press, 1993).

2. It is unclear whether Ma Hezhi was employed by the emperor as a painter or instead belonged to the higher-status class of scholar-officials. In either case, the project likely also included the work of multiple court painters and calligraphers.

3. Each painting in the scroll is prefaced by an inscription that includes the poem it illustrates, written in a hand modeled on the calligraphy of Emperor Gaozong.

4. Arthur Waley, *The Book of Songs* (New York: Grove Press, 1960), 165.

5. Waley, *Book of Songs,* 167.

Four Song Cups

Song tableware survives in an astonishing range of sophisticated glazes. The four vessels gathered here, produced by Jun, Ding, Guan, and Yaozhou kilns, illustrate this tremendous artistic variety. In the Song dynasty, the table settings for an elite feast would have consisted of matching sets of bowls, dishes, and cups in spectacular wares such as these. All roughly the same size, these small cups would have served wine or tea. The gentlemen drinking in *Evening Literary Gathering* (cat. 33) illustrate how cups such as these functioned within contemporary dining practices. The painting shows cups either in the hands of revelers or set on lacquer cup stands (see cat. 39). One unused or emptied cup lies upside down on its stand.

Circular Cup (cat. 35) is an unusual green-glazed example of Jun ware, more commonly recognized for its distinctive blue and purple glazes. Jun ware was regarded as one of the "five famous wares" of the Song period. Produced in Henan province, Jun vessels were thickly potted and known for bright, opaque glazes that thin at the rim. The subtle green glaze on this cup may have held greater appeal for a literati audience, such as the gentlemen in *Evening Literary Gathering*, than the flashier blue- or purple-splashed glazes typically associated with Jun ware.[1]

Guan, or "official" ware, represented by a fine example here (cat. 36), was another famed Song dynasty ceramic. Established by imperial decree of the Southern Song at its newly created capital of Hangzhou, Guan ware kilns were initially charged with replacing the northern Ru ware, which had previously supplied the Song court prior to the Jurchen invasion of the north. Later Guan wares have a thin body accompanied by thick layers of glaze. One of the most distinguishing characteristics of Guan vessels is their crazing, which resulted from the glaze shrinking at a greater rate than the body during cooling. This clearly defined crackle was often stained by a dark pigment, as seen in this cup, to emphasize the decorative pattern of the craze lines.

A third famous Song dynasty ceramic ware is represented by the Ding ware cup with a lotus design. Ding ware was first produced in Hebei province in northern China during the Tang dynasty. Famed for their cream-colored porcelain (cat. 37), although brown and black Ding ware are also known, Ding potters created delicate, thin-walled vessels featuring incised or molded ornamental motifs in light relief. The interior of this ivory-toned cup is decorated with a lotus blossom attached to a tendril from which curling leaves spring. The artist created the flower using only a few swiftly incised lines, some of which overshoot the ends of the petals. The restrained elegance of the resulting design owes much to this seemingly casual method of execution. As was the practice with many Ding ware vessels, the unglazed rim of the cup would have originally been fitted with a thin metal band.[2]

The Yaozhou bowl (cat. 38) with molded decoration provides a parallel to the more conically shaped cups seen in *Evening Literary Gathering*. Yaozhou wares, which originated in the kilns of Shaanxi province, are often referred to as "Northern celadons," in contrast to the Yue ware celadons of the south (see cat. 10). Yaozhou ware has a deep olive–green glaze that deepens in color in areas where it is thicker. This potential contrast of light and dark glaze was exploited by Yaozhou potters in the varying depths of the relief decoration they created. In order to repeatedly produce complex designs in an efficient, uniform manner, Yaozhou potters frequently made use of molds. The interior decoration of this bowl was created using such a mold. It comprises a tendril with alternating small and large chrysanthemums surrounding a central open flower. The space between flowers is filled by small, curling leaves sprouting from the tendrils. The exterior carries a simple pattern of vertical fluting.[3]

NOTES

1. A slightly larger green-glazed Jun ware cup survives in the collection of the Art Gallery of New South Wales; Jackie Menzies, *The Asian Collections: Art Gallery of New South Wales* (Sydney: Art Gallery of New South Wales, 2003), 105.

2. Other Ding ware objects also feature this decorative pattern. Regina Krahl, *Chinese Ceramics from the Meiyintang Collection*, 2 vols. (London: Azimuth Editions, 1994), 1:204–5, cats. 358 and 361.

3. The survival of cups matching this one testifies to the popularity of the design. See Krahl, *Meiyintang Collection*, 1:239, cat. 429; Suzanne G. Valenstein, *A Handbook of Chinese Ceramics* (New York: Metropolitan Museum of Art, 1989), pl. 74; Shaanxi sheng bowuguan, *Yao ci tulu* (Beijing: Zhongguo gudian yishu chubanshe, 1956), part 1, pls. 17 and 18.

Cat. 35 Northern Song dynasty–Jin dynasty
Circular Cup
late 11th century–first half of the 12th century
Green Jun ware; light-gray stoneware
with celadon glaze
H. 4.7 cm, diam. 9.5 cm
Harvard Art Museums/Arthur M. Sackler
Museum. Gift of William B. Goldstein, M.D.
(2004.154)

Cat. 36 Song dynasty
 Wine Cup
 Guan ware; glazed dark-brown stoneware
 H. 3.5 cm, diam. 8 cm
 The Cleveland Museum of Art.
 Gift of Mr. and Mrs. Severance A.
 Millikin (1957.71)

Cat. 37 Northern Song dynasty
 Circular Cup or Bowl with Lotus Decor
 11th–early 12th century
 Ding ware; porcelaneous white stoneware
 with glaze over incised decoration
 H. 4 cm, diam. 9 cm
 Harvard Art Museums/Arthur M. Sackler
 Museum. Gift of Shirley Nye in memory
 of Warren E. Cox (1999.334.31)

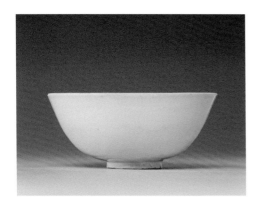

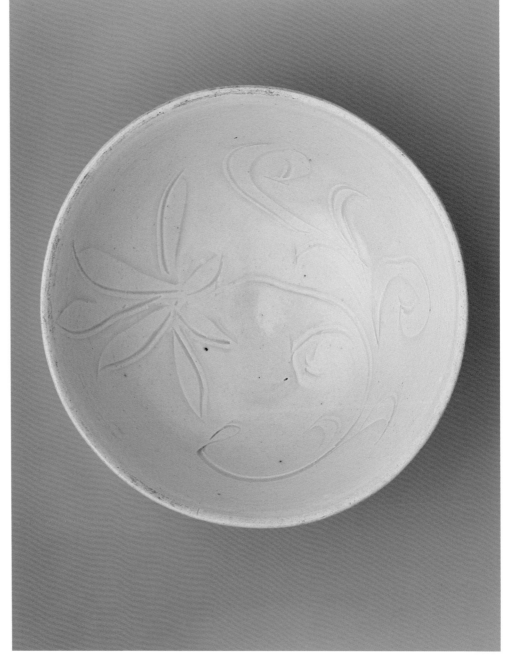

Cat. 38 Song dynasty
 Celadon Bowl, late 11th–12th century
 Yaozhou ware; glazed ceramic with
 molded designs
 H. 3.9 cm, diam. 9.7 cm
 Princeton University Art Museum.
 Gift of Robert L. Poster, Class of 1962,
 and Amy Poster (2015-6770)

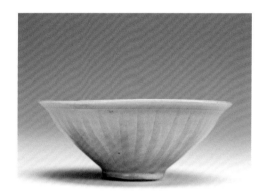

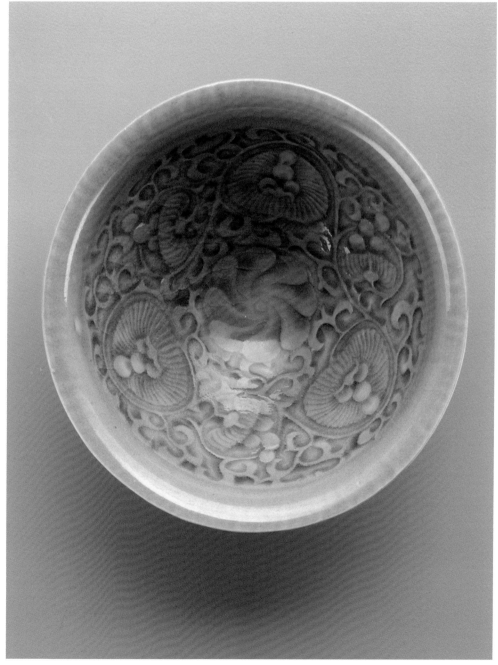

Cat. 39 Southern Song dynasty
Cup Stand
Wood with brown-black lacquer
H. 9.5 cm, diam. 15.9 cm
Detroit Institute of Arts. Founders Society
Purchase, Aquisitions Fund (79.150)

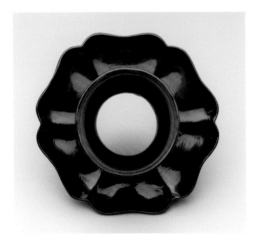

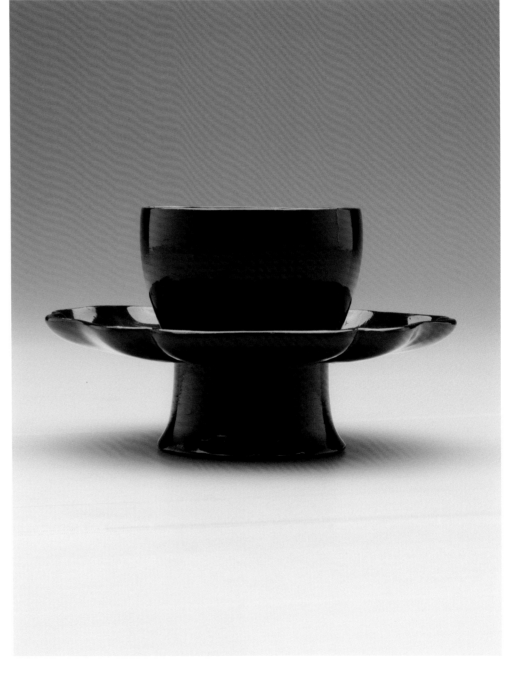

fig. 48 / Detail of *Evening Literary Gathering* (cat. 33)

This supremely elegant cup stand represents the epitome of fine lacquerware from the Song period. In China, lacquer objects were produced as luxury wares from the Neolithic period. Made from the highly toxic sap of the lacquer tree (*Rhus vernic-iflua*), lacquer is applied in layers, sometimes as many as thirty, over the surface of a variety of materials, including wood or cloth. The lustrous surface of the finished lacquer creates a hard, smooth, protective envelope with excellent durability, both waterproof and highly resistant to heat and acids. Lacquer may be colored with different pigments. During the early Bronze Age, cinnabar and lampblack were added to lacquer, resulting in the red and black colors of early painted designs. Over time new pigments, such as lead white, were added to the lacquerer's palette. Inlay, sometimes in gold and silver, as well as relief carving of the underlying support, were also widely used methods for decorating lacquer objects.

Despite all these design options, simple, unadorned lacquer vessels enjoyed perhaps the greatest prestige during the Song dynasty. This dark brown–hued cup stand reflects the restrained aesthetic admired by the Song elite. The wood support of the cup stand is delicately carved to form a tripart design, consisting of a cup-shaped upper section resting on a dish set atop a tall ring foot. The object's visual interest lies partially in its striking silhouette, which subtly inverts the convex curving profile of the upper section in the ring foot emerging below the dish. The gentle contours of the upper section and foot are punctuated by the more rapid undulations along the rim of the multilobed tray. Viewed from above, the hollow tube of the stand makes up the center of the six-petaled flower defined by the dish.

Relatively few lacquer cup stands survive from the Song. Stoneware versions with dark glazes that imitate the color of lacquer demonstrate the popularity of the originals.[1] Similar stands are also pictured in *Evening Literary Gathering* (cat. 33; fig. 48). Cup stands are often associated with tea drinking, but their presence on the tables of the inebriated partiers depicted in the painting demonstrates their appropriateness for supporting warm cups of wine.[2] The cup stands are depicted as either all red or all black, two colors long associated with lacquerware, suggesting that lacquer was the intended material. In the painting, they are paired with ceramic wine cups that resemble cats. 35–38. A single-character inscription (西 *xi*) appears inside the foot of the vessel (see opposite).

NOTES

1. Robert D. Mowry, *Hare's Fur, Tortoiseshell, and Partridge Feathers: Chinese Brown-and Black-glazed Ceramics, 400–1400* (Cambridge, MA: Harvard University Art Museums, 1996), 102–4.

2. See also Regina Krahl, "White Wares of North China," in Regina Krahl, John Guy, J. Keith Wilson, and Julian Raby, eds., *Shipwrecked: Tang Treasures and Monsoon Winds* (Washington, DC: Smithsonian Institution, 2011), 205.

Cat. 40 Southern Song dynasty
Lotus Bowl, 13th century
Longquan ware; green-glazed
porcelaneous stoneware
H. 10.5 cm, diam. 21.6 cm
The Cleveland Museum of Art.
John L. Severance Fund (1957.54)

Cat. 41 Northern Song dynasty
Large Bowl, 11th–12th century
Ding ware with russet glaze
H. 6.3 cm, diam. 19.6 cm
Princeton University Art Museum.
Museum purchase, Fowler McCormick,
Class of 1921 Fund (2002-298)

figs. 49 and 50 / Details of *Evening Literary Gathering* (cat. 33) showing cups for drinking and bowls of food

The feast depicted in *Evening Literary Gathering* (cat. 33) would have provided guests with a sumptuous meal and bountiful wine. Song dynasty dining practices would have called for multiple courses of individual dishes shared by all the diners at the table. Unfortunately, the painting does not provide a great deal of information concerning the food the gentlemen are enjoying. Only the final refreshments of the meal, which is already drawing to a close, are shown. Each table in the painting features plates with curved sides and shallow bowls of varying sizes. In the vessels containing food, large, round objects, some with pointed ends, could be buns, steamed or fried, or a variety of fruit, such as pears or peaches. Smaller, round foodstuffs seen in some smaller bowls on the tables are possibly sweetmeats or other small fruits, perhaps lychee.[1]

Several different plates and large bowls are seen in *Evening Literary Gathering*, but, given the small scale of the depictions, particulars regarding their glaze or design are difficult to discern. Similar in profile to bowls seen in the painting, these two bowls would be possible candidates for the type of ceramic vessels used at a gentlemen's feast. The steep, conical shape of this Southern Song lotus bowl (cat. 40) is reminiscent of a vessel on the third table, glimpsed above the raised arm of a guest (fig. 49). Named for its exterior decoration, which resembles the petals of a lotus flower, this bowl exhibits a lustrous bright blue–green glaze that marks it as among the best of the Longquan kiln's products. Few examples as large as this survive today.[2]

The majority of the serving dishes in the painting are wide, shallow bowls or plates with curved sides (fig. 50) similar to this large Northern Song bowl (cat. 41). The bowl is a rare example of a russet-glazed Ding ware vessel in this shape (see cat. 37 for a white Ding ware example; see also cat. 14).[3] The bowl features a six-cusped rim. Subtle thinning of the glaze along the rim accentuates the cusped design, revealing the white ceramic body beneath. Ding kilns were in operation in northern China from the late Tang period to around 1300. Russet- and brown-black-glazed

ceramics produced at Ding kilns were likely imitations of red and black lacquers that represented the height of fashion during the Song period (see cat. 39). Although not discernible on this bowl, some russet-glazed vessels were painted with gold decoration. Fine, wide bowls such as this would have been fitting tableware for a luxurious feast.

NOTES

1. The menus and records of lavish imperial feasts indicate that fruit was served at the beginning of meals, but it is unclear when it would have appeared at far less formal gatherings. See Michael Freeman, "Sung," in K. C. Chang, ed., *Food in Chinese Culture: Anthropological and Historical Perspectives* (New Haven, CT: Yale University Press, 1977), 166.

2. A similar bowl is in the collection of the Palace Museum, Beijing; see Zhejiang sheng qinggongye ting, ed., *Longquan qingci* (Beijing: Wenwu chubanshe, 1966), pl. 28.

3. For a similar bowl, see Robert D. Mowry, *Hare's Fur, Tortoiseshell, and Partridge Feathers: Chinese Brown- and Black-Glazed Ceramics, 400–1400* (Cambridge, MA: Harvard University Art Museums, 1996), 107.

Cat. 42 Southern Song dynasty
Wine Ewer and Warming Bowl
Qingbai ware; porcelain with pale blue glaze
over incised decoration
22.2 × 14 × 14 cm
Herbert F. Johnson Museum of Art, Cornell
University. George and Mary Rockwell Collection
(81.110)

The shape of the ewer, which nestles into the matching basin, is similar to the *Inscribed Green-Glazed Ewer and Cover* in this exhibition (cat. 10). The ewer's small, oval body features a short, arching spout and a double-stranded loop handle. The bottom half of the ewer, which would have been visible only when not placed in the warming basin, is undecorated. The top half is decorated with large, incised peony flowers with combed petals. An incised geometric leaf pattern encircles the ewer's lid, atop of which sits a roaring lion. The six-lobed warming basin features a similar incised and combed floral pattern. The set is an example of *qingbai* ware, as are the porcelain cup and stand (cat. 9) in the Dining in the Afterlife section and the pair of foliate dishes (cat. 26) in the Ladies Banqueting in Seclusion section.

Wine served from ewers, such as this one, was kept warm by the hot water that filled the matching basin. Ewer and basin sets seem to have first appeared during the Northern Song dynasty.[1] There is a charming depiction of one in the famous Northern Song handscroll *Along the River during the Qingming Festival* (fig. 51). The vessel in the Qingming painting serves just two restaurant customers, an intimate number of drinkers that would have also been appropriate for the diminutive size of the example in this show. The vessel type is also depicted in a mural from a Liao dynasty tomb dated to 1116 (fig. 17).

NOTE

1. See Zhang Bai, ed., *Zhongguo chutu ciqi quanji*, vol. 7, *Jiangsu, Shanghai* (Beijing: Kexue chubanshe, 2008), 116, for a similar example; and Regina Krahl, *Chinese Ceramics from the Meiyintang Collection*, 2 vols. (London: Azimuth Editions, 1994), 1:318.

fig. 51 / Northern Song dynasty, Zhang Zeduan (1085–1145), *Along the River during the Qingming Festival* (detail), 12th century. Ink, color, and silk. Palace Museum, Beijing

Several magnificent long-necked, ovoid ewers stand on the gentlemen's tables in *Evening Literary Gathering* (cat. 33). These ewers, along with two other large storage vessels seen at the left end of the scroll — one so heavy that two young serving girls struggle to carry it — serve and store the wine intended for the increasingly inebriated guests of the party. It is unclear whether the painter intended these vessels to be ceramic or metal. Ewers and storage vessels of this shape and great size do not seem to have survived from the Song or Yuan periods in either material. Smaller versions of the types are known, however, such as this wine ewer and warming bowl.

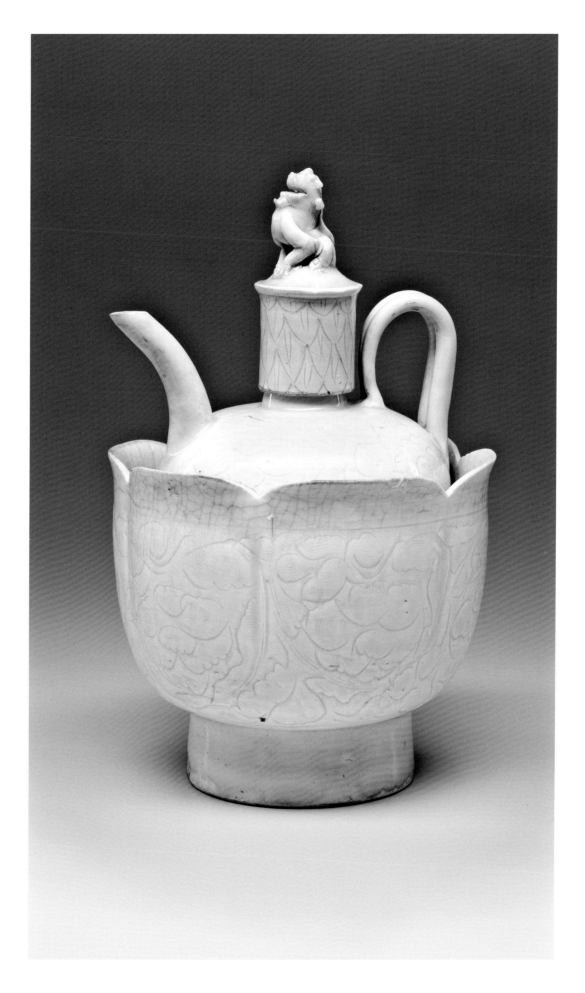

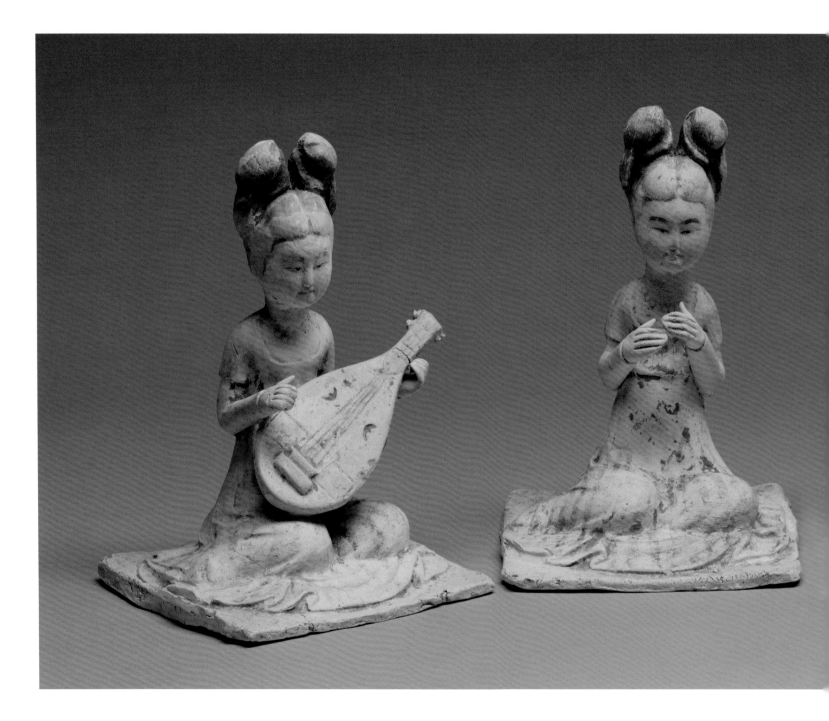

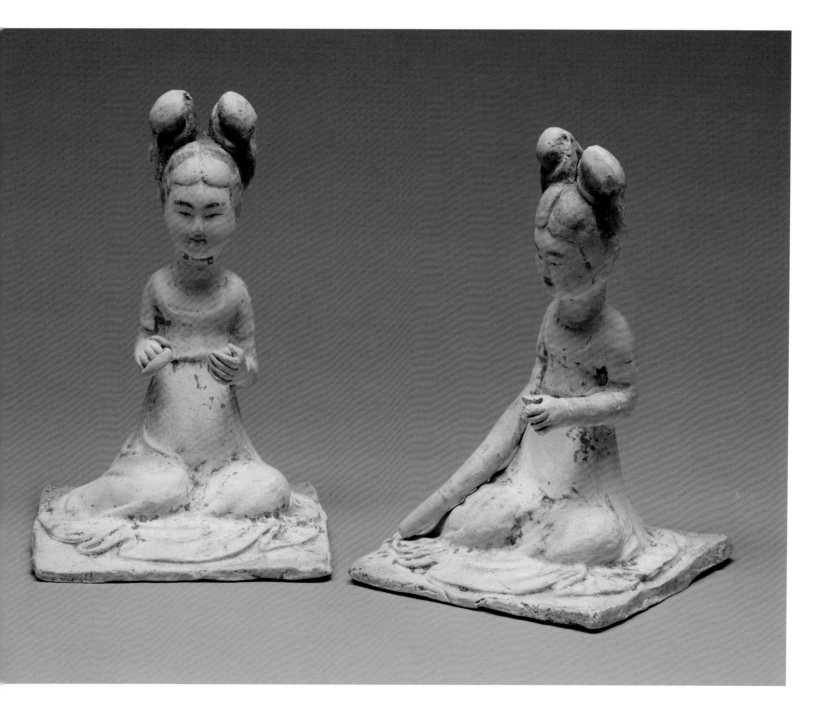

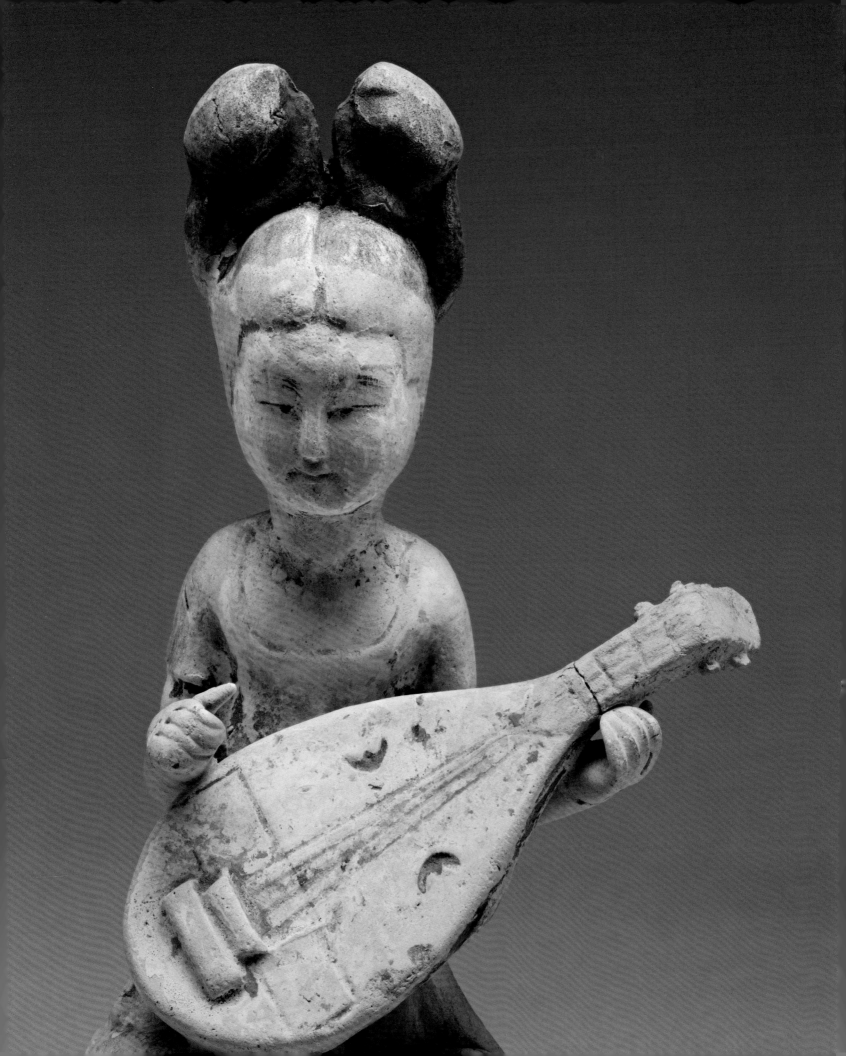

Although the gentlemen of *Evening Literary Gathering* (cat. 33) rely solely on wine and their own banter for amusement, such parties often included entertainment from musicians and dancers. The ancient feast scene portrayed in *Odes of the State of Bin* (cat. 34) includes an all-male group of performers. Female-only ensembles, represented by this group of Tang dynasty tomb figures, seem to have been a common feature of Tang and Song banqueting culture. Inevitably, the makeup of the dance troupe and musical ensemble would have been dictated by the occasion.

Music has a long and rich tradition in China that is amply attested to in the material record. Extravagant bronze bell sets and chimestones, as well as other luxurious instruments discovered in Zhou period (ca. 1050–256 BC) tombs, demonstrate the overwhelming importance of music in both the public and private lives of the elite from an early date. During the Tang dynasty, imperial households included hundreds of female entertainers, many of whom were musicians. By the late Tang, even minor officials employed female musicians.[1] This practice continued and expanded in the Song and Yuan periods to the point where female musicians were an indispensable part of a successful literati household.[2]

The ladies in this set are kneeling on the floor. Traces of cold-painted details (pigments applied after the ceramic body was fired) survive: black ink delineates the ladies' thick eyebrows; red pigment highlights their lips; and dark-orange vertical lines decorate the drapery of their flowing gowns. Although these figures date from the Tang dynasty, the instruments they play, the *pipa* lute and the *tongbo* cymbals (see cat. 29), continued to enjoy popularity throughout the rest of dynastic Chinese history.[3] Introduced from West Asia, the *pipa* lute came into fashion during the Tang dynasty. It was played with a triangular plectrum during the Tang; by the Song period the strings were plucked by hand, as is the practice today. The two figures without instruments may originally have held ones made of a more perishable material that no longer survives.

NOTES

1. Beverly Bossler, "Vocabularies of Pleasure: Categorizing Female Entertainers in the Late Tang Dynasty," *Harvard Journal of Asiatic Studies* 72, no. 1 (June 2012): 81, 84.

2. Beverly Bossler, "Floating Sleeves, Willow Waists, and Dreams of Spring: Entertainment and Its Enemies in Song History and Historiography," in *Senses of the City: Perceptions of Hangzhou and Southern Song China, 1127–1279*, ed. Joseph S. C. Lam, Shuen-fu Lin, Christian de Pee, and Martin Powers (Hong Kong: Chinese University Press, 2017), 1–24.

3. Tang Yin (Ming dynasty), *Tao Gu Presenting a Lyric*, National Palace Museum, Taipei; Qing dynasty, pair of cymbals (*tongbo*), Museum of Fine Arts, Boston (17.2160a–b). See also *Lady Su Hui and Her Verse Puzzle*, Metropolitan Museum of Art (33.167).

Cat. 44 Tang dynasty
Figure of a Dancer
Painted earthenware with white slip
H. 18.1 cm
Minneapolis Institute of Art.
Bequest of Alfred F. Pillsbury
(50.46.182)

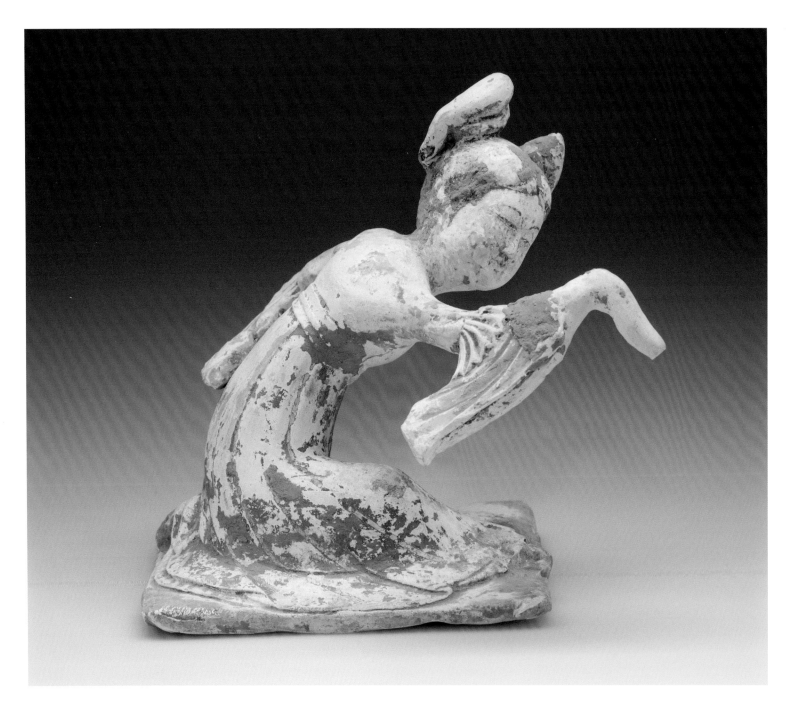

Dancers, like musicians, were a common feature of gentlemen's feasts during the Tang, Song, and Yuan dynasties. Two verses written by the Tang poet Meng Haoran (689–740) describe a banquet at an official's house that featured performances by musicians and dancers.[1] Poetry from the Song dynasty includes plentiful references to gentlemen's feasts and parties featuring young female dancers.[2]

During the Tang dynasty several different classes of dance are recorded, including complicated and daring sword dances as well as "supple" dances that were performed by women sometimes with the aid of fans or ribbons.[3] This particular tomb figure is captured in the middle of a sleeve dance, a category of dance belonging to the supple class that had a long history — examples of tomb figures depicting sleeve dancers survive from the Han dynasty. Shown kneeling on the ground, the dancer bends forward at the hip, her head tilted toward her raised right arm. Her other arm reaches downward behind her body. The long sleeves of her gown flutter with the motion of her arms and hands.

Sleeve dancing seems to have remained popular in the Song dynasty, although dance from that period is more notable for its acrobatic moves.[4] Dance continued to develop in the Song period and expanded as the steadily growing theatrical art forms began to include more dance segments during performances. By the Yuan period far fewer references to dancers entertaining gentlemen at feasts survive, perhaps because the fashion for writing poems about banquets had faded.[5]

NOTES

1. Beverly Bossler, "Vocabularies of Pleasure: Categorizing Female Entertainers in the Late Tang Dynasty," *Harvard Journal of Asiatic Studies* 72, no. 1 (June 2012): 79

2. Beverly Bossler, "Floating Sleeves, Willow Waists, and Dreams of Spring: Entertainment and Its Enemies in Song History and Historiography," in *Senses of the City: Perceptions of Hangzhou and Southern Song China, 1127–1279*, ed. Joseph S. C. Lam, Shuen-fu Lin, Christian de Pee, and Martin Powers (Hong Kong: Chinese University Press, 2017), 7.

3. Charles D. Benn, *China's Golden Age: Everyday Life in the Tang Dynasty* (New York: Oxford University Press, 2004), 168–69; Shih-Ming Li Chang and Lynn E. Frederiksen, *Chinese Dance: In the Vast Land and Beyond* (Middletown, CT: Wesleyan University Press, 2016), 20.

4. Bossler, "Floating Sleeves," 7.

5. Bossler, "Floating Sleeves," 21.

Cat. 45 Qing dynasty
Taihu Rock
Limestone with *hongmu* wood base
134.6 × 47.0 × 45.7 cm
Princeton University Art Museum.
Gift of the P. Y. and Kinmay W. Tang Center
for East Asian Art, and Museum purchase,
Asian Art Department Fund (2008-65)

fig. 52 / Detail of *Evening Literary Gathering* (cat. 33)

The gentlemen's party portrayed in *Evening Literary Gathering* (cat. 33; fig. 52) takes place outdoors without any suggestion of a specific location. However, the depiction of a cobblestone path and several magnificent rocks indicate that the feast takes place in a private garden, surely near a large residence. With their pitted surfaces and contorted shapes, these rocks are known as "scholar's rocks" because they were especially admired by gentlemen of the scholar-literati class. Thought to embody a scholar's uncompromising character, such rocks, often large in size, were placed in gardens to be admired and contemplated.

Among the many varieties of scholar's rocks, Taihu rocks, such as this one, farmed from Lake Tai in Jiangsu province, were most desirable. The rocks may seem as though they are objects shaped by nature and untouched by human intervention, but that is usually not the case. The perforated surfaces of the stones were formed by drilling the limestone and then immersing the stones in a lake, where the motion of water and sand eroded them over time — sometimes over many decades. When harvested, the perforations often appear to be natural, and the rocks resemble miniature cosmic mountains, with heavenly grottoes and fantastic peaks.

Walled gardens — in palaces or in the urban homes of scholars, officials, and merchants — have long been viewed as both extensions of domestic space and places of escape from it. Designed for contemplating a carefully constructed version of the natural world, they offered respite from familial and professional duties. Many gardens were created based on the idealized landscapes found in Chinese paintings — some were even designed by painters. The close connection of gardens to landscape painting is clearly reflected in one of the leading principles of garden design: the inclusion of a path that guides the visitor through a series of carefully composed scenes of architecture, rocks, and plants.

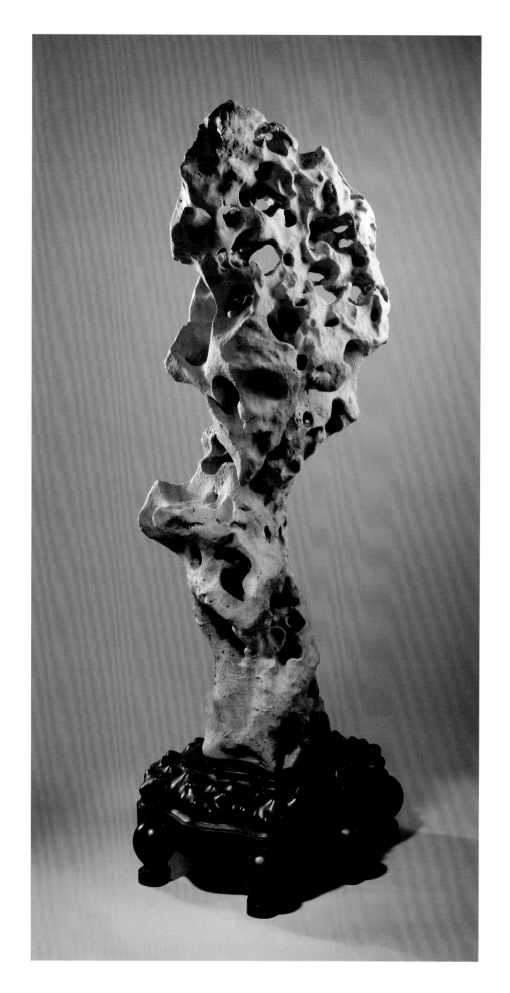

Cat. 46 Yuan dynasty
 Ni Zan (1301–1374)
 Twin Trees by the South Bank, 1353
 Hanging scroll; ink on paper
 56 × 27 cm (painting);
 203.8 × 45.8 cm (overall with mounting)
 Princeton University Art Museum.
 Gift of Wen C. Fong, Class of 1951 and
 Graduate School Class of 1958, and Constance
 Tang Fong in honor of Mrs. Edward L.
 Elliott (y1975-35)

The gentlemen depicted in *Evening Literary Gathering* (cat. 33) belonged to a class of educated elites, almost all of whom would have been competent, if not always gifted, calligraphers and poets. Beginning in the Song period, some of these scholarly gentlemen also became proficient painters, with a few truly excelling in the art form. When gentlemen of this class gathered, the performance of poetry, calligraphy, and painting was often a feature of the event. The inclusion of these cultural pursuits at feasts helped further strengthen the social bond between host and guest as well as reaffirm the shared intellectual, political, and cultural identities of all participants. Gift giving of an artistic work, sometimes occasioned by a feast, was also a part of social etiquette. In this way paintings, often with poetic inscriptions, were exchanged among friends and colleagues.

This small hanging scroll by Ni Zan, himself an educated scholar, is an example of a painting given as a farewell gift to a friend. One of the most celebrated painters in Chinese history, Ni was known as one of the Four Masters of the late Yuan period. Once one of the wealthiest men in his home region of Wuxi, Ni was forced to begin selling off his estate beginning in the 1340s, eventually living on a houseboat or as a guest at the homes of friends and family. The downturn in his personal fortunes was precipitated by significant natural disasters and famine, which led to rebellions across the Wuxi region that eventually brought down the Yuan dynasty.

Throughout the course of his artistic career, Ni developed a deeply personal painting style, almost exclusively devoted to the genre of landscape. His interpretation of nature is sparse and tinged with melancholy. His compositions often include isolated locations set against a distant vista separated by water. In the case of *Twin Trees by the South Bank*, the composition is limited to foreground: a pair of trees, one nearly bare, nestled together on a riverbank, accompanied by a handful of small boulders and bamboo. The special features of Ni's remote landscapes are usually seen to reflect his own greatly diminished personal circumstances, but the fact that similar compositions predate this downturn suggest that they owe at least as much to his artistic interests. The dry brushwork, minimalist compositions, and general eschewing of human figures became instantly recognizable features of Ni Zan's work and were later admired and emulated by generations of artists and connoisseurs.

The inscription Ni Zan wrote on *Twin Trees by the South Bank* declares the painting to be a farewell gift to a now-unknown younger gentlemen named Gongyuan. The attached poem celebrates the two trees that form the main subject of the painting, symbolic of the friendship between the two men. Other paintings by Ni Zan also carry inscriptions that indicate they were painted as gifts; he might have offered these works to repay a kindness bestowed upon him by a friend. A farewell feast likely accompanied exchanges such as this. After the initial gift, this painting and others like it might have changed hands many times, with feasts or special banquets often creating the occasion for the exchange.[1]

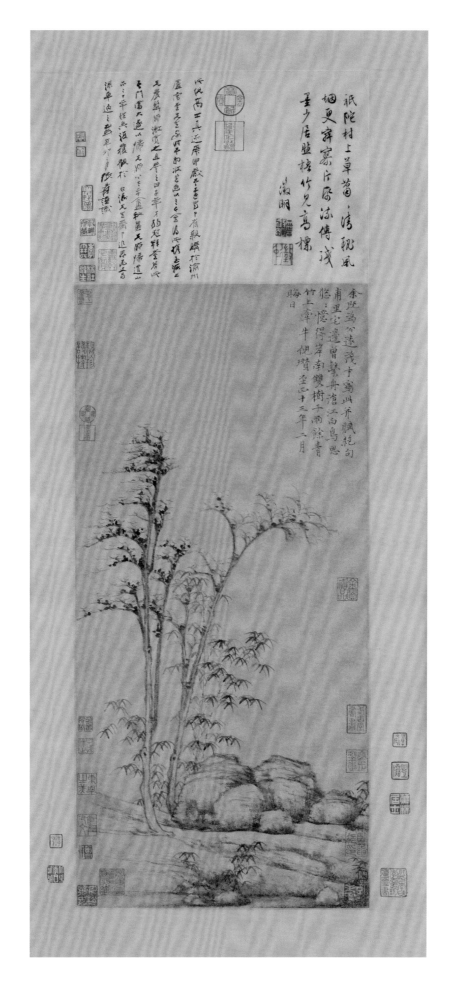

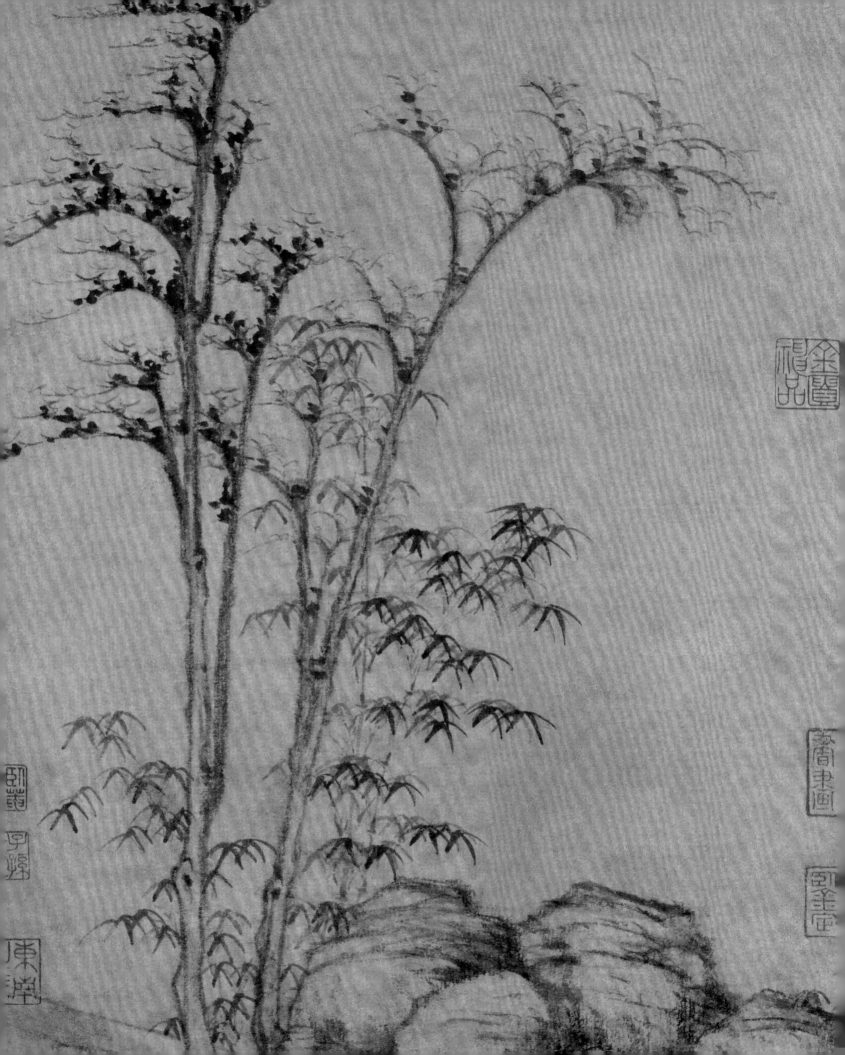

The inscription reads:

Having "written" this picture for the young scholar Gongyuan, I further composed a quatrain:

I once tied my boat near the cottage at Fuli, / Where the green river and white gulls stirred my melancholy thoughts. / I shall remember the two trees on the south bank, / How the blue-green bamboo clings, after rain, like morning glories. / Ni Zan on the last day of the second lunar month of the thirteenth year of the Zhizheng era (April 4, 1353)[2]

Colophons

Wen Zhengming 文徵明 (1470–1559)
Zhang Yuan 張爰 (Zhang Daqian 張大千; 1899–1983)

Seals

Zhu Zhichi 朱之赤 (active 16th century), 8 seals
Zhang Dai 張岱 (1597–ca. 1684), 1 seal
Liang Qingbiao 梁清標 (1620–1691), 2 seals
Bian Yongyu 卞永譽 (1645–1712), 2 seals
Li Enqing 李恩慶 (1793–after 1867), 3 seals
Zhang Shanzi 張善孖 (1882–1940), 2 seals
Zhang Yuan 張爰 (1899–1983), 4 seals
Chen Rentao 陳仁濤 (1906–1968), 3 seals
Qi Geng 杞畊 (20th century), 1 seal
Li Lin 李霖 (20th century), 3 seals
2 unidentified seals

NOTES

1. In the case of *Rongxi Studio* (1372), Ni Zan personally aided the regifting of the work by adding a new dedication inscription years after it was painted. He did so in order for Bi Xian, the painting's original recipient, to gift it to a medical doctor named Renzhong, whose studio mentioned in the inscription now provides the title for the work. At the time, Ni Zan was among the most esteemed painters alive. Given the great value of the painting and the identity of the new recipient, it is possible that both the original and subsequent exchanges of the gift were each meant to repay a debt. See James Cahill, *Hills Beyond a River: Chinese Painting of the Yüan Dynasty, 1279–1368* (New York: Weatherhill, 1976), 118–19.

2. Translated by Wen C. Fong. See Wen C. Fong et al., *Images of the Mind: Selections from the Edward L. Elliott Family and John B. Elliott Collections of Chinese Calligraphy and Painting at The Art Museum, Princeton University* (Princeton, NJ: The Art Museum, Princeton University, 1984), 118.

Bibliography

Anderson, E. N. *The Food of China*. New Haven, CT: Yale University Press, 1988.

Bagley, Robert. "The Prehistory of Chinese Music Theory." *Proceedings of the British Academy* 131 (2005): 41–90.

Bary, William Theodore de. *The Message of the Mind in Neo-Confucianism*. New York: Columbia University Press, 1989.

Benn, Charles D. *China's Golden Age: Everyday Life in the Tang Dynasty*. New York: Oxford University Press, 2004.

Bickford, Maggie. "Huizong's Paintings: Art and the Art of Emperorship." In Patricia Buckley Ebrey and Maggie Bickford, eds. *Emperor Huizong and Late Northern Song China: The Politics of Culture and the Culture of Politics*, 453–513. Cambridge, MA: Harvard University Asia Center, 2006.

Blanchard, Lara C. W. *Song Dynasty Figures of Longing and Desire: Gender and Interiority in Chinese Painting and Poetry*. Leiden: Brill, 2018.

Bossler, Beverly. "Floating Sleeves, Willow Waists, and Dreams of Spring: Entertainment and Its Enemies in Song History and Historiography." In Joseph S. C. Lam, Shuen-fu Lin, Christian de Pee, and Martin Powers, eds. *Senses of the City: Perceptions of Hangzhou and Southern Song China, 1127–1279*, 1–24. Hong Kong: Chinese University Press, 2017.

———. "Vocabularies of Pleasure: Categorizing Female Entertainers in the Late Tang Dynasty." *Harvard Journal of Asiatic Studies* 72, no. 1 (June 2012): 71–99.

Bower, Virginia L. "Two Masterworks of Tang Ceramic Sculpture." *Orientations* 24, no. 6 (June 1993): 72–77.

Brindley, Erica Fox. *Music, Cosmology, and the Politics of Harmony in Early China*. Albany: SUNY Press, 2012.

Brinker, Helmut, and François Louis. *Chinesisches Gold und Silber: Die Sammlung Pierre Uldry*. Zurich: Museum Rietberg Zürich, 1994

Cahill, James. *Hills Beyond a River: Chinese Painting of the Yüan Dynasty, 1279–1368*. New York: Weatherhill, 1976.

———. "The Imperial Painting Academy." In Wen C. Fong and James C. Y. Watt, eds. *Possessing the Past: Treasures from the National Palace Museum*, 159–99. New York: Metropolitan Museum of Art, 1996.

———. *The Painter's Practice: How Artists Lived and Worked in Traditional China*. New York: Columbia University Press, 1994.

———. *Pictures for Use and Pleasure: Vernacular Painting in High Qing China*. Berkeley: University of California Press, 2010.

———. "The Yuan Dynasty (1271–1368)." In Richard M. Barnhart et al., eds. *Three Thousand Years of Chinese Painting*, 139–95. New Haven, CT: Yale University Press, 1997.

Cai Chunjuan. "The Confucian School Education in the Dadu Route in the Yuan Dynasty." *Journal of Chinese Historical Studies* 3 (2015): 155–67.

Chang, K. C. Introduction to *Food in Chinese Culture: Anthropological and Historical Perspectives*, 3–21. New Haven, CT: Yale University Press, 1977.

———, ed. *Food in Chinese Culture: Anthropological and Historical Perspectives*. New Haven, CT: Yale University Press, 1977.

Chang, Shih-Ming Li, and Lynn E. Frederiksen. *Chinese Dance: In the Vast Land and Beyond*. Middletown, CT: Wesleyan University Press, 2016.

Chen Guo'an 陳國安. "Qiantan Hengyangxian Hejiazao Bei Song mu fangzhipin" 淺談衡陽縣何家皂北宋墓紡織品. *Wenwu* 文物 12 (1984): 77–81.

Chen Yunru 陳韻如. "Jiehua zai Song Yuan shiqi de zhuanzhe: Yi Wang Zhenpeng de jiehua wei li" 「界畫」在宋元時期的轉折: 以王振鵬的界畫為例. *Guoli Taiwan Daxue meishushi jikan* 國立台灣大學美術史集刊 26, no. 3 (2009): 135–92.

Chung, Anita. *Drawing Boundaries: Architectural Images in Qing China*. Honolulu: University of Hawaii Press, 2004.

Chung, Priscilla Ching. *Palace Women in the Northern Sung, 960–1126*. Leiden: Brill, 1981.

Cook, Constance A. "Moonshine and Millet: Feasting and Purification Rituals in Ancient China." In Rod Sterckx, ed. *Of Tripod and Palate: Food, Politics, and Religion in Traditional China*, 9–33. New York: Palgrave Macmillan, 2005.

Di Cosmo, Nicola. "Liao History and Society." In Hsueh-man Shen, ed. *Gilded Splendor: Treasures of China's Liao Empire (907–1125)*, 15–24. New York: Asia Society, 2006.

Ebrey, Patricia Buckley. *Accumulating Culture: The Collections of Emperor Huizong*. Seattle: University of Washington Press, 2008.

———. *Emperor Huizong*. Cambridge, MA: Harvard University Press, 2014.

Feng Yongqian 馮永謙. "Yemaotai Liao mu chutu de taociqi" 葉茂台遼墓出土的陶瓷器. *Wenwu* 文物 12 (1975): 40–48.

Fong, Mary H. "Antecedents of Sui-Tang Burial Practices in Shaanxi." *Artibus Asiae* 51, nos. 3/4 (1991): 147–98.

Fong, Wen C. *Beyond Representation: Chinese Painting and Calligraphy, 8th–14th Century*. New Haven, CT: Yale University Press, 1992.

Fong, Wen C., et al. *Images of the Mind: Selections from the Edward L. Elliott Family and John B. Elliott Collections of Chinese Calligraphy and Painting at The Art Museum, Princeton University*. Princeton, NJ: The Art Museum, Princeton University, 1984.

Franke, Herbert. "Sung Embassies: Some General Observations." In Morris Rossabi, ed. *China among Equals: The Middle Kingdom and Its Neighbors, 10th–14th Centuries*, 118–48. Berkeley: University of California Press, 1983.

Freeman, Michael. "Sung." In K.C. Chang, ed. *Food in Chinese Culture: Anthropological and Historical Perspectives*, 141–76. New Haven, CT: Yale University Press, 1977.

Fujian sheng bowuguan 福建省博物館. *Fuzhou Nan Song Huang Sheng mu* 福州南宋黃升墓. Beijing: Wenwu chubanshe, 1982.

Gernet, Jacques. *Daily Life in China on the Eve of the Mongol Invasion, 1250–1276*. Translated by H. M. Wright. Stanford, CA: Stanford University Press, 1962.

Goldin, Paul R. "The Motif of the Woman in the Doorway and Related Imagery in Traditional Chinese Funerary Art." *Journal of the American Oriental Society* 121, no. 4 (October–December 2001): 539–48.

Gyllensvärd, Bo. *Chinese Gold, Silver, and Porcelain: The Kempe Collection*. New York: Asia Society, 1971.

Harrist, Jr., Robert E., Wen C. Fong, et al. *The Embodied Image: Chinese Calligraphy from the John B. Elliott Collection*. Princeton, NJ: The Art Museum, Princeton University, 1999.

Hearn, Maxwell K. "Along the Riverbank." In Maxwell K. Hearn and Wen C. Fong. *Along the Riverbank: Chinese Paintings from the C. C. Wang Family Collection*, 59–71. New York: Metropolitan Museum of Art, 1999.

———. "Painting and Calligraphy under the Mongols." In James C. Y. Watt, ed. *The World of Khubilai Khan: Chinese Art in the Yuan Dynasty*, 181–240. New York: Metropolitan Museum of Art, 2010.

Hearn, Maxwell K., and Wen C. Fong. *Along the Riverbank: Chinese Paintings from the C. C. Wang Family Collection*. New York: Metropolitan Museum of Art, 1999.

Hebei sheng wenwu yanjiusuo 河北省文物研究所, ed. *Xuanhua Liao mu: 1974–1993 nian kaogu fajue baogao* 宣化遼墓: 1974–1993 年考古發掘報告. 2 vols. Beijing: Wenwu chubanshe, 2001.

———, ed. *Xuanhua Liao mu bihua* 宣化遼墓壁畫. Beijing: Wenwu chubanshe, 2001.

Hebei sheng wenwu yanjiusuo 河北省文物研究所 and Baoding shi wenwu guanlichu 保定市文物管理處, eds. *Wudai Wang Chuzhi mu* 五代王處直墓. Beijing: Wenwu chubanshe, 1998.

Henan sheng wenwu yanjiusuo 河南省文物研究所, ed. *Mixian Dahuting Han mu* 密縣打虎亭漢墓. Beijing: Wenwu chubanshe, 1993.

Ho, Wai-kam. "Aspects of Chinese Painting from 1100 to 1350." In *Eight Dynasties of Chinese Painting: The Collections of the Nelson-Atkins Museum, Kansas City, and the Cleveland Museum of Art*, xxv–xxxiv. Cleveland: Cleveland Museum of Art, 1980.

Ho, Wai-kam, Sherman E. Lee, Laurence Sickman, and Marc F. Wilson. *Eight Dynasties of Chinese Painting: The Collections of the Nelson-Atkins Museum, Kansas City, and the Cleveland Museum of Art*. Cleveland: Cleveland Museum of Art, 1980.

Hobson, R. L. "A T'ang Silver Hoard." *British Museum Quarterly* 1 (1926): 18–21.

Hong, Jeehee. "Changing Roles of the Tomb Portrait: Burial Practices and Ancestral Worship of the Non-Literati Elite in North China (1000–1400)." *Journal of Song-Yuan Studies* 44 (2014): 203–64.

———. *Theater of the Dead: A Social Turn in Chinese Funerary Art*. Honolulu: University of Hawaii Press, 2016.

Hubei sheng bowuguan 湖北省博物館, ed. *Suixian Zeng Hou Yi mu* 隨縣曾侯乙墓. Beijing: Wenwu chubanshe, 1980.

Hubei sheng Jingsha tielu kaogudui 湖北省荊沙鐵路考古隊, ed. *Baoshan Chu mu* 包山楚墓. Beijing: Wenwu chubanshe, 1991.

Hunan sheng bowuguan 湖南省博物館 and Zhongguo kexueyuan kaogu yanjiusuo 中國科學院考古研究所, eds. *Changsha Mawangdui yi hao Han mu* 長沙馬王堆一號漢墓. Beijing: Wenwu chubanshe, 1973.

Hung, Wu. *The Art of the Yellow Springs: Understanding Chinese Tombs*. London: Reaktion, 2010.

Jang, Scarlett. "Representations of Exemplary Scholar-Officials, Past and Present." In Cary Y. Liu and Dora C. Y. Ching, eds. *Arts of the Sung and Yüan: Ritual, Ethnicity, and Style in Painting*, 38–67. Princeton, NJ: Princeton University Art Museum, 1999.

Johnson, Linda Cooke. *Women of the Conquest Dynasties: Gender and Identity in Liao and Jin China*. Honolulu: University of Hawaii Press, 2011.

Kerr, Rose. *Song Dynasty Ceramics*. London: V & A Publications, 2004.

Kerr, Rose, and Nigel Wood. *Science and Civilisation in China*. Vol. 5, *Chemistry and Chemical Technology*, part 12, *Ceramic Technology*. Cambridge: Cambridge University Press, 2004.

Kieschnick, John. *The Impact of Buddhism on Chinese Material Culture*. Princeton, NJ: Princeton University Press, 2003.

Knechtges, David R. "A Literary Feast: Food in Early Chinese Literature." *Journal of the American Oriental Society* 106, no. 1, Sinological Studies Dedicated to Edward H. Schafer (January–March 1986): 49–63.

Krahl, Regina. *Chinese Ceramics from the Meiyintang Collection*. 2 vols. London: Azimuth Editions, 1994.

———. "White Wares of North China." In Regina Krahl, John Guy, J. Keith Wilson, and Julian Raby, eds. *Shipwrecked: Tang Treasures and Monsoon Winds*, 201–7. Washington, DC: Smithsonian Institution, 2011.

Kuhn, Dieter. "Decoding Tombs of the Song Elite." In Dieter Kuhn, ed. *Burial in Song China*, 11–159. Heidelberg: Editio Forum, 1994.

———, ed. *Burial in Song China*. Heidelberg: Editio Forum, 1994.

Kwok, Zoe Song-Yi. "An Intimate View of the Inner Quarters: A Study of Court Women and Architecture in *Palace Banquet*." PhD diss., Princeton University, 2013.

Laing, Ellen Johnston. "Notes on *Ladies Wearing Flowers in Their Hair*." *Orientations* 21, no. 2 (February 1990): 32–39.

Lee, De-nin. *The Night Banquet: A Chinese Scroll through Time*. Seattle: University of Washington Press, 2010.

Lee, Hui-shu. "The Emperor's Lady Ghostwriters in Song Dynasty China." *Artibus Asiae* 64, no. 1 (2004): 61–101.

———. *Empresses, Art, and Agency in Song Dynasty China*. Seattle: University of Washington Press, 2010.

Liu, Cary Y., and Dora C. Y. Ching, eds. *Arts of the Sung and Yüan: Ritual, Ethnicity, and Style in Painting*. Princeton, NJ: The Art Museum, Princeton University, 1999.

Liu, Heping. "Empress Liu's *Icon of Maitreya*: Portraiture and Privacy at the Early Song Court." *Artibus Asiae* 63, no. 2 (2003): 129–90.

Liu Xu 劉昫 et al., comps. *Jiu Tangshu* 舊唐書. Beijing: Zhonghua shuju, 1975.

Loehr, Max. *Chinese Painting after Sung*. New Haven, CT: Yale University Press, 1967.

Louis, François. "Iconic Ancestors: Wire Mesh, Metal Masks, and Kitan Image Worship." *Journal of Song-Yuan Studies* 43 (2013): 91–115.

———. "The 'Palace Concert' and Tang Material Culture." *Source: Notes in the History of Art* 24, no. 2 (2005): 42–49.

———. "Shaping Symbols of Privilege: Precious Metals and the Early Liao Aristocracy." *Journal of Song-Yuan Studies* 33 (2003): 71–109.

Luoyang shi di er wenwu gongzuo dui 洛陽市第二文物工作隊. "Luoyang shi Zhucun Dong Han bihua mu fajue jianbao" 洛陽市朱村東漢壁畫墓發掘簡報. *Wenwu* 文物 12 (1992): 15–20.

McCausland, Shane. *The Mongol Century: Visual Cultures of Yuan China, 1271–1368*. Honolulu: University of Hawaii Press, 2014.

Menzies, Jackie. *The Asian Collections: Art Gallery of New South Wales*. Sydney: Art Gallery of New South Wales, 2003.

Mowry, Robert D. *Hare's Fur, Tortoiseshell, and Partridge Feathers: Chinese Brown- and Black-glazed Ceramics, 400–1400*. Cambridge, MA: Harvard University Art Museums, 1996.

Murray, Julia. *Ma Hezhi and the Illustration of the "Book of Odes."* Cambridge: Cambridge University Press, 1993.

Pierson, Stacey, ed. *Qingbai Ware: Chinese Porcelain of the Song and Yuan Dynasties*. London: Percival David Foundation of Chinese Art, 2002.

Pirazzoli-t'Serstevens, Michèle. "Two Eastern Han Sites: Dahuting and Houshiguo." In Michael Nylan and Michael Loewe, eds. *China's Early Empires: A Re-appraisal*, 83–113. Cambridge: Cambridge University Press, 2010.

Rachewiltz, Igor de, and May Wong, et al. *In the Service of the Khan: Eminent Personalities of the Early Mongol-Yüan Period (1200–1300)*. Wiesbaden: Harrassowitz, 1993.

Rorex, Robert A., and Wen Fong. *The Story of Lady Wenchi: A Fourteenth Century Handscroll in the Metropolitan Museum of Art*. New York: New York Graphic Society, 1974.

Schafer, Edward. *The Golden Peaches of Samarkand*. Berkeley: University of California Press, 1963.

———. "T'ang." In K.C. Chang, ed. *Food in Chinese Culture: Anthropological and Historical Perspectives*, 85–140. New Haven, CT: Yale University Press, 1977.

Scott, Hugh. *The Golden Age of Chinese Art: The Lively T'ang Dynasty*. Rutland, VT: C.E. Tuttle & Co., 1966.

Shaanxi sheng bowuguan 陕西省博物館. *Yao ci tulu* 耀瓷圖錄. Beijing: Zhongguo gudian yishu chubanshe, 1956.

Sharf, Robert. "Art in the Dark: The Ritual Context of Buddhist Caves in Western China," 38–65. In David Park, Kuenga Wangmo, and Sharon Cather, eds. *Art of Merit: Studies in Buddhist Art and Its Conservation*. London: Courtauld Institute of Art, 2013.

Shen, Hsueh-man. "Body Matters: Manikin Burials in the Liao Tombs of Xuanhua, Hebei Province." *Artibus Asiae* 65, no. 1 (2005): 99–141.

———, ed. *Gilded Splendor: Treasures of China's Liao Empire (907–1125)*. New York: Asia Society, 2006.

Shenzhen bowuguan 深圳博物館 and Neimenggu bowuyuan 內蒙古博物館. *Qidan Feng Yun: Neimenggu Liaodai wenwu zhenpin zhan* 契丹風韻: 內蒙古遼代文物珍品展. Beijing: Wenwu chubanshe, 2011.

Smith, Cyril Stanley. "Porcelain and Plutonism." In *A Search for Structure: Selected Essays on Science, Art and History*, 317–38. Cambridge, MA: MIT Press, 1981.

Smith, Monica L. "Feasts and Their Failures." *Journal of Archaeological Method and Theory* 22 (2015): 1215–37.

Song Lian 宋濂 et al., comps. *Yuan shi* 元史. Taipei: Institute of History and Philology, Academia Sinica, 2009.

Steinhardt, Nancy Shatzman. "The Architectural Landscape of the Liao and Underground Resonances." In Hsueh-man Shen, ed. *Gilded Splendor: Treasures of China's Liao Empire (907–1125)*, 41–53. New York: Asia Society, 2006.

Steinke, Kyle. "Erligang and the Southern Bronze Industries." In Kyle Steinke with Dora C.Y. Ching, eds. *The Art and Archaeology of the Erligang Civilization*, 151–70. Princeton, NJ: P.Y. and Kinmay W. Tang Center for East Asian Art, Department of Art and Archaeology, Princeton University, in association with Princeton University Press, 2014.

———. "Script Change in Bronze Age China." In Stephen D. Houston, ed. *The Shape of the Script: How Writing Systems Change and Why*, 135–58. Santa Fe: School for Advanced Research Press, 2012.

Steinke, Kyle, with Dora C.Y. Ching, eds. *The Art and Archaeology of the Erligang Civilization*. Princeton, NJ: P.Y. and Kinmay W. Tang Center for East Asian Art, Department of Art and Archaeology, Princeton University, in association with Princeton University Press, 2014.

Sterckx, Roel, ed. *Of Tripod and Palate: Food, Politics, and Religion in Traditional China*. New York: Palgrave Macmillan, 2005.

Sturman, Peter C. "*Cranes above Kaifeng*: The Auspicious Image at the Court of Huizong," *Ars Orientalis* 20 (1990): 33–68.

Su Bai 宿白. *Baisha Song mu* 白沙宋墓. Beijing: Wenwu chubanshe, 2002.

Tackett, Nicolas. *The Origins of the Chinese Nation: Song China and the Forging of an East Asian World Order*. Cambridge: Cambridge University Press, 2017.

Tao Jingshen. "Barbarians or Northerners: Northern Sung Images of the Khitans." In Morris Rossabi, ed. *China among Equals: The Middle Kingdom and Its Neighbors, 10th–14th Centuries*, 66–86. Berkeley: University of California Press, 1983.

Thote, Alain. "Artists and Craftsmen in the Late Bronze Age of China (Eighth to Third Centuries BC): Art in Transition." *Proceedings of the British Academy* 154 (2008): 201–41.

Tillman, Hoyt Cleveland. "The Treaty of Shanyuan from the Perspectives of Western Scholars." *Sungkyun Journal of East Asian Studies* 5, no. 2 (2005): 135–55.

Tōkyō Kokuritsu Hakubutsukan zuhan mokuroku: Chūgoku tōji hen (Illustrated Catalogues of the Tokyo National Museum: Chinese Ceramics) 東京国立博物館図版目録: 中国陶磁篇, 2 vols. Tokyo: Tōkyō Bijutsu, 1988.

Twitchett, Denis, and Klaus-Peter Tietze. "The Liao." In Herbert Franke and Denis Twitchett, eds. *The Cambridge History of China*. Vol. 6, *Alien Regimes and Border States, 907–1368*, 43–153. Cambridge: Cambridge University Press, 1994.

Valenstein, Suzanne G. *A Handbook of Chinese Ceramics*. New York: Metropolitan Museum of Art, 1989.

Waley, Arthur. *The Book of Songs*. New York: Grove Press, 1960.

Wang Gungwu. "The Rhetoric of a Lesser Empire: Early Sung Relations with Its Neighbors." In Morris Rossabi, ed. *China Among Equals: The Middle Kingdom and Its Neighbors, 10th–14th Centuries*, 47–65. Berkeley: University of California Press, 1983.

Wang Zhongshu. *Han Civilization*. Translated by K.C. Chang et al. New Haven, CT: Yale University Press, 1982.

Watson, Burton. *Records of the Historian: Chapters from the "Shih-chi" of Ssu-ma Ch'ien*. New York: Columbia University Press, 1969.

Watt, James C.Y., and Anne E. Wardwell, with Morris Rossabi. *When Silk Was Gold: Central Asian and Chinese Textiles*. New York: Metropolitan Museum of Art, 1997.

White, Julia M., and Emma C. Bunker, with Chen Peifen. *Adornment for Eternity: Status and Rank in Chinese Ornament*. Denver: Denver Art Museum, 1994.

Wood, Nigel. *Chinese Glazes: Their Origins, Chemistry, and Recreation*. London: A & C Black, 1999.

Wu Tong. *Tales from the Land of Dragons: 1,000 Years of Chinese Painting*. Boston: Museum of Fine Arts, 1997.

Xu Daoxun 許道勛. *Tang Minghuang yu Yang Guifei* 唐明皇與楊貴妃. Beijing: Renmin chubanshe, 1990.

Xu Guangji 徐光冀. *Zhongguo chutu bihua quanji* 中國出土壁畫全集. 10 vols. Beijing: Kexue chubanshe, 2012.

Xuanhe huapu 宣和畫譜. Taipei: Taiwan Shangwu yinshuguan, 1971.

Yoshinobu, Shiba. "Sung Foreign Trade: Its Scope and Organization." In Morris Rossabi, ed. *China among Equals: The Middle Kingdom and Its Neighbors, 10th–14th Centuries*, 89–115. Berkeley: University of California Press, 1983.

Yü Ying-shih. *Chinese History and Culture*. Vol. 1, *Sixth Century BCE to Seventeenth Century*. New York: Columbia University Press, 2016.

———. "Han." In K.C. Chang, ed. *Food in Chinese Culture: Anthropological and Historical Perspectives*, 55–83. New Haven, CT: Yale University Press, 1977.

Yue, Isaac, and Siufu Tang, eds. *Scribes of Gastronomy: Representations of Food and Drink in Imperial Chinese Literature*. Hong Kong: Hong Kong University Press, 2013.

Zhang Bai 張柏, ed. *Zhongguo chutu ciqi quanji* 中國出土瓷器全集. 16 vols. Beijing: Kexue chubanshe, 2008.

Zhang Mengzhu 張孟珠. "'Shiba xueshi tu' yuanliu ji tuxiang yanjiu" 「十八學士圖」源流暨圖像研究. MA thesis, National Taiwan Normal University, 1998.

Zhang Mingqia 張銘洽. *Zhanghuai taizi mu bihua* 章懷太子墓壁畫. Beijing: Wenwu chubanshe, 2002.

Zhejiang sheng qinggongye ting 浙江省輕工業廳, ed. *Longquan qingci* 龍泉青瓷. Beijing: Wenwu chubanshe, 1966.

Zhongguo mushi bihua quanji 中國墓室壁畫全集. 3 vols. Shijiazhuang: Hebei jiaoyu chubanshe, 2011.

Zhongguo taoci chaju: Chaju wenwuguan Luo Guixiang zhencang 中國陶瓷茶具: 茶具文物館羅祥珍藏. Hong Kong: Xianggang shizhengju, 1991.

Zhongguo taoci quanji 中國陶瓷全集. 15 vols. Shanghai: Shanghai renmin meishu chubanshe, 1999.

Zhongxing jisheng: Nan Song fengwu guanzhi 中興紀勝: 南宋風物觀止. Beijing: Zhongguo shudian, 2015.

Index

A

Abaoji (Liao dynasty emperor Taizu 太祖), 30, 37
afterlife, 21, 27, 30, 31, 37, 49, 53, 60, 109, 143;
 in Buddhism, 53; passage to, 41, 47–48, 86;
 See also feast, for the afterlife
Along the River during the Qingming Festival
 (Zhang Zeduan), 172, *172*
ancestor worship, 21, 22, 49, 53
Auspicious Cranes (attrib. Emperor Huizong), 87

B

Baisha 白沙, Henan province: Tomb 1, 46, *46*, 78n27
Baoshan 包山, Hubei province: Tomb 2, 32n8
Baoshan 寶山, Inner Mongolia: Tomb 1, 87n10
banquet: definition of, 19, 32n3; at Hongmen, 24–25;
 Liao, 105, 109, 117; state, 21, 23, 62, 63–64, 107;
 See also Palace Banquet (cat. 21); feast; Khitan,
 dining practices
basin (cat. 18), 114–15, *114*, *115*
Beijing, 35, 107
bird motifs, 39, 40, 83, 86, 87, 90, 105, 110, 117, 137,
 141; chicken, 110; cranes, 87, *90*, 116–17, *116*,
 117; phoenix-head vessels (cats. 15–17), 40, 100,
 110–13, *111–113*, 115
bottle (cat. 14), 108–9, *108*, 171
bowl, basket-weave (cat. 11), 40, *102*, 102–3; celadon
 (cat. 38), 163, 167, *167*; large (cat. 41), 170–71, *170*;
 lotus (cat. 40), 170–71, *170*
bronze, industry, 22, 32nn10–11; ritual vessels,
 21–23, 32n11
Bronze Age, 19, 20–24, 32n12, 33n16, 151, 169
Buddhism, 29, 32n2, 87n5, 101, 141, 145;
 afterlife in, 52–53; and Liao funerary practice,
 79n42; tea's connections to, 79n42, 101

C

Cai Jing 蔡京, *62*, 63
Cai Wenji 蔡文姬. *See* Wenji, Lady, as theme
calligraphy/calligraphers, 20, 35, 53, 93n1, 101, 151,
 161n2; as elite/literati pastime, 20, 36, 151, 182;
 Bronze Age, 20, 23, 32n7, 32nn14–16; female, 151;
 Gaozong's, 93n1, 151, 161n3; paintings connected
 to, 62–63, 68, *70*, 71, 79n58, 79nn66–67, *160*,
 161, 182, 183, 185; performance of, 20–21, 31, 182;
 Quatrain on Autumn (Yang Meizi) (cat. 32),
 150, 151; vessels with inscriptions, 26, *100*, 101,
 168, 169
Central Asia, 29, 53, 105, 117, 137, 145

ceramics, 20, 31, 32n5, 75, 103, 109, 115, 149, 171, 172;
 Song, 29, 53, 141, 163; *See also* Guan ware; Jun
 ware; porcelain; Ru ware; *sancai* ware; Yaozhou
 ware; Yue ware
Chen 陳, Princess of: tomb of, 87n10
coffin panels, Liao: *Endboard with Floral Motif,
 Endboard with Door and Attendants*, 48, 82, *83*,
 87n1, 87n8; from Sumuzuoai, Inner Mongolia,
 87n6; *See also* Princeton Liao panels (cats. 1–6)
Confucianism, 52, 71, 141, 161
Court Lady (cat. 29), 144–45, *144*, 177
cuisine, 22, 24, 25, 27, 29, 107; *See also* food
 and drink
cup, circular (cats. 35 and 37), 163, 164, *164*, 166, *166*,
 171; stand (cats. 8, 9, and 39), 98, *98*, 99, *99*, 137, 139,
 163, 168–69, *168*, 171, 172; wine (cats. 8, 9, and 36),
 97, 98, *98*, 99, *99*, 139, 163, 165, *165*, 172

D

Dahuting 打虎亭, Henan province: Tomb 1 (tomb
 of Zhang Boya), 45, 78n25; Tomb 2 (figs. 21 and
 22), 45–46, *45*, 78n25
Dai 軑, Lady Marquis of. *See* Mawangdui,
 Changsha, Hunan province, Tomb 1
Dai 軑, Marquis of. *See* Mawangdui, Changsha,
 Hunan province, Tomb 2
dance/dancers, 20, 21, 24, 27, 31, 46, 69, 161, 177, 179
Daoism, 29, 32n2, 71, 141
Ding 定 ware. *See* porcelain, Ding ware
dining ware service (cat. 25), 136–37, *136*
dish, foliate (cat. 26), 138–39, *138*, *139*, 172; lobed
 (cat. 12), 39, 10, 104–5, *104*
Dishuihu 滴水壺, Inner Mongolia: tomb (fig. 44),
 107, *107*
Dunhuang 敦煌, Gansu province, 31, 83, 87n5

E

Eastern Han 東漢 (25–220), 28, 45, 71, 78nn25–26,
 79n67; *See also* Han dynasty
Eastern Jin 東晉 (317–420), 110; *See also* Six
 dynasties
Eastern Zhou 東周 (770–256 BC), 22; *See also*
 Warring States; Zhou dynasty
Eighteen Scholars of the Tang (*Tang shiba xueshi*
 唐十八學士), 60, 63, 65–68, 69, 73, 76, 79n62, 155
*Eighteen Songs of a Nomad Flute: The Story of
 Lady Wenji* (cat. 7), 42–43, 92–93, *92*, *94*, *95*, 119
entertainment; *See* dance/dancers; music/
 musicians

Erligang 二里崗 civilization (ca. 1500–ca. 1300 BC), 32nn11–12
Evening Literary Gathering (cat. 33), 31, 35, 37, 61, 64–65, *64, 65,* 69–75, *74,* 79n68, 154–56, *156–57,* 161, 163, 169, *169,* 171, *171,* 172, 177, 180, *180,* 182 colophon, 68, 69, 155; comic/satiric readings of, 73–75; dating of, 154, 155; Eighteen Scholars theme in, 60, 65–68, 69, 73, 76, 155; *See also* Eighteen Scholars of the Tang; frontispiece, 68, 69, 155, 155n1; Taihu rocks in, 69, 154, 180, *180*
ewer, green-glazed (cat. 10), 40, 100–101, *100,* 163, 172; phoenix-head (cats. 15 and 17), 40, 100, 110, 111, *111,* 113, *113;* wine (cat. 42), 172, *173*
examination system, civil/imperial, 36, 49, 151, 155

F

feast: attended by immortals, 71; Bronze Age, 20–24; Chinese terminology for, 21, 49; court ladies', 30, 49–50, *50,* 55–58, *See also Palace Banquet* (cat. 21); definition of, 19–20, 32n1; for the afterlife, 21, 26, 27, 28, 29, 33n23, 40, 42, *42, 43,* 45, *45,* 46, *46,* 75, 78n19, 78n27, *100,* 101, *108, 109,* 110, *See also* Princeton Liao panels (cats. 1–4); gentlemen's, 60–65, *61, 62, 70,* 71, 75, *160,* 161, *171, 172,* 179, 182, *See also Evening Literary Gathering* (cat. 33); Han dynasty, 24–28; *See also* banquet; Khitan, dining practices
Figure of a Dancer (cat. 44), 161, 178–79, *178*
Five Dynasties and Ten Kingdoms (907–979), 35, 37–38, 57, 61, 79n70, 127, 131; *See also* Later Jin; Later Liang; Southern Tang
Five Tang Scholars (attrib. Liu Songnian), 66–68, *67*
flower/floral motifs, 29, 39, 53, 83, 87, 97–99, *98, 99,* 104–5, *104,* 114–15, *114–15,* 116–17, *116–17,* 118–19, *118–19,* 127, 136–37, *136,* 138–39, *138–39, 146,* 147, 148–49, *148–49,* 154, 163, 168–69, *168,* 170–71, *170,* 172, *173; See also* hibiscus; lotus
food and drink, 19–20, 32nn2–3, 32n11, 40, 49, 56, 61, 69, 78n19, 127n7; preparation of, 23; ritual offerings of, 21, 22, 23, 42; vessels, 23, 43, 64, 75, 109; *See also* wine
Four Kneeling Musicians (cat. 43), 145, 174–77, *174–75, 176*
fruit, 23, 27, 42, 72, 86, 137, 154, 171
funerary art: Bronze Age, 21–23; feast imagery in, 27, 42, 45, 49, 52, 53, 54; Five Dynasties and Ten Kingdoms, 57; Han, 27–28, 45–46, 78n26; Liao, 40–41, 42, 49, 87, 107, 110; Song, 40–41, 54; Tang, 46; *See also* tomb

G

Gaozong 高宗, Song dynasty emperor, 35–36, 93, 93n1, 161; calligraphy of, 93n1, 151, 161n3
Guan 官 ware, 163
Gu Hongzhong 顧閎中
 Night Revels of Han Xizai, 57, 60–63, *61,* 69
Guo Guan 郭貫, 68, 69, 155
Guo Xi 郭熙, 72

H

hairpin (cat. 30), 127, 146–47, *146*
Han dynasty 漢 (206 BC–AD 220), 19, 20, 24–25, 27–28, 33n23, 42, 45, 71, 78nn25–26, 79n67, 93, 107, 141; dining practices, 24–27; fall of, 28–29, 151; founding of, 24; incense burner (cat. 27), 122, 140–41, *140;* tombs, 25–28, 30, 45–47, 78nn24–26, 179; *See also* Eastern Han; Western Han
Han Shixun 韓師訓: tomb of, 78n19; *See also* Xuanhua, Tomb 4
Han Xizai 韓熙載, 60–61, 63; *See also Night Revels of Han Xizai* (Gu Hongzhong)
Hangzhou, 35–36, 77n2, 93, 124, 163
headpiece (cat. 20), 118–19, *118, 119*
Hengyang 衡陽, Hunan province: Northern Song tomb, 149
hibiscus, 124, 154
Huang Sheng 黃升, Lady: tomb of, 149n1
Huizong 徽宗, Song dynasty emperor, 35, 49, 64, 66, 93; *Auspicious Cranes,* 87; Eighteen Scholars, 66, 79n62; *Literary Gathering,* 60, 62, 63–64, 68, 69

I

incense, 50, 56, 59, 122, 141; burner (cat. 27), 122, 140–41, *140*
In the Palace (cats. 23–24), 55, 127, 129, 131–34, *132–33, 134*

J

jade, 20, 27, 33n14, 33n33, 103n1
Jin 金 dynasty (1115–1234), 19, 35, 36, 75, 77n6, 93, 93n2
Jun 鈞 ware, 163, 163n1
Jurchen (*Nuzhen* 女真), 35, 93, 93n2, 163

K

Kaifeng, 35, 38, 93

Khitan (*Qidan* 契丹), 35, 37–38, 42, 82, 93, 103, 105, 107; dining practices, 39–40, *39*, *42*, 42–43, *43*, *44*, 83, 86, *88*, *89*, 93, 107, *107*, 109, 117; dress/hairstyles, 40–41, 43, 78n18, 82, 83, 86; horseback-riding prowess, 78n18, 83, 87; nomadic lifestyle, 30, 37, 43–45, 87, 93; tombs, 38, 49, 109; *See also* Liao dynasty; Princeton Liao Panels (cats. 1–6)

Khubilai Khan, 72

Khubilai Khan Hunting (attrib. Liu Guandao), 72, 79n71

L

lacquerware, 20, 27, 31, 33n14, 33n26, 33n30, 75, 163, 169; cup stand (cat. 39), 168–69, *168*; Han dynasty manufacturing of, 33n26; Song, 29, 137, 169, 171

ladle (cat. 13), 106–7, *106*

Later Jin 後晉 (936–947), 37–38; *See also* Five Dynasties and Ten Kingdoms

Later Liang 後梁 (907–923), 57; *See also* Five Dynasties and Ten Kingdoms

Liao 遼 dynasty (907–1125), 31, 35, 36, 75, 87, 97, 103, 107, 119; ceramics, 109, 110, 115; fall of, 19, 35; founding of, 19, 30, 37–38, 117; funerary art, 40–42, 87, 110; geographic extent, 30, 37, 38, 117, 119; hoards, 103; Khitan rule, 31, 35, 37, 38, 49, 103, 105; metalware, 103, 105, 117; Song and, 38, 43, 77n9, 97, 101, 107, 109, 110; southern capital/Beijing, 107; Tang and, 30, 38, 42, 46, 76; textiles, 117; tombs, 38, 42, 45, 46–48, 75, 78n15, 78n17, 79n42, 87n6, 87n10, 101, 107, 117, 119, 172; *See also* coffin panels, Liao; Khitan; Princeton Liao panels (cats. 1–6)

Li Cang 利蒼. *See* Mawangdui, Changsha, Hunan province, Tomb 2

Li Gonglin 李公麟, 66, 131, 134n4

Li Jiben 李繼本, 68, 155

Li Xian 李賢. See Zhanghuai, Prince

Literary Gathering (attrib. Emperor Huizong), 60, *62*, 63–64, 68, 69

literati, 37, 60, 63, 73, 74, 76, 127, 163, 177, 180; burial practices, 30, 52, 78n26; painting, 36, 53, 74, 77nn5–6, 155n5; pastimes, 69, 73, 151, 155n5

Liu Bang 劉邦, 24

Liu Chen and Ruan Zhao Entering the Tiantai Mountains (Zhao Cangyun), *70*, 71, 73, 79nn69–70

Liu Guandao 劉貫道, 72, 79n71; *Khubilai Khan Hunting*, 72, 79n71; *Whiling Away the Summer*, 72–74, *72*

Liu Shang 劉商, 93

Liu Songnian 劉松年, 66, 74; *Five Tang Scholars*, 66–68, *67*

Li Yu 李煜, Southern Tang emperor, 61, 131

lotus, 97, 115, 119, 122, 123, 141, 147, 149, 154, 163; bowl (cat. 40), 170–71, *170*

Lu Zhen 路振, 107

M

Ma Hezhi 馬和之, *Odes of the State of Bin* (cat. 34), 69, 93n1, 160–61, *160*, 177

Mawangdui 馬王堆, Changsha, Hunan province: Tomb 1 (tomb of Xin Zhui, Lady Marquis of Dai), 25–28, *25–28*, 33nn22–23, 33nn27, 30, 33n33. dining ware, 26, 27; funeral banner, 27–28, *27*, *28*, 33nn27–30, 33n33; musician ensemble, 26, 27. Tomb 2 (tomb of Li Cang, Marquis of Dai), 26; Tomb 3, 26, 33n27

Meng Haoran 孟浩然, 179

metallurgy, 20, 32n11

metalware, 31, 103, 137; Liao, 105, 117; Song, 29, 97, 103; Tang, 97, 101, 103, 137; *See also* bronze

Mingdi 明帝, Han dynasty emperor, 79n67

Ming 明 dynasty (1368–1644), 42, 43, 93, 93n1, 93n4, 155

Mongol/Mongolia, 30, 31, 33n26, 36, 37, 71, 72–73, 77n6, 93, 103

mural/wall painting: Dunhuang, 31, 83, 87n5; tomb, 28, 29, 33n32, *42*, 45, *45*, 46, *46*, 47, *56*, 78n25, 78n29, 79n42, *107*, 172

music/musicians, 20, 21, 31, 33n16, 43, 46, 50, 55, 56, 57, 58, 59, 61, 69, 93, 122, 124, 161, 177, 179; bells, 23, *23*, 33n16, 72, 177; chimestones, 33n16, 177; clapper, 56, 57, 69, 122, 129; ensembles, 23, 26, 27, 33n16, 57, 69, 78n27, 131, 145, 177. lute, 56, 61, 63, 86, 161; *pipa* 琵琶, 122, 124, 177; *ruan* 阮, 71, 72. *tongbo* 銅鈸 (cymbals), 145, 177; zither, 26, 33n24, 56, 69, 122

N

Night Revels of Han Xizai (Gu Hongzhong), 57, 60–63, *61*, 69

Ningzong 寧宗, Song dynasty emperor, 66, 151

Ni Zan 倪瓚, *Twin Trees by the South Bank* (cat. 46), 182–85, *183*, *184*

Northern Song 北宋 (960–1127), 35–36, 46, 53, 66, 72, 77n6, 110, 149, 171, 172; *See also* Song dynasty

O

Odes of the State of Bin (Ma Hezhi) (cat. 34), 69, 93n1, 160–61, *160*, 177

P

painting/painters: architectural, 37, 50–55, 58–59, 76, 122–27, 127n2, 127n9; court, 35, 36, 58–59, 73, 74, 131, 161n2; court-lady, 31, 37, 50, 54, 55–57, 76, 79n45, 124–27, 127n8, 129, 143, 149; Eighteen Scholars, 60, 65–69, 76, 79n62, 155; figural, 30, 37, 46, 52–55, 72, 73, 74, 76, 122, 124–27, 155n5; ink-outline (*baimiao* 白描), 131, 134n4; landscape, 53, 180; literati, 36, 53, 66, 74, 77nn5–6, 155n5; *See also* mural/wall painting

Palace Banquet (cat. 21), 30–31, 35, 36–37, 49, *51*, *54*, 55–59, *57*, 60, 75–76, 79n51, 122–27, *123*, *124*, *125*, *126*, 137, 139, 141, *141*, 143, 149; architecture in, 37, 50–52, 53, 55, 58–59, 75–76, 122–27, 127n2, 127n9; erotic/romantic themes in, 76, 122, 124, 127; Tang references in, 31, 37, 54–55, 58, 60, 76, 124, 127, 129

Palace Concert, 49–50, *50*, 52, 54, 55

Palace Ladies Bathing Children (cat. 22), 55, 83, 127, 128–29, *128*, 147

Persia, 110, 145, 149

pitcher (cat. 16), 110, 112, *112*, 115

poetry, 29, 131, 179; as elite/literati pastime, 63, 69, 151, 182; paintings connected to, 63, 93, 93n1, 151, 161, 161n3, 182; performance of, 31, 182; *Quatrain on Autumn* (Yang Meizi) (cat. 32), *150*, 151

porcelain, 97, 109, 137, 163; development of, 20, 32nn5–6; Ding ware, 109, 163, 163n2, 171; *qingbai* ware, 97, 110, 139, 172

Princeton Liao panels (cats. 1–6), 30, 35, 37, 47–49, 75, 78n33, 82, 87n2, 93, 107; *Arranging an Outdoor Banquet* (cat. 4), *39*, 39, 40, 43, 46, 86, 89, *89*, 105; *Attendants Bearing Offerings* (cat. 2), 40, *41*, 78n27, 85, *85*, 87n6, 107; *Four Figures Flanking a Doorway* (cat. 5), 37, 41, 47–48, *48*, 86–87, *90*, 90; *Gentlemen Attendants* (cat. 1), 37, 40–41, *41*, 78n27, 84, *84*, 86; *Horse and Grooms* (cat. 6), 37, 41, 82, *91*, 91; *Preparing for an Outdoor Banquet* (cat. 3), 39–40, *40*, 43, 46, 83–86, *88*, 88, 97, 101, 103, 110

Q

qingbai 清白 ware. *See* porcelain, *qingbai*
Quatrain on Autumn (Yang Meizi) (cat. 32) *150, 151*

R

Ru 汝 ware, 163

S

sancai 三彩 ware, 110, 115, 145
scholar-official, 49, 63, 64, 131, 134n4, 151; painting, 66, 77n6, 161n2; *See also* literati
sculpture, 24, 27, 28, 31, 54, 129
Shang 商 dynasty (late 2nd millennium BC), 20, 22, 32n12
Shanyuan Covenant (*Chanyuan zhi meng* 澶淵之盟), 38, 77n9
Shiji 史記 (*Records of the Grand Scribe*), 24–25
Shijing 詩經 (*Books of Odes*), 161
silk, 20, 33n14, 33n23, 33n27, 38, 117, 119, 149; sericulture as a theme, 161
Sima Qian 司馬遷, 24–25
Six Dynasties (220–589), 79n67, 110, 161; *See also* Eastern Jin; Western Jin
Sixteen Prefectures, 37–38
Song 宋 dynasty (960–1279), 19, 30–31, 35–36, 37, 42, 46, 49, 50, 52, 53–55, 60, 66, 69, 72, 75–76, 77n6, 83, 87, 93, 110, 117, 124, 129n3, 131, 137, 141, 145, 147, 149, 149n1, 151, 161, 171, 172, 177, 179, 182; burial practices, 30, 46, 49, 52–53, 78n26; ceramics/porcelain, 29, 53, 97, 110, 137, 139, 141, 163, 171; civil examination system, 36, 49, 151; copies of Tang paintings, 83, 127; court-lady painting, 31, 37, 127, 149; court painting, 36, 58–59, 71, 74, 77n6; Eighteen Scholars theme in, 66–68; figural painting, 73, 74, 76, 127; founding of, 35, 38, 49; funerary art, 40–41, 54; Jurchen invasion of, 35–36, 93, 163; lacquerware, 29, 137, 169, 171; Liao and, 38, 43, 77n9, 97, 101, 107, 109, 110; literati painting, 36, 53, 77n6; metalware, 29, 97, 103; Mongol conquest of, 36, 71, 77n6; Neo-Confucianism in, 52, 71, 161; Northern Song capital/Kaifeng, 35, 93; patronage, 35, 36, 37, 53–54, 75, 93n1; Southern Song capital/Hangzhou, 35–36, 77n2, 93, 124, 163; tableware, 97, 110, 137, 163; tombs, 30, 46, *46*, 78n26; *See also* Northern Song; Southern Song
Southern Song 南宋 (1127–1279), 30–31, 36, 37, 60, 66, 69, 77n6, 93n2, 129n3, 137, 171; *See also* Song dynasty
Southern Tang 南唐 (937–976) 61, 131; *See also* Five Dynasties and Ten Kingdoms
Standing Court Lady (cat. 28), 54, 83, 142–43, *142*

T

Taihu rock (cat. 45), 68, 69, 154, 180, *181*
Taizong 太宗, Liao dynasty emperor, 37–38
Taizong 太宗, Tang dynasty emperor: Eighteen Scholars and, 60, 66–68, 151, 155
Tang 唐 dynasty (618–907), 28–30, 31, 37, 57, 87n5, 110, 115, 117, 141, 149, 151, 161, 177, 179; Buddhism in, 53; capital/Chang'an, 37, 38; court ladies of, 31, 37, 54–55, 58, 60, 76, 79n45, 83, 124, 127, 129, 143, 147, 149; Ding ware, 163, 171; fall of, 30, 35, 38, 49, 97, 103, 115, 131; founding of, 28, 145; Liao and, 30, 38, 42, 46, 76; metalware, 97, 101, 103, 137; as model/referent, 30, 31, 37, 38, 41, 42, 46, 54–55, 60, 63, 65–68, 73, 76, 79n45, 83, 93, 105, 124, 127, 129, 143, 155; tomb figures, 143, 145, 177; tomb painting, 46, *47*; *See also* Eighteen Scholars of the Tang
textile, 29, 31, 53, 75, 87, 117; *Flowers, Cranes, and Clouds* (cat. 19), 87, 116–17, *116, 117*; *Textile Fragment with Boys in Floral Scrolls* (cat. 31), 29, 127, 148–49, *148, 149*
The Thirteen Emperors (attrib. Yan Liben), 66, *66*, 68
tomb: Baisha, 46, *46*, 78n27; Baoshan (Hubei), 32n8; Baoshan (Inner Mongolia), 87n10; Dahuting, 45–46, *45*, 78n25; Dishuihu, 107, *107*; elite, 19, 21, 28, 35, 46. figures: *Court Lady* (cat. 29), 144–45, *144*, 177; *Figure of a Dancer* (cat. 44), 161, *178*, 178–79; *Four Kneeling Musicians* (cat. 43), 122, 145, 174–77, *174–75, 176*; *Standing Court Lady* (cat. 28), 54, 83, 142–43, *142*. Hengyang, 149; of Han Shixun, 78n19; of Lady Huang Sheng, 149n1; of the Lady Marquis of Dai, 25–28, *25–28*, 33nn22–23, 33nn27–30, 33n33; of the Marquis of Dai, 26; of Marquis Yi of Zeng, 22, 23–24, *23*, 26–27, 33nn14–16, 33n22; of Prince Zhanghuai, 46, *47*; of the Princess of Chen, 87n10; of Wang Chuzhi, *56, 57*; of Zhang Shiqing, 42, *42*, 78n17, 79n42; of Zhang Wenzao, 42, *43*; *See also* coffin panels, Liao; funerary art; Mawangdui; Princeton Liao Panels (cats. 1–6); Xuanhua
Twin Trees by the South Bank (Ni Zan) (cat. 46), 182–85, *183, 184*

U

Uyghur, 37

V

vessel, ritual, 21, 23, 27, 33n30; *See also* food and drink; wine

W

Wang Chuzhi 王處直: tomb of, 56, 57
Wang Xizhi 王羲之, 151
Warring States (481–221 BC), 23, 27; *See also* Zhou dynasty; Eastern Zhou
Wenji 文姬, Lady, as theme
 Eighteen Songs of a Nomad Flute (cat. 7), 42–45, 92–93, 92, 94, 95, 119; *Lady Wenji's Return to China*, 42–45, 44, 78n23, 93, 93n1; *See also* headpiece (cat. 20)
West Asia, 117, 149, 177
Western Han 西漢 (206 BC–AD 9), 141; *See also* Han dynasty
Western Jin 西晉 (265–317), 79n67; *See also* Six dynasties
Western Zhou 西周 (ca. 1050–771 BC), 22; *See also* Zhou dynasty
Whiling Away the Summer (Liu Guandao), 72–74, 72, 79n70
wine, 61, 78n16, 171, 177; pouring/serving, 23, 24, 64, 71; preparation of, 42, 42; vessels: 21, 23, 26, 32n11, 33n14, 61, 69, 154, 155, 163, 169; cup (cats. 8, 9, and 36), 97, 98, 98, 99, 99, 139, 163, 165, 165, 172; ewer (cat. 42), 172, 173
women: calligraphers, 151; musical ensembles, 145, 177; *See also Court Lady* (cat. 29); feast, court ladies'; *In the Palace* (cats. 23–24); painting/painters, court-lady; *Palace Banquet* (cat. 21); *Palace Ladies Bathing Children* (cat. 22); *Standing Court Lady* (cat. 28)
Wudi 武帝, Western Jin dynasty emperor, 79n67

X

Xiang Yu 項羽, 24
Xin Zhui 新追. *See* Mawangdui, Changsha, Hunan province, Tomb 1
Xi Xia 西夏 dynasty (1032–1227), 19, 35
Xiongnu 匈奴, 42, 93; *See also* Wenji, Lady, as theme
Xuanhe huapu 宣和畫譜 (*Painting Catalogue of the Xuanhe Period*), 49
Xuanhua 宣化, Hebei province, 42, 45, 79n42; Tomb 1 (tomb of Zhang Shiqing), 42, 42, 78n17, 79n42; Tomb 4 (tomb of Han Shixun), 78n19; Tomb 7 (tomb of Zhang Wenzao), 42, 43
Xuanzong 玄宗, Tang dynasty emperor, 55, 143

Y

yan 宴 (feast), 21, 49
Yang Guifei 楊貴妃, 55, 143
Yang Meizi 楊妹子, Empress, 151; *Quatrain on Autumn* (cat. 32), 150, 151

Yan Liben 閻立本: Eighteen Scholars handscroll, 66, 68; *Thirteen Emperors*, 66, 66, 68
Yan Zhenqing 顏真卿, 151
Yaozhou 耀 ware, 163
Yelü Deguang 耶律德光. *See* Taizong, Liao emperor
Yuan 元 dynasty (1260–1368), 19, 31, 35, 37, 49, 60, 68, 69–70, 76, 137, 149, 154, 155, 172, 177, 179; court painting, 36, 69–70, 72, 74, 76, 77n6, 79n71; fall of, 182; Four Masters of, 182; literati painting, 36, 73, 74, 77n6; Mongol rule, 31, 36, 71, 73; patronage, 36, 73, 75, 77n6
Yue 越 ware, 101, 110, 163

Z

Zeng, Marquis Yi of (*Zeng Hou Yi* 曾侯乙): tomb of, 22, 23–24, 23, 26–27, 33nn14–16, 33n22
Zhang Boya 張伯雅: tomb of, 45, 78n25; *See also* Dahuting, Tomb 1
Zhang Cheng 張澂, 131, 134nn3–4
Zhanghuai 章懷, Prince: tomb of, 46, 47, 78n28
Zhang Shiqing 張世卿, 42, 78n17; tomb of, 42, 42, 78n17, 79n42; *See also* Xuanhua, Tomb 1
Zhang Wenzao 張文藻: tomb of, 42, 43; *See also* Xuanhua, Tomb 7
Zhang Xuan 張萱, 129, 131
Zhang Zeduan 張擇端: *Along the River during the Qingming Festival*, 172, 172
Zhao Cangyun 趙蒼雲: *Liu Chen and Ruan Zhao Entering the Tiantai Mountains*, 70, 71, 73–74, 79n69
Zhao Kuangyin 趙匡胤 (Song dynasty emperor Taizu 太祖), 49
Zhongzong 中宗, Tang dynasty emperor, 78n28
Zhou 周 dynasty (ca. 1050–256 BC), 20, 22, 23–24, 177; *See also* Eastern Zhou; Western Zhou
Zhou Fang 周昉, 127, 129, 131; *Palace Ladies Bathing Children* (cat. 22), 55, 83, 127, 128–29, 128, 147
Zhouli 周禮 (*Rites of Zhou*), 23–24
Zhou Wenju 周文矩, 79n70, 127, 131; *In the Palace* (cats. 23–24), 55, 127, 127n4, 129, 130, 131–34, 132–33, 134, 135
Zhucun 朱村, Henan province: Tomb 2, 28, 29, 33n32

Photography Credits

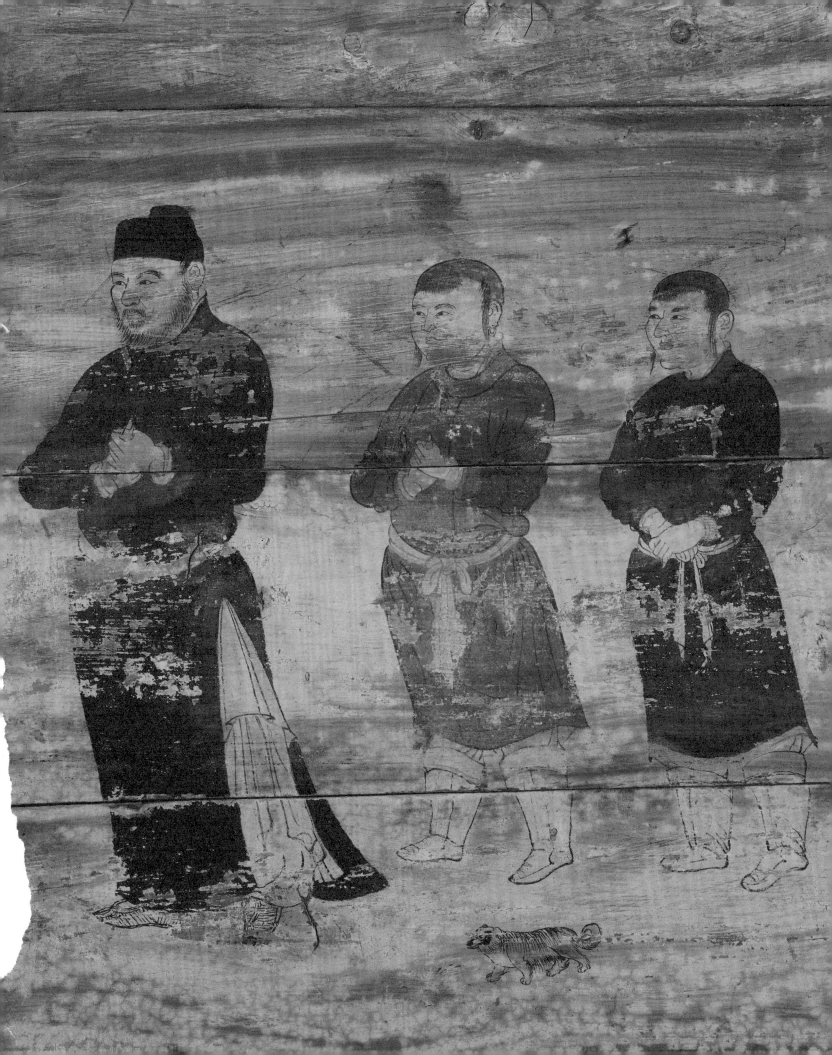

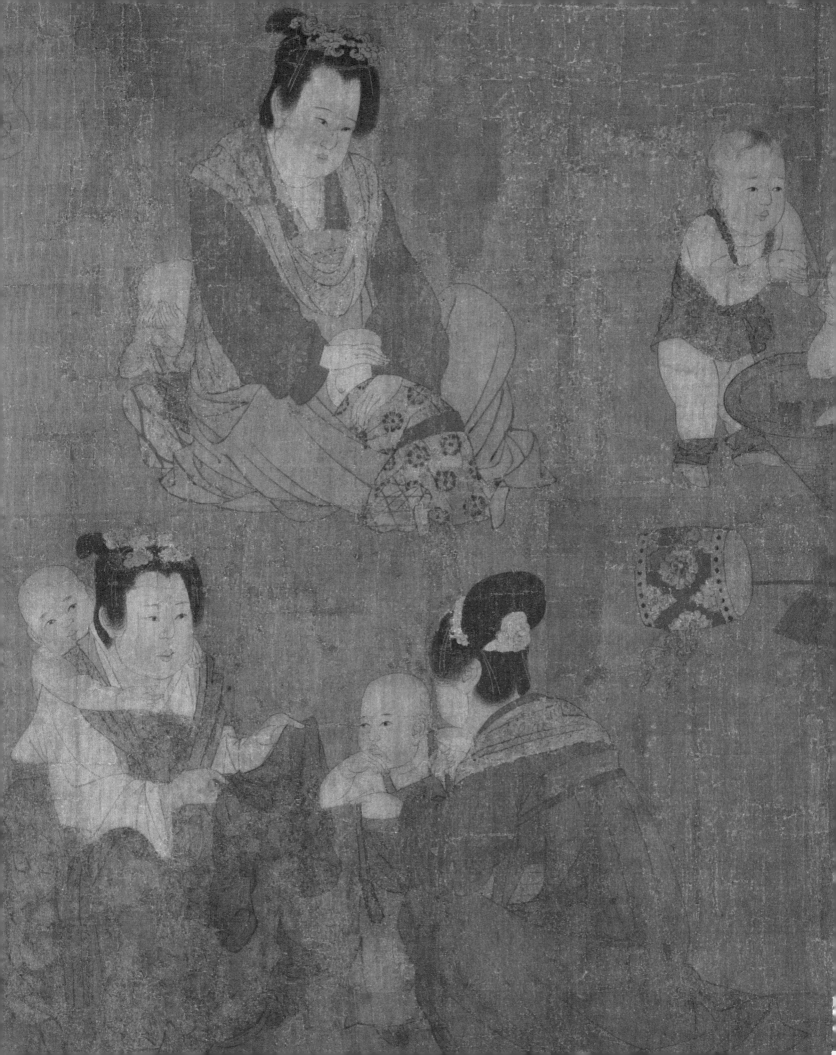